POSTMODERN
MEDIA CULTURE

For Lib

POSTMODERN MEDIA CULTURE

Jonathan Bignell

EDINBURGH
University Press

© Jonathan Bignell, 2000

Edinburgh University Press Ltd
22 George Square, Edinburgh

Typeset in Palatino Light
by Pioneer Associates, Perthshire, and
printed and bound in Great Britain by
The Cromwell Press, Trowbridge, Wilts

A CIP record for this book is available from the
British Library

ISBN 0 7486 0988 1 (paperback)

CONTENTS

PREFACE

———◦∽◦———

This is a book that I have wanted to write for a long time. Some fifteen years ago, as a graduate student, I was already interested in the writing of such people as Marshall McLuhan, Fredric Jameson and Jean Baudrillard. Although I was by training a student of literature, and enthused primarily by French structuralist theory, I had a hazy sense that their diverse ideas about culture might have interesting relation-ships to the media. As my studies turned increasingly toward film and television, aspects of postmodern thought began to have more influence on my work. Teaching film, television and other contempo-rary media involved communicating versions of postmodern theory to students, and the complexities and problems of these approaches became increasingly evident. When what seemed a long stretch of research time became available, I decided to embark on this project. The scope of the book has both expanded and contracted during the writing. The often helpful comments of anonymous readers of the original proposal have encouraged me to add strands of argument and topics of analysis which were not originally planned, and I hope that this finished product does justice to these suggestions. In order to make room for a broader discussion, I have simplified the planned structure of the book, and reduced the space for detailed analysis of particular films, television programmes, computer games and other media products which were going to be included. The book aims for a balance between close analysis and discursive argument, though the proportions of these kinds of writing vary from chapter to chapter. I hope that the book will be a helpful contribution to debates about postmodern media culture, and will enable future work on contempo-rary media culture and theories of the postmodern.

At a point near the completion of the book I changed jobs, and this caused considerable disruption to my plans. In this context, I would like to take this opportunity to thank all those people who provided support and encouragement during the writing of this book. The editorial team at Edinburgh University Press were consistently supportive of the project, and I thank them for their forbearance and understanding. During my time in the Department of English at the University of Reading, I was given research leave which allowed me to complete a first draft of the book. I am grateful to Cedric Brown, Head of Department, for this opportunity, as well as for his renowned efficiency and effectiveness more generally. Colleagues at the University of Reading, both in English and in other departments, were also helpful intellectually and personally. In particular, I am grateful to the members of the Critical Theory Reading Group for their indulgence of my obsessions and their contributions to my thinking. Karín Lesnik-Oberstein, Stephen Thomson and Daniela Caselli deserve especial thanks. When I moved to the Department of Media Arts at Royal Holloway College, University of London, completing this book prevented me for a while from embracing my new environment as wholeheartedly as I would have liked, and I am grateful to Carol Lorac, Head of Department, for smoothing my transition to new responsibilities, and to my new colleagues for their friendly welcome. Among the many others who have made important contributions, I would like to thank David Lusted for his salutary scepticism about the postmodern, Jacqui Griffiths for her incisive thinking about critical theory, and Mandy Merck for alerting me to a useful source at the last minute. My friend Joel Soiseth provided the cover illustration for this book, and I hope that the writing inside does justice to his fascinating work. My partner Lib Taylor has supported me intellectually and emotionally throughout, and she has my grateful thanks and my love.

INTRODUCTION:
MEDIA CULTURE AND THE POSTMODERN

———∞———

Critical discourses which make use of the term 'postmodern' are one of the dominant forms for addressing contemporary culture as something which is undergoing significant change, and as John Storey notes, 'popular culture is usually cited as a terrain on which these changes are to be most readily found'.[1] The citation of popular culture, and of mass-media culture in particular, is a central concern of this book. Some of the theorists of the postmodern in contemporary culture have used examples of specific media products, institutions, or audiences (especially Jean Baudrillard and Fredric Jameson, for instance), while some (like the influential Jean-François Lyotard or Jürgen Habermas) rarely use media examples, despite the relevance of their ideas to the media. However, many of the current studies which take their lead from these theorists have labelled particular media texts or practices as postmodern without being able to integrate a wide-ranging critique of contemporary media culture with a critique of theories of the postmodern. In this book I demonstrate and analyse the interdependence of theories and examples in critical approaches to the postmodern and media culture. The purpose of this re-examination of existing work is to show that the postmodern is a discursive construct which depends on the citation of particular kinds of objects, be they texts, institutions, audiences, or ways of conceptualising these and other aspects of media culture. This issue is central to the debates outlined in the first chapter of this book, which discusses the versions of the postmodern proposed by critical theories of media culture. As well as outlining key

1

propositions about media culture which have been advanced in theories of culture, the chapter places emphasis on the use of media culture itself as a terrain on which critical discourse stands. For while the post-modern is 'readily found' in media culture, media culture enables the discourses in and of the postmodern to establish themselves as modes of address to the contemporary.

The media examples referred to in the work I consider in Chapter 1 include television, cinema and information technology, and I shall discuss theories of the postmodern by cultural critics in relation to examples of, or references to, media products, media institutions, or media consumption. I shall show that theories of the postmodern are in part a response to developments in media culture, and that the theoretical discourses about the postmodern provide relevant models of how contemporary media culture can be evaluated. In other words, contemporary media and theories of the postmodern are mutually implicated and mutually defining, and this double movement is taken further in the chapters which follow. Chapter 1 sets the terms for the rest of the book by arguing that there are three interrelated critical projects which need to be carried out. These are: to assess the status of media examples in definitions of the postmodern; to evaluate the role of discourses about the postmodern in studying the media; and con-sequently to discuss the relationships between the media, the notion of the postmodern and contemporary culture. It is these three kinds of work which dominate this book, in different proportions and with different emphases. As well as rethinking some of the extensive work on the postmodern which has already been done, I also contribute conceptual and analytical work of my own, which supports or reorients significant strands of thought on postmodern media culture.

My contention is that the postmodern is a flexible and often useful conception which both allows discussion of disparate developments in media culture relating to production, texts and consumption, and performs a role in theoretical discourse which has been left empty by the supposed demise of other theoretical models (like Marxist criticism or empirical sociology), which have been deployed in critical work on media culture. From the 1970s onwards, academic work on media culture has taken a lead from Louis Althusser's essays on ideology,[2] and Roland Barthes' work on the mythologies of popular culture,[3] seeking to show how media texts position individual subjects in

processes of interpellation. Classic works like Judith Williamson's *Decoding Advertisements* demonstrated with subtlety, conceptual complexity and political rigour, how media texts displace production by consumption as the basis of identity, obscure class and economic relations between people, and solicit the subject to construct meaning through relations with objects.[4] Agency is located in the text or media object itself, with only minimal opportunities for agency by the viewer, consumer or user. While conflict, contradiction and resistance may occasionally be present in the text as part of its internal dynamics of signification, leading to possibilities of process and struggle by the subject, the function of the text as an agent of interpellation would finally be successful. This predominantly Leftist discourse, whose effectivity I have myself promoted elsewhere,[5] began to be challenged with increasing force until by the middle of the 1980s it had been replaced at the centre of intellectual culture by a heterogeneous mix of critical discourses grouped under the umbrella term 'postmodernism'. While this situation has been variously applauded or attacked, the notion of the postmodern has a significant role and some enabling effects in contemporary thinking about media culture. However, there is considerable ambiguity and diversity in the ways in which the terms modern, modernity, postmodern, postmodernity and other related forms are deployed in discourses in and about media culture. One of these is the vexed question of periodising the postmodern, and I have already implicitly claimed in this paragraph that a shift to a postmodern form of media theory can be identified in a particular decade.

Modernity, postmodernity, postmodernism and the postmodern are terms which suggest a historical consciousness, and which view history as a whole that can be divided into periodising segments. The terms describe culture, which is thus simultaneously addressed as if it were a whole, and also as something that is in a process of dynamic and uneven change from one state to another. As Peter Osborne has written: 'What is rare is to find the ideas of postmodernism, postmodernity and the postmodern the object of philosophical attention at the level at which they are constituted, as periodising concepts of cultural history'.[6] As Osborne shows, versions of the postmodern in cultural theory have rarely been analysed systematically as theories of time, history and cultural change, and need to be considered as discourses which constitute the temporality, history and referentiality of the postmodern,

rather than simply denoting a set of texts or cultural relations which
could be grouped together. The subtitle of this book was to have been
Theoretical Discourses and Their Objects, and a version of this title now
appears as the title of chapter one. The title was and is intended to alert
the reader to two ways in which the book will address postmodern
media culture. One of these is a focus on which objects, drawn from
contemporary media culture, theories take, or can take, as the examples
on which to base their conceptions of the postmodern. The second
interpretation would be to note what the objectives of theoretical dis-
course may be. For, among other objectives, theoretical discourse on
postmodern media culture may describe, celebrate, or decry either the
use of the term postmodern in relation to media culture, or the media
culture which is taken to be postmodern, or both. One of the problems
in writing about the relationship of postmodern media to culture and
politics is the issue of the relationship between the objects of analysis
and the subject of interpretation. I have already signalled that the
objects of analysis have a constitutive relationship to the theoretical
outcomes which they support, and the status of the subject of theory is
parallel to this. The subject of interpretation can take a range of guises.
This subject can be the critic, as producer of a critical discourse, or the
spectator or audience of a media production who is spoken for by the
critical discourse, or a generalised and abstract subject of postmoder-
nity, a collective 'we' which is claimed to inhabit a postmodern scene,
and may even be constituted by it. Conversely, as in Terry Eageleton's
The Ideology of the Aesthetic, a 'we' dominates a discourse critical of the
postmodern, and 'our present conditions of life' demand a moral and
political rejection of the postmodern in favour of an anticipated unity
of humanity underwritten by a transhistorical biological nature and
its needs.[7] Just as I argue that the objects of analysis in the postmodern
are crucial to its significance, so too the subjects of postmodern theory
are an important topic of analysis in constituting its address to con-
temporary media culture.

Any reference to the distinctiveness of the media culture of the
present must imply a history, either of a genetic and diachronic
developmental process which prepares for it, or a synchronic structural
break whereby an earlier period gives way to a new structure. Osborne
diagnoses the usage of the term postmodern in cultural theory correctly
I think, stating that 'the popularity and tenacity of postmodernism as a

diagnostic discourse of "the times" can be seen to bespeak a desire for totalization in the medium of cultural experience which is not currently satisfied by any other critical tendency'.[8] The postmodern is a loose set of ideas critiquing Enlightenment reason, and having a Neitzchean flavour, combining Nietzsche's questioning of the categories of thought and of the status of theory itself, with a legacy of Marxian political engagement that stresses the relationship between cultural activity (or the lack of it) and politico-economic power structures. Media culture is a terrain on which communication between people in a concrete historico-economic situation takes place. This conclusion both derives from and departs from Marx's theory of the commodity, which addressed texts, technologies and media as things which mediate relations between thing-like individuals in capitalism. I argue that the objects of postmodern media culture, whether considered as texts, technologies, or modes of audience relations, function as the location of communicative relationships between people. But the critical meta-languages which address this situation are widely regarded to have lost the stability and authority which legitimate their claims to seize their objects of analysis adequately and to communicate satisfactory theories of culture. Postmodern theory shares with Marxism a commitment to analysing the politics of culture and the relations of culture to political and economic power. As a corollary to this, it shares Marxism's Hegelian heritage in idealist philosophy by invoking a theory of history, but at the same time postmodern cultural theory problematises that history. For postmodern theory, by virtue of the prefix 'post', suggests a totalising history in which the postmodern is both a stage in a teleological progression, but also a final subsumption of history into a null state that has absorbed past, present and future into itself. One of the characteristic moves in postmodern theory is the resistance to totalising grand narratives of history, as identified by Jean-François Lyotard. So postmodern theory is both a grand narrative itself, and a means of claiming that such grand narratives have lost their legitimacy. The consequence of this, as Osborne has shown, is that postmodern theory is marked by 'this paradox of self-referentiality' around historicisation and the power of theoretical discourse to produce it.[9] This book, while occupying a different terrain to Osborne's philosophical study of time and modernity, will focus on and explore the ramifications of this problem of self-referentiality.

The other significant connotation of the prefix 'post' in the postmodern is the definition of the postmodern in contrast to modernity or the modern. The modern is itself posited in contrast to the traditional, which the modern reacts against and assigns to a previous time. But as time and change continue to occur, what was modern keeps falling back into the traditional at the same time as further exemplars of the modern appear. Again, Osborne encapsulates this paradox of modernity well:

> Modernity is a form of historical time which valorizes the new as the product of a constantly self-negating temporal dynamic. Yet its abstract temporal form remains open to a variety of competing articulations. In particular, by producing the old as remorselessly as it produces the new, and in equal measure, it provokes forms of traditionalism the temporal logic of which is quite different from that of tradition as conventionally received.[10]

Therefore modernity as the time of the modern should not refer to an epoch with a starting and ending point, whether the modern is centred on the appearance of a new kind of individual subject, or a newly postfeudal socio-economic arrangement, for example. Because it is the term for what is new, the modern keeps producing the traditional as its other, and both the traditional and the modern thereby continually change their meaning. Furthermore, the production of the modern in the West has been the starting point for the use of the term modern, and therefore has a spatial dimension as well as a temporal one. To extend the notion of modernity to postcolonial societies already imposes a homogeneous production of spatiality and temporality across the globe which may cover over the specific cultural differences which affect what space and time mean, and what modernity and tradition mean. One of the concerns of this book is the limits which can be set to the spatial, geographical reach of postmodern media culture, and the relationship between a media culture which is postmodern and one which is not.

In the postmodern, the modern takes the place of the traditional as that which has been superseded, in the sense that in some places and at some times, a decisive change in culture seems to occur that creates this new third stage. So while modern means 'of the present' as

opposed to 'of the traditional past', postmodern could denote the transformation of the tradition of modernity into a new modernity, or a return to the traditional which has occurred as part of this new version of the modern. The postmodern is discursively placed as at once another kind of modernity and as something distinctly different from it. The point is made by Osborne, who writes, referring to Lyotard's postmodern as the nascence of the modern, which I discuss in Chapter 1:

> It is the irreducible doubling of a reflexive concept of modernity as something which has happened, yet continues to happen – ever new but always, in its newness, the same – that the identity and difference of the 'modern' and the 'postmodern' plays itself out at the most abstract level of the formal determinations of time.[11]

Modernity happened in the past, so that the postmodern goes beyond it. But the fact that the postmodern is also the new makes it part of the modern since 'modern' refers to the presentness of a state of affairs. In this book my own discourse refers as consistently as possible to 'the postmodern' as a means of addressing and distinguishing a media culture claimed to be different from that of an anterior modernity, and is thus used relationally rather than as a way of denoting a particular period.

The discourses which address the postmodern have their own histories. For the discursive status of theorists, media objects and practices which are cited in critical discourse changes, so that analysing the citations of theoretical discourses and examples of media culture could provide a history of notions of the postmodern. This task is taken up by, for example, Hans Bertens' *The Idea of the Postmodern: A History*, where the ambiguity of the term requires its materialisation through examples and a history of its use, stabilising its viability as an analytical description of the present.[12] One of the confusions which this entails, however, is caused by the different ways in which the term postmodern is used in discourses that address different aspects of culture. There are significant differences between the evolving attributions of the term in theoretical work on, for example, literature, film and the visual arts. Since the topic of this book is media culture, these differences are not addressed in any detail, but they are occasionally relevant to this study for two reasons. First, while I analyse film, television and computer-based

media most often in the chapters which follow, I do include some work on popular written fiction where films are based on a literary source, and I do discuss some studies of the postmodern in photography which have a bearing on photography as an art form. Second, some of the philosophical and theoretical writing on the postmodern originated in the contexts of aesthetics and art criticism, though it has since been disseminated widely in criticism of other cultural forms, particularly contemporary media. However, while it would be interesting to follow up these problems of origin and cross-fertilisation, I am content to claim that the drift of work on the postmodern across disciplines and cultural forms is part of the issue of reference, of how a theoretical discourse makes claims to address a particular object of analysis, which is discussed throughout this book. Indeed it could be argued that postmodern theories of culture are in part distinguished by an implicit claim to generalisability across disciplines and cultural forms, at the same time as such a totalising ambition is problematised by postmodern theories.

Developmental history is one of the modes of thought which is questioned in theories of the postmodern, as I have already briefly outlined, and as I discuss further in Chapter 1. Indeed one of the shorthand phrases for pinning down what the postmodern consists in is 'the end of history', in the sense that notions of progress, development and perfectibility have lost their force. The second chapter of this book draws together theoretical writing on the end of history thesis with examples drawn from media culture, in particular from cinema, which concern apocalyptic scenarios. As Mick Broderick has noted,[13] apocalyptic scenarios have been evident since the beginning of film, in such diverse forms as the natural catastrophes of *The Comet* (1910), *The End of the World* (1916), or the technological annihilations of *The Airship Destroyer* (1916), *Metropolis* (1926), *Deluge* (1923), and *Things to Come* (1936). Apocalyptic fictions include a concept of repetition that permits the production of new stories about the end, and since predictions of apocalypse are perpetually disconfirmed, narratives about the end have to keep recommencing. My analysis of apocalypse focuses specifically on the relationships between the postmodern, conceived as an end of history and thus as a perpetual endtime, and the gendering of two films which explicitly concern imminent apocalypses, *The Name of the Rose* (1986) and *Seven* (1996). As Christopher Sharrett has

argued, both theories of the postmodern and recent cinema are concerned with an apocalypticism in which there is both a crisis of meaning and a sense of the end of Western culture.[14] In Chapter 2, I show that postmodern discourse shares much with conservative *fin-de-siècle* thinking in relation to masculinity, for the end of history is simultaneously the end of masculine mastery for a Western male subject. End of history theses, notably those produced by Francis Fukuyama and Fredric Jameson, rest on crises of mastery which I find at work in the two films I discuss, demonstrating the interweaving of theoretical discourse with examples drawn from contemporary media culture.

Chapter 3 returns to the same two films, along with further films and popular literature, to discuss problems of judgement and value in the postmodern. As I show in Chapter 1, some critical writing on the postmodern proposes that one of its attributes is the impossibility of a critical distance from it, so that the discourse which names an example and states a case cannot legitimately claim the distance which allows evaluative judgement. The problem is how to establish the postmodern as the referent of discourse and at the same time to evaluate it. Already in the 1960s, Susan Sontag had claimed that the evolving 'new sensibility' which she discerned in the New York cultural scene was characterised by the fact that 'the distinction between "high" and "low" culture seems less and less meaningful'.[15] The assumption of Modernist art into official culture could be seen to reinforce the existing separation between elite cultures and popular ones, and for Andreas Huyssen, writing in 1986, 'it is by the distance we have travelled from this "great divide" between mass culture and modernism that we can measure our own cultural postmodernity'.[16] The third chapter of this book addresses the issue of the interrelation between high and popular culture, situating the discussion in further work on *The Name of the Rose* and *Seven*. The film *The Name of the Rose* was an adaptation of a bestselling paperback, a metafictional novel by the Italian semiotician Umberto Eco which had sold over two million copies by 1986, the year of the film's release.[17] The film, like the novel, straddled the divide between discourses associated with both high and popular culture, alluding to the heretical sects and theological politics of the fourteenth century as well as the cinematic murder mystery and thriller genres. *Seven* also deploys reference to high culture in ways which problematise the status and value of canonical traditions, especially the written,

textual traditions represented by English literature and the Bible. The chapter also analyses *Bram Stoker's Dracula* (1992) and the 1897 novel on which it is based. Stoker's novel was once a popular-cultural vampire thriller, but has now become a literary 'classic'. The film plays a complex game of allusion to the literary, to the history of cinema, and to contemporary cultural concerns, mixing and multiplying its systems of reference and meaning. The diverse films and texts referred two in Chapter 3 enable a discussion of postmodern referentiality and problems of value and judgement, and the paralleling of theoretical questions of cultural hierarchies with the ways that these problems appear in these different cultural objects. Again, the relationships between theory and example, thesis and illustration, form part of the structure and the topic of the chapter.

Part of the postmodern problem of judging value in cinema relates back to the apocalyptic motifs which are the subject of Chapter 2. Contemporary cinema has been described as apocalyptic in that it is claimed to have abandoned classical narrative form, and become a cinema of attractions, especially in the Hollywood blockbuster. The death of cinema which is addressed here is the end of a relation between the subject and object of vision whose history goes back at least to the proto-cinematic devices of the nineteenth century. I would argue, along with Anne Friedberg, that image-producing apparatuses have become increasingly important in contemporary culture, to the extent that their effects provide the exemplarity on which a theory of postmodern media subjectivity can be constructed. Part of the body of reference for such a claim is the work on nostalgia and historicity produced by Fredric Jameson, and Friedberg states that her conception of postmodern subjectivity 'parallels Jameson's theorization of a "cultural dominant". Rather than simply proclaiming a temporal moment of rupture, I have traced the subtle transformation produced by the increasing cultural centrality of the image producing and reproducing apparatuses'.[18] This account immediately raises problems of politics, since it appears both univalent and global. Thus, for example, Jennifer Wicke[19] notes that Jameson's 'Postmodernism, or the Cultural Logic of Late Capitalism'[20] is focused on large-scale issues of aesthetics and politics, and so cannot take note of local resistances against hegemony, and ignores the gendering of the subject in the postmodern. In subsequent work, Jameson draws back from the totalising tendencies of this

first essay. The account of postmodern cinema as an index of a post-modern condition contains its own nostalgia, a longing for both theory and cinema to engage critically with lived experience. Thus my work on the postmodern as an apocalyptic end of history, and as a means of debating problems of judgement and value in culture, aims to politicise these issues in part by specifying them in terms of their gender politics and their relations to a Western tradition.

If postmodernism, in Sontag's words, is 'defiantly pluralistic',[21] rejecting the distinction between objects of legitimised value and contingent objects of pleasure, the discourse which takes unto itself the power to evaluate and analyse media culture is itself faced with a problem of legitimation. Simon Frith and Howard Horne asked:

> Who now determines significance? Who has the right to interpret? For pessimists and rationalists like Jameson the answer is multinational capital – records, clothes, films, TV shows, etc. are simply the results of decisions about markets and marketing. For pessimists and irrationalists, like Baudrillard, the answer is nobody at all – the signs that surround us are arbitrary. For optimists like Larry Grossberg, the answer is consumers themselves, stylists and subculturalists, who take the goods on offer and make their own marks with them.[22]

The fourth and fifth chapters of this book deal in different ways with the question of determinacy of meaning. The fourth chapter concerns children's media culture, partly because the figure of the child is adduced by writers on modernity and postmodernity, notably Walter Benjamin and Jean-François Lyotard, as a model of the subject. My analysis argues that the child is an ambiguous and ambivalent figure in media culture, conceived both as active and passive, as a proto-adult and as the other to adult rationality, even as both human and inhuman. This indeterminacy of the child is parallel to the indeterminacy which I discover in the objects of children's media culture, so that at the different levels of theory, subject and object, a similar instability and liminal status can be found. Since children's toys, television programmes, computer games and other media forms are often global, integrated, mass marketed and evanescent, they provide a suitable site for considering questions of analytical method. Children's media

culture crosses between a range of different media technologies, insti-
tutions, objects and audiences, and raises questions of which of these
potential fields of study most helpfully explicate it, and of how they
interconnect with each other. Issues addressed in the fourth chapter
include the claims for determination of meaning in children's media
culture by global organisation, properties of the objects and texts
themselves, and the potential for child consumers and audiences to
refigure the significance of objects, texts and practices. I argue that just
as the child is constructed in different ways by different discourses,
children's media culture too is an unstable and elusive object. In this
respect, my study of children's media culture as a postmodern culture
aims to highlight questions of theoretical address and methodology
in a novel and illuminating way. One of these problems is the status of
the child as either an active participant in media culture, or a passive
object of it, and consequently the question of how different modes of
media research repeat this problem of agency. Whereas Chapters 2 and
3 address examples of media culture in primarily textual terms, the
focus of the book becomes increasingly oriented toward the audiences
of media culture, whether conceived as consumers, users, or active
appropriators of it.

Chapter 5 centres on representations of events in the news, particu-
larly in photojournalism and television news programming. It begins
with an analysis of debates around photography, as an indexical form
of representation whose status has been said to be challenged by the
recent mutation of photographic images by digital techniques, and the
dissemination of photographic images by electronic transmission
systems. The relationship between the photographic image and theo-
retical elaborations of modernity as an urban culture of images is
outlined, in order to test notions of a break into a postmodern culture
with the arrival of 'post-photographic' images. Such a postmodern
media culture is shown to be constituted by arguments for shifts in the
technologies and institutions of photography, and by assumptions about
the referential value of photographs as representations of the real. I
argue for continuities between the cultural forms of the 'traditional'
photograph and the more recent digital image, drawing attention to
the relations between photography and the body. In particular, the
presence and absence of the human body in war photography can be
adduced as an example to show that the institutional controls over the

photographic image centre on continuing patterns of supervision. The central media event considered in the chapter is the Gulf War of 1991, which was chosen because of the debates around its media coverage. The chapter refers to Baudrillard's controversial writing on the media coverage of the war and to rebuttals of his arguments, diagnosing this debate as one which centres on conceptions of the audience for news coverage. In order to test questions of media coverage as an example of the postmodern, I discuss conceptions of media audiences as abstract masses, as national constituencies, and finally as particular individuals whose complex national, ethnic and cultural allegiances complicate univalent models of media effects. As the chapter proceeds, I argue for the conception of the postmodern not as a particular technological or representational form in the media, but as a kind of analytical approach to media culture which prioritises difference and heterogeneity within that culture. This movement from object or technology to audience and research methodology prepares for the focus on media audience research in Chapter 6.

In relation to the audiences of media culture, I argue that the post-modern is a suitable term for an attention to plurality and difference in the ways in which audiences constitute themselves for the media. Thus I regard the movement in the discourses of media studies from text-centred perspectives to audience-centred ones as itself part of the postmodern. Issues of heterogeneity, difference, and the sidelining of a dominant and univalent tradition are identified in Chapters 1 and 2 for example, in relation to the Western tradition of historiography and the patriarchal authority of high culture. Whereas in earlier chapters these issues are paralleled in examples of media culture and in theo-retical discourse, Chapter 6 focuses centrally on the discourses of ethnographic media audience research. In Chapter 6 especially, the dominant discourses of research into media culture are themselves discussed in terms of a production of difference and resistance in these theoretical discourses. The emergence of this form of the postmodern as a challenge to the orthodoxy of text-centred ideological analysis was described by some academic commentators as either a positive opening out of critical and theoretical discourse to new voices and new constituencies, or as a crisis for theory in the academy, whose own legit-imacy in relation to the culture it addressed was threatened. Angela McRobbie regards the situation positively, enabling the legitimacy of

'those whose voices were historically drowned out by the (modernist) metanarratives of mastery, which were in turn both patriarchal and imperialist'.[23] Her valuation of this shift as opening up access to critical legitimacy for writing from subject positions marked by gender, class, ethnicity and sexual preference is echoed by Linda Hutcheon, who regards the postmodern and the postcolonial as having 'a strong shared concern with the notion of maginalization'.[24]

I argue that the effort of audience research to identify resistance and heterogeneity in the relationships between the objects of media culture and their audiences produces a problem of mastery and referentiality in the discourses of research themselves. In other words, the properties found in the research object (the media audience) as resistant, specific, and internally differentiated, are duplicated at the level of theory. The result of this is a problem of representativeness, in that research results relate uneasily to overarching conceptions of media culture in general. Questions of agency and political effectivity also emerge, because of the uncertain status of the researcher's relationship to their subjects, and the problematic identifications which circulate between them. I draw parallels between this problem of the status of resistance in work on media audiences with the valorisation of resistant interpretation in postcolonial theory, referring especially to arguments by Homi Bhabha about the postcolonial and the postmodern. The postcolonial other, refiguring the discourses of Western mastery, shares claims to resistant agency with particular kinds of television audience, and the role of gender and ethnic difference in television audience studies and in postcolonial theory are shown to work in similar ways. Although earlier chapters of this book pay attention to questions of geographical, ethnic and gender difference, these concerns are central to Chapter 6, which combines work on media globalisation, non-Western television and methodologies for addressing difference in media culture. I argue that while media audience research is postmodern in its recognition of difference, agency and heterogeneity, it is also postmodern in its reflexive awareness of its own methodological underpinnings, and especially the problematic relationship between specific examples and theories of media culture.

The seventh and final chapter of this book returns to many of the key concerns of earlier chapters, in the different context of the cultures of new media, including virtual reality, computer games and

computer-mediated interaction. These new digital and interactive media appear to have strong claims to be decisively different from their predecessors, and to constitute the basis of a distinctively postmodern media culture, in the periodising sense of the term. At the start of the chapter, I analyse the discourses in popularising magazines such as *Wired*, which celebrate this novelty and make claims for its political and cultural effects. Rather than considering interactive media to be resources for a reformation of culture, however, I show that they are mobilised ambivalently, and with a reversible value, in the discourses which take them as their object. Indeed, I argue that virtual reality in particular is a virtual object of discourse, in the sense that its conceptualisation runs ahead of its material forms. Furthermore, the chapter argues for the connections between 'new' media and the 'old' media which they are said to supersede. David Robinson argues that in video games, virtual reality systems and interactive media like CD-ROM, 'new entertainment experiences . . . call on cinematic models while reshaping our habits as spectators'.[25] He notes that the emergent cinema of the late nineteenth and early twentieth centuries drew on the representational techniques and expectations familiar in optical toys like the zoetrope, and 'interactive' environments like the diorama. In the late twentieth century, he argues, 'a variety of similar, though far more elaborate devices, are vying with cinema for cultural predominance, with each form inflecting our experience of the other'.[26] Just as the postmodern signals a new form of the modern, turning the modern into the traditional, computer-based media seem to relegate their antecedents to the past. But also, while the postmodern entails the re-emergence of the traditional, paradoxically linking up with what preceded the modern, computer-based media draw on modes of media experience and pleasure which precede the electronic age. I argue in Chapter 7 that drawing on the postmodern in this self-referential and paradoxical sense enables the claims for the newness of new media and the claims for their oldness to be understood.

Computer-based media are represented in both journalistic and critical discourse as supplements to, substitutes for, and inheritors of familiar media forms like cinema and television, but with the capacity to reposition, displace and problematise identity in new and radical ways. The convergence of text with graphics, photorealistic images, movement and sound in multimedia products demonstrates the

ability of the digital to transform and integrate previously distinct media. Together with interactivity, which attaches modes of response including reading, listening, watching and selecting, computer media appear to provide an experience whose constituents are not new, but which bring together, in new ways and with new effects, the characteristics of several pre-existing forms of social engagement with representations. Whatever the content of the interactive object, its viewer is neither the glancing television viewer, nor the cinema spectator enraptured by narrative, nor the reader following information spatially or sequentially, but a mixture of all of these, where the user is required to become an active controller of the information. New media therefore produce the 'old' media as old by mixing and incorporating them in new ways, allowing for the attribution of computer-based media as postmodern at the same time as they perpetuate modes of interaction which are equivalent to the media cultures they appear to leave behind. One of the important continuities between computer-based media and their antecedents is the Western tradition of spatiality and subjectivity. It can appear that the use of computers to produce images which have no referent, by simulating objects in a virtual data space, offers a challenge to the mimeticism of photography. But even though objects can be modelled by mathematical algorithms and do not require objects of which an image is made, the resulting image is aligned with a particular perspectival point of view, and objects pictured seem to exist in a space which conforms to the codes of Renaissance perspective. The reality effect of such simulated images depends on point of view, perspective, disposition of space and objects, and simulations of the play of light on surfaces and textures, which derive from painting and from photography, thus borrowing their effect from relationships with pre-existing codes, conventions and histories of viewing. Part of this inheritance is the linkage between the production of new technologies and Western military research, and between colonialist representations of otherness and the otherness of virtual worlds. The chapter discusses the relationship between representations of virtual space and models of colonial domination, and between the Western dominance over modes of representation and the production of technology in computer media culture. Here again, the claims of new media culture to be a postmodern culture rest on repetitions and rearticulations of familiar cultural tropes.

The final strand of work to which I would like to draw attention with respect to Chapter 7 is the continuation from earlier chapters of work on the relationships between media culture, the postmodern and the body. On the one hand, some of the computer-mediated communication enabled by new media involve the separation of subjective identity from the material body of the user, as in Multi-User Domains (MUDs), and this separation has been claimed as a liberatory release from determinations of identity by age, gender, class, or race. Similarly, in virtual reality environments it is claimed that the body can be remodelled. These features of new media culture can be assimilated into the postmodern as the virtualisation of determining constraints on identity, and the resource for new kinds of cultural interaction. But at the same time, such new media technologies require intimate connections with the body, whether by clothing the body with technological apparatuses, or in the user's physical interactions with the interfaces and control devices of technology. There is also a repeated trope in writing about computer mediated interaction which stresses the anxieties and pleasures of meeting virtual interlocutors in their physical, 'real-world' forms. The chapter considers the debates about the subjective consequences of bodiliness and its virtualisation, arguing that each is dependent on the other. The indeterminacy of new media culture, at the levels of its politics and its bodiliness, shares the problems of judgement, agency, difference, and discursive address to postmodern media culture which are demonstrated in various ways throughout this book. The chapter, like the book as a whole, aims to focus attention on the interdependence of theoretical discourses on the postmodern in the media and the media examples used to substantiate these different and competing discourses.

NOTES

1. John Storey, *Cultural Consumption and Everyday Life* (London: Arnold, 1999), p. 131.
2. See especially Louis Althusser, 'Ideology and Ideological State Apparatuses: Notes towards an Investigation', in *Lenin and Philosophy*, trans. B. Brewster (London: New Left Books, 1971), pp. 121–73.
3. Roland Barthes, *Mythologies*, trans. A. Lavers (London: Granada, 1973).
4. Judith Williamson, *Decoding Advertisements: Ideology and Meaning in Advertising* (London: Marion Boyars, 1978).

5. Jonathan Bignell, *Media Semiotics: An Introduction* (Manchester: Manchester University Press, 1997).
6. Peter Osborne, *The Politics of Time: Modernity and the Avant-Garde* (London: Verso 1995), p. vii.
7. Terry Eagleton, *The Ideology of the Aesthetic* (Oxford: Blackwell, 1990), p. 412.
8. Osborne, p. ix.
9. Ibid.
10. Ibid., p. xii.
11. Ibid., p. 13.
12. Hans Bertens, *The Idea of the Postmodern: A History* (London: Routledge, 1995).
13. Mick Broderick, 'Heroic Apocalypse: *Mad Max*, Mythology and the Millennium', in Christopher Sharrett (ed.), *Crisis Cinema: The Apocalyptic Idea in Postmodern Narrative Film*, PostModernPositions series 6 (Washington, DC: Maisonneuve, 1993), pp. 250ff.
14. Christopher Sharrett, 'Introduction: Crisis Cinema', in Sharrett (ed.), pp. 1–9.
15. Susan Sontag, *Against Interpretation* (New York: Stein and Day, 1966), p. 302. The quotation is cited in Storey, p. 131.
16. Andreas Huyssen, *After the Great Divide: Modernism, Mass Culture and Postmodernism* (London: Macmillan, 1986), p. 57. The quotation is cited in Storey, pp. 131–2.
17. Sales information is given on the back cover of Umberto Eco, *The Name of the Rose* (New York: Warner 1986), first published in Italian 1980, in English 1983.
18. Anne Friedberg, *Window Shopping: Cinema and the Postmodern* (Berkeley, CA: University of California Press, 1993), p. 170.
19. Jennifer Wicke, 'Postmodern Identities and the Politics of the (Legal) Subject', in Margaret Ferguson and Jennifer Wicke (eds), *Feminism and Postmodernism* (London: Duke University Press, 1994), pp. 10–33.
20. Fredric Jameson, 'Postmodernism, or the Cultural Logic of Late Capitalism', *New Left Review* 146, July/August 1984, pp. 53–92.
21. Sontag, p. 304.
22. Simon Frith and Howard Horne, *Art into Pop* (London: Methuen, 1987), p. 169. The quotation is cited in Storey, p. 133.
23. Angela McRobbie, *Postmodernism and Popular Culture* (London: Routledge, 1994), p. 23.
24. Linda Hutcheon, 'Circling the Downspout of Empire', in Bill Ashcroft, Gareth Griffiths and Helen Tiffin (eds), *The Post-Colonial Studies Reader* (London: Routledge, 1995), p. 132.

25. David Robinson, 'New Technologies', in *The Chronicle of Cinema: 1895–1995*, vol. 5, 1980–1994, supplement to *Sight and Sound* 5: 1, January 1995, p. 117.
26. Ibid.

1

THEORETICAL DISCOURSES:
SUBJECTS AND OBJECTS

This chapter considers critical positions in relation to twentieth-century media culture, with a particular focus on two interrelated issues. The first of these is the political evaluation of media culture, in which I shall include cinema, television and electronic communications media. Very broadly, the debate concerns the political effects of a perceived increase in the social significance of mass media, with some writers regarding media culture as politically empowering, and others representing media culture as a threat to the political effectivity of the human subject, or even regarding media culture as putting an end to subjectivity. The second focus of this chapter is the discursive construction of these theoretical positions. I am interested in how references to media culture function as the grounds for critical theories of culture in general. Sometimes the writers whose work I shall discuss make specific references to particular media products, technologies or practices, but more often these references are general and unspecific. The argument of this chapter is that the deployment of references to media culture is a key part of critical formulations which establish and evaluate twentieth-century life, under the headings of modernity, postmodernity, the modern and the postmodern. I shall be less concerned with trying to make hard and fast distinctions between these terms, than with following through the rhetorical process of establishing their pertinence. Of course it is pertinent to ask whose twentieth-century life is being addressed, which brings with it the related question of whereabouts the life is lived. Of the theorists of media culture discussed at

some length in this chapter, few have much to say about media culture
outside of the United States and Europe, nor about the relationship
between general theories of the postmodern and differences in race,
gender and ethnicity which may inflect the purchase of a discourse on
its objects. Issues and questions around these silences of theory are
raised at intervals throughout this chapter, to show how they reorient
notions of modernity, postmodernity, the modern and the postmodern,
and I pursue these issues of difference in later chapters. My aim is to
reflect on discourses about contemporary media culture, before begin-
ning the sequence of chapters addressing particular aspects of media
culture that follow this chapter.

THE LEGACY OF THE FRANKFURT SCHOOL

One strand of thinking about media culture regards it as a mechanism
for the manipulation of audiences. What is at stake here is the rela-
tionship of the critic to the people, and the distinction between, on the
one hand, an empowering and progressive culture, and on the other, the
foreclosure of political thought and action by forms of subordination
and mystification. In relation to the position of the critic, the discourse
establishes a subject-position which claims to speak for the people,
conceived as a collective political subject analogous to Marx's concep-
tion of the proletariat. This collective subject, regarded as a mass, takes
a generalised and abstract form. Similarly, the media under discussion
figure as univalent forces, under the control of a univalent and perni-
cious hegemonic authority. The most influential statement of this
position comes from the Frankfurt School, Theodor Adorno and Max
Horkheimer's *Dialectic of Enlightenment*, and argues that technological
rationality uses reason instrumentally for the purpose of refining
means, rather than defining the proper ends of society.[1] Adorno and
Horkheimer attacked both Fascist and Communist societies, where
they argued that culture was a tool used to disempower the intellectual
resources of the masses, and to bolster the control of the state by an
individual (Fascism) or an elite party (Communism). The products of
mass culture are argued to position the individual as a machine for
production and consumption, work and leisure, who is regulated
administratively. The individual no longer participates in the concrete
historical situation but instead retreats into a privatised experience

dominated by fictional mass cultural substitutes for real experience. The products of the culture industry console, produce resignation and conformity, and seduce people into acceptance of the *status quo*.

This monolithic function of media culture, Adorno and Horkheimer argue, contrasts with the role attributed to art, which is seen as having a role in protesting against political conditions and invigorating society. Enlightenment rationality and its accompanying work ethic are translated into culture, so that domination in relations of production is reproduced in the domination of the people by acquiescent consumption. In *Dialectic of Enlightenment*, Adorno and Horkheimer simply state that 'Films, radio and magazines make up a system which is uniform as a whole and in every part'.[2] The subject of the critical discourse claims a legislative authority, which enables it to constitute itself, and the object of the discourse (the media technology, product or audience) loses any capacity for agency, resistance or struggle. Thus the critic as subject, while speaking for an imagined potential political subject, deplores the foreclosure of subjective agency which he or she has diagnosed in the media culture of the present. What enables the critique to function, therefore, is a nostalgia for subjectivity which extends to everyone but the critic himself or herself and the elite intellectual group to which he or she belongs.

Jürgen Habermas is part of the second generation of the Frankfurt School, and re-launched the Critical Theory project set in motion by Adorno, Horkheimer and Herbert Marcuse. His aim is to revise the Marxist critique of capitalism for the conditions of technological society, shifting its focus from a critique of the economic base to the ideological control of a society which he regards as the betrayer of reason. Habermas' response to Adorno and Horkheimer's monolithic critique is to value communicative action and reflection. He calls for unrestricted communication between people about decisions made in society, enabling reflection about what should be done. While this communication would not itself necessarily lead to a better society, it would provide the grounds for people to emancipate themselves from the administered society and realise their individual potential. The obstacle in the way of this intersubjective exchange is the depoliticised realm of the public sector, where administrative bodies represent people's supposed interests. The class antagonism of earlier phases of society is therefore replaced by conflicts over access to the mass communications

media, in which debates about the activities of the administration can be carried out. The technocratic ideology of late capitalism is never fundamentally challenged by the media, Habermas argues, and seeks to immunise itself against any questioning of its large-scale aims of maximising production and consumption, and prevents its ideology from being threatened: 'Insofar as mass media one-sidedly channel communication flows in a centralized network – from the center to the periphery or from above to below – they considerably strengthen the efficacy of social controls'.[3] The possibility of change depends on freeing communication from the controlling power of administrative institutions of communication, so that a discussion about how to live would replace the perpetual focus on what people desire. A radicalised subject is required to engage in this struggle, and Habermas is fundamentally opposed to the notion of the dissolution of the subject. For Habermas, the subject is essential as the one who speaks and takes practical communicative action, for media communications 'cannot be reliably shielded from the possibility of opposition by responsible actors'.[4]

There are two interrelated ways of responding to the Frankfurt School's critique of media culture. The first is a reconsideration of the human subject, whereby subjectivity is no longer seen as a unified product of the media technologies or texts which are disseminated. Following the poststructural and psychoanalytic understanding of the subject as divided, perpetually in process, and constituted in and through language and representation, temporary and partial subjectivities may be available from which resistance and agency can be formed. Jennifer Wicke and Margaret Ferguson recommend this reconceptualisation of subjectivity in order to allow for agency, based on a feminist understanding of the postmodern: 'postmodernism is, indeed, a name for the way we live now, and it needs to be taken account of, put into practice, and even contested within feminist discourses as a way of coming to terms with our lived situations'.[5] Wicke and Ferguson regard postmodern theory and feminism as sharing concerns to decentre and multiply discourses and identities, and insist on a dialogue between the two, especially in the relation between theory and practice. A second response to Frankfurt School theories is that media technologies can be shown to be both particular in their different ways of affecting culture, and not determining of the relations between people, and

between people and media culture. These interrelated ways of address-
ing media culture are found in a variety of forms in the discourses of
cultural studies, and will be found as the basis of much of the work in
the following chapters of this book.

MECHANICAL REPRODUCTION AND FEMININITY

One of key coordinates for work on media culture is Walter Benjamin's
essay 'The Work of Art in the Age of Mechanical Reproduction', first
published in 1936.[6] Where the Frankfurt School tradition critiques
popular media culture, and is limited by technological determinism,
Benjamin is neither uniformly pessimistic about the political effects of
media culture, nor concerned with rescuing a political subject from its
influence. But unlike other commentators on film and photographic
technology at the time, Benjamin was especially interested in the social
specificity of these new apparatuses and media. In his 'Work of Art'
essay, he noted that reproductions of artworks always lack the dimen-
sion in time and space of the original of which they are the copy, thus
removing the 'aura' which derives from their specific geographical and
institutional position, and freeing them to be circulated among all
classes. Mechanical reproduction was seen not only in terms of the
object itself but also the manner of its reception, which conformed to
'the desire of contemporary masses to bring things "closer" spatially
and humanly, which is just as ardent as their bent toward overcoming
the uniqueness of every reality by accepting its reproduction'.[7] The
closeness between people and the representations found in cinema,
Benjamin argued, led to the audience's identification with the camera
rather than the actors, producing a critical attitude towards films which
is encouraged by the collective situation of the cinema audience. While
Benjamin's theoretical ideas about the functioning of cinema may be
open to question, what is of interest for me in his formulations is the
use of references to media culture to elaborate a notion of modernity
which takes into account both media technologies and the particular
and situated nature of their cultural conditions of reception. Rather
than proclaiming that the political effects of cinema are dependent on
its technology, Benjamin situates cinema in culture, and considers how
the politics of mechanical reproduction depend on the institutional
and economic formations of the media. While being an advocate of a

Marxist project of enlightenment of the mass public, and thus a critic of Hollywood cinema's illusionism, Benjamin considers the media to be open to multiple possibilities of cultural use and political significance.

One of the ways in which Benjamin's work on media culture was intended to feed into discourse was in his unrealised plan for a work to be called the 'Arcades Project' (*Pariser Passagen*).[8] He had certainly seen some of Sergei Eisenstein's films, and his method for the writing of the project is parallel to Eisenstein's dialectic of visual montage. The Arcades Project was to be a collection of written meditations arranged in dialectical relation to each other, where details of Parisian life, especially the consumer objects on display in the shop windows of arcades, were a key to the analysis of modernity. Although Adorno criticised Benjamin for seeing culture as simply reflective of its economic base, he wrote in his posthumous introduction to Benjamin's works:

> his plan for the book *Pariser Passagen* envisages as much a panorama of dialectical images as their theory. The concept of a dialectical image was meant objectively, not psychologically: the presentation of the modern as at once the new, the already past and the ever-same was to have been the work's central philosophical theme and central dialectical image.[9]

As a mode of discourse taking modernity as its object, Benjamin's Arcades Project is a stimulating model for work on postmodern media culture. It avoids the objectification of cultural experience into a set of texts, and juxtaposes a theoretical mode of writing with a discourse which remains close up with its subject. Furthermore, it focuses on the experience of modernity as one characterised by a mobile subject, momentarily positioned but continually shifted within a set of relationships to consumer culture. The modernity proposed by Benjamin is one which has many parallels with the postmodern as I defined it in the Introduction to this book. It is new, but continually changing, refiguring as it does so the culture which precedes it.

The mobile subject of Benjamin's account had been anticipated by the late nineteenth-century figure of the *flâneur*, the male bourgeois wanderer through the cosmopolitan environment whose sensibility was explored in the poetry of Charles Baudelaire. The relationship between the *flâneur* and the media technologies of photography and

cinema both contributes to an understanding of Benjamin's discourse on media culture, and to the place of these media in his notion of modernity. In 1859, Baudelaire described photography as a 'cheap method of disseminating a loathing for history' and simultaneously a way of preserving 'precious things whose form is dissolving and which deserve a place in the archives of our memory'.[10] Baudelaire's dislike of photography derives from its removal of the need for bodily movement around the city, and thus the curtailment of the freedom of the male urban observer. On the other hand, photography offered the means to record the voluptuous sights encountered on the *flâneur*'s wanderings. As outlined above, Benjamin's Arcades Project was to both present and theorise the situation of the subject of modernity as the *flâneur*, and this cultural trope is one of the bases for Benjamin's positive remarks about the cinema. For Benjamin argued that the cinema liberated the nineteenth-century *flâneur* from the imprisoning real space of the period, to wander in virtual space and time:

> Our taverns and our metropolitan streets, our railroad stations and our factories appeared to have us locked up hopelessly. Then came the film and burst this prison-world asunder by the dynamite of the tenth of a second, so that now, in the midst of its far-flung ruins and debris, we calmly and adventurously go travelling.[11]

This discourse on modernity and the media functions in part by associating the city as the paradigmatic site of modernity as a consumer culture, the male bourgeois subject, and the capacity of the cinema to transform the experiences of space and time.

As I have begun to suggest, some of the experiences which predate twentieth-century media culture (shopping in arcades, for instance) are importantly gendered, and mark the relationship between the rise of the female urban consumer and the rise of commodity culture. Anne Friedberg argues that to see how contemporary media culture became dominant it is necessary to investigate the cultural histories which have contributed to it, including those of shopping and tourism, for example, since these features of modernity empowered women to be subjects for these consumer experiences.[12] These experiences were and are in the public realm, and in contemporary media culture they are also evident in the private sphere, in television and video viewing, for

instance. David Simpson argues that if postmodernism is seen as part of a continuum of evolution from the modern, this is a Hegelian history implying idealist evolution and development of an unhistorical kind.[13] If it is radically new, this panders to the advertising industry's and other capitalist institutions' wish to valorise the present and neglect social and historical determinants. For Simpson, as for Andreas Huyssen,[14] post-modernism's celebration of mass culture is a celebration of feminisation, for modernity depended on feminisation in order to constitute a mass culture of consumption. The gender of the modern and postmodern subject is not only a matter of historical research, but also bears on the politics of the discourse used to theorise him or her. This discourse might rest on a feminisation of the male subject (as the figure of the *flâneur* can be argued to do), and thus either continue a history of the association of feminisation with distraction and disempowerment, or claim processes of media consumption for a feminist politics which centralises them in postmodern culture as the new dominant.

BAUDRILLARD AND THE DEATH
OF THE SUBJECT

Like Benjamin, Adorno, Horkheimer and Habermas, Jean Baudrillard is a European intellectual with interests in the mass-media culture most closely associated with the United States. Indeed, across his theoretical writings, there are few references to media examples which do not originate from there. Baudrillard's work oscillates between the critical and contemptuous attitude to media culture observed in the Frankfurt School tradition, and a vertiginous celebration of what he sees as the total triumph of the media over social life. He argues in *America* that the USA is the source of modernity: 'America is the original version of modernity. We [Europeans] are the dubbed or sub-titled version'.[15] This pronouncement derives from a historical sketch of the foundation of American society, in which America was from the start a utopian society, and therefore associated the real with the utopic as a realised or realisable project. Cinema plays a part in this situation by presenting fictions of utopia and achieved resolution in Hollywood films. The problem for America, therefore, is how to preserve or to make permanent a utopian society, rather than how to achieve one in the future. Europe, on the other hand, was not a utopia and had to

invent one, originally through the Enlightenment notions of historical progress and emancipation.

A variant of this argument appears in the work of Zygmunt Bauman, and returns us to the relationship between modernity and the *flâneur*. What happens in modernity, Bauman argues, is that European capitalism modifies its utopian sense of history from one where state institutions will deliver utopia, to one where utopia is privatised into individual consumption, transferring the *flâneur's* pleasure in modern urban consumerism to everyone in society: 'The right to look gratuitously was to be the *flâneur's*, tomorrow's customer's reward'.[16] Whereas the *flâneur*, as Benjamin showed, is a figure whose pleasure is contingent on a specificity of time and place, and is not systematic, postmodern culture is preoccupied with the construction of systems of media spectatorship and consumption which will deliver the same mobile pleasures of looking to each citizen. In this discursive approach to modernity and media culture, a history of Americanisation, privatisation, and the contingency of subjectivity come together, and the function of references to media culture is to provide evidence in a social theory of contemporary societies. But the widespread dissemination of a Baudrillardian conception of the postmodern can lead to the neglect of changing means of production in the twentieth-century period, like changes in the geographical distribution of manufacturing, and the casualisation of the workforce and mobile labour which is common in media production. Economics and politics become displaced by the cultural in Baudrillard's work, thus displacing issues around the organisation of labour and the significance of class. Political questions of industry and labour have only reduced in significance in certain geographical zones (like parts of the United States), whereas elsewhere the political economy of production, whose end he proclaims, remains central to the organisation of culture.

Baudrillard's work resists the objectives of critique and reconstruction which I have outlined in relation to the theorists discussed so far. In order to produce a discourse which can construct a political subject, theories of media culture require the assumptions that media communication entails the transmission or broadcast of meaning, and that there is a possibility of resistance on the part of the subject to the place of the receiver and the ideology of the message. Baudrillard does not argue for a critical practice because for him pragmatic activity must be

founded on notions of the real, the social or the community, which have been absorbed and nullified by capitalism and its law of value, and replaced by complicit simulations produced in the media. For Baudrillard, the implosion or absorption of meaning, the re-absorption of the dialectic of communication in a circularity of the model, and the implosion of the social in the masses, is not itself catastrophic. It appears catastrophic only:

> in regard to the idealism that dominates our whole vision of information. We all live by a fanatical idealism of meaning and communication, by an idealism of communication through meaning, and, in this perspective, it is very much a catastrophe of meaning which lies in wait for us.[17]

He argues instead for hyperconformism, passivity and disinvestment, which will lead to the system's collapse through its implosion on itself: 'the strategic resistance is that of a refusal of meaning and refusal of the word – or of the hyperconformist simulation of the very mechanisms of the system, which is a form of refusal and non-reception'.[18] It is this refusal which Baudrillard outlines in his discussion of the passive mass audience, particularly of television, which absorbs and nullifies the messages of the medium. Inasmuch as this is a strategy of resistance, it seems to duplicate in reverse the calls for a political subject which I have identified above in theorists from a Marxist tradition. The mass audience of television becomes a kind of anti-subject, or an object, which fills the empty space left in his theory by the removal of the rational subject of Enlightenment reason and communicative action.

The key move in Baudrillard's critique of communication and ideology is the linking of Marxism and semiology in his early work, through the inversion of their binary oppositional structures. For Baudrillard, the commodity form and the sign form share the same structure. While Marx theorised exchange-value and use-value in the commodity, prioritising the importance of exchange-value, semiology theorised signifier and signified in the sign giving priority to the signifier. In Marx, commodity fetishism mystifies real labour into abstract social labour. Use-value is not fetishised because it is transparent, a natural property of objects in relation to humankind's needs, and irreducible. Baudrillard argues that concrete social labour was abstracted

into social labour embodied in the occult form of exchange-value, and also that, contrary to Marx, the principle of utility in use-value is also an abstraction, a code of abstract equivalence, and together with exchange-value, both sides of the commodity are involved in the nullification of symbolic exchange:

> Considered as useful values, all goods are already comparable among themselves, because they are assigned to the same rational-functional common denominator, the same abstract determination. Only objects or categories of goods cathected in the singular and personal act of symbolic exchange (the gift, the present) are strictly incomparable.[19]

Just as occurs for Marx with exchange-value where the producer's creativity becomes abstract social labour power, so for Baudrillard the consumer in the system of use-value has neither enjoyment nor desire, but abstract social need power. Marx's championing of the naturalness of use-value and the needs it satisfies cannot produce a non-alienated society where everyone receives according to their needs, because this relies on the principle of general equivalence of use-value which is parallel and homologous to the general equivalence in exchange-value, underlain by money, which allows the principle of general equivalence via something with negligible use-value.

Therefore the hierarchy of exchange and use function as a code, a binary opposition in which objects simply mark a difference, indeed become signs in a system of equivalence. Baudrillard calls this the 'semiological reduction': 'This semiological reduction of the symbolic properly constitutes the ideological process'.[20] He relates this analysis to the theory of the subject by discussing fetishism. For Baudrillard, fetishism is not the worship of an object primarily, but the worship of the object's coded inscription in the semiological system. The commodity form is grounded in an illusory naturalness of use-value, and the sign form is grounded in the reality-effect produced by the signified/referent. The reality-effect of the signified/referent becomes an ideological effect produced by the sign form: 'This "world" that the sign evokes (the better to distance itself from it) is nothing but the effect of the sign, the shadow that it carries about, its "pantographic" extension. Even better, this world is quite simply the Sd.-Rft'.[21] So as

the empire of signs expands, primarily through the media and especially television, everything undergoes a semiological reduction, and the code eliminates exteriority so that the model takes over from the real. Indeed the real becomes an ideological guarantee, the 'hyperreal'. When all referents, like the real, the social, or nature, are already reproduced in the terms of the code, there is no more real at all.

Thus an event exists not as 'real', but as always-already a representation, replacing 'real' subjective experience by virtual represented experience, and replacing 'real' time with virtual time. This postmodern condition entails the perpetual vanishing of the real into representation, rather than the persistence of the real as anterior and external to representation. In relation to cinema, for example, Baudrillard claims that cinema produces an image which shapes and predominates over the reality it reproduces. This precession occurs as temporal anteriority, when a film defines the perception of an event which occurs after it (he discusses, for instance, *The China Syndrome* (1979) and the Harrisburg nuclear accident) and the terms for experiencing something proposed by the media are mapped on to the 'real' occurrence of the event when it takes place.[22] Precession also occurs in terms of effective perceived anteriority, where the media representation swallows up a 'real' event which occurred in the past. For Baudrillard, contemporary media occupy the role of virtual gazes, through which history and authentic experience are re-formed or indeed abolished except inasmuch as they are simulated.

Questions of history and of the geographical specificity of Baudrillard's diagnosis of media culture gradually fall away in the course of his work. I referred briefly above to symbolic exchange, quoting Baudrillard's contention that there are some kinds of gift exchange which retain the authenticity of symbolic exchange. Of course none of these symbolic exchanges could occur in his model of the media, but a brief detour to consider the place of symbolic exchange in his discourse will illuminate questions of cultural politics in relation to the postmodern. Every theory of the postmodern implicitly or explicitly constructs a history in which it can be thought, and Baudrillard's model posits an imaginary mythic society as a lost origin, seen in terms of communication rather than (for Marx) in terms of production. 'Primitive' societies are characterised by symbolic exchange, an anthropological notion found in the work of, among others, Claude Lévi-Strauss. Symbolic exchange

denotes the interaction based on gift and counter-gift (like wedding
rings), where the objects exchanged have stable symbolic meanings of
reciprocal obligation, and the exchange has value through its symbol-
isation of relationship, regardless of the value or usefulness of the
objects themselves. As the quotation above showed, Baudrillard's early
work on Marxist theory allowed the existence of symbolic exchanges
as the other of commodity culture. In his more recent work, the real
existence of this epoch of symbolic exchange comes into question, and
is referred to as a 'dream', while still fulfilling its structural functions
of anteriority and externality in his argument.[23] The signs of this
symbolic epoch are not subject to a principle of general equivalence,
they are not arbitrary, and are stable marks of social relations. Symbolic
exchange then functions as the other of the commodity system which
he attacks, and this form of society looks a lot like that of the noble
savage, the primitive, which has bolstered the claims of Western
imperialism at least since Jean-Jacques Rousseau. The description of
the anterior society of symbolic exchange appears to repeat the
description given of it in the discourse of the Enlightenment which
Baudrillard wishes to displace.

The postmodern is seen by Baudrillard as a loss of a mythic and
religious past, replaced by alienation, secularisation and rationalism,
and I have argued that there is a nostalgia lurking in his discourse
which is not dissimilar from the nostalgia exhibited by the Frankfurt
School critics. But since for Baudrillard the system's powers extend to
subjectivity and language, then there is no exteriority from which an
enabling critique can derive. For even the concepts of ideology and
alienation are seen as themselves alienated and as effects of the system,
so that his rereading of political economy and of semiology leaves him
without a discursive position for his own writing. His critique of the
binary oppositions of political economy and of the sign follows the
first move of a deconstructive logic, by displacing the privileged term,
and showing the interleaving of one term in the other. But the form of
totalising identity which remains has no outside or edge except the
categories of symbolic exchange and the real, both of which have been
bracketed out, and he therefore re-enacts the totalisation for which
he attacks both political economy and semiology. The implosion of
meaning in the media can only be total if the category of the real
remains as the lost originary referent, just as the semiological reduction
can only be total if symbolic exchange remains as the lost origin from

which 'we' have been barred. The illusory world of simulation can only be illusory as the negative of these positive and anterior terms. The supplement which is both inside and outside Baudrillard's critique is the everyday notion of communication itself. Communication is the precondition for his own texts, the possibility of meaning-effects, which is at once outside his work as the terrain of theoretical and practical activity which he inhabits, and also inside his work as the medium through which his message is communicated.

Baudrillard is aware of these problems of discursive subject-positioning, and has referred to his writing practice as one of 'objective irony'. When the media have inaugurated the hyperreal, the difference between illusion and reality, and the critical work of negation, come to an end because the real is definitively absent. The irony of distance which philosophy is said to have used in order to analyse reality can no longer operate, and analysis cannot mediate between reality and illusion. So the distance which is left is that within the system under discussion, an irony of the object of discussion itself. Baudrillard claims to play the system against itself, by writing as if there were meaning, as if there were theoretical discourse, though the analysis of the system proclaims this to be impossible: 'What I try to do, if you like, is to get out of the objectivity/subjectivity dialectic, in order to reach a point where I can make of the system an object, a pure object, one with no meaning whatsoever'.[24] Baudrillard claims to shift between the positions of analyst or one who judges, and representer of the system or one who describes, and a third position where both subject and object of the discourse are volatilised. Resistance as object is only resistance if the system has taken over the world, and if it has there is no possible subject-position for Baudrillard as critic and strategist to write his text. If the system has not achieved dominance, resistance as object is complicit with the system's repression and oppression, against which subjectivity is the strategy he recommends. If the poles of sender and receiver of messages have collapsed into each other because communication is abandoned in favour of fascination with the code, then Baudrillard's own writing cannot function as critique.

MCLUHAN'S MEDIA UTOPIA

One of the theorists of media culture who Baudrillard claims as an antecedent for his work is Marshall McLuhan, whose writing on the

media of film, television and computer technologies I shall consider next. Baudrillard claims that:

> McLuhan's formula, the medium is the message, which is the key formula of the era of simulation, this very formula must be envisaged at its limit, where, after all contents and messages have been volatilised in the medium, it is the medium itself which is volatilised as such.

And he argues that McLuhan's formulation:

> signifies not only the end of the message, but also the end of the medium. There are no longer media in the literal sense of the term (I am talking above all about the electronic mass media) – that is to say, a power mediating between one reality and another, between one state of the real and another – neither in content nor in form.[25]

McLuhan does not explicitly situate his discourse in relation to materialism or semiology, and his work belongs not in the tradition of critical social theory but instead of infomatics or information theory. This approach uses a cognitive methodology to study the dynamics of information flows, and McLuhan's contribution to this field is primarily to focus attention not on the content of communication but on the forms it takes, hence the slogan 'the medium is the message'. However, he does address the nature of language and the image, and questions of alienation and subjectivity, and links these in a similar way to Baudrillard.

McLuhan's 1964 book *Understanding Media: The Extensions of Man* is divided into two parts.[26] Part One is a series of essays outlining his method and approach to media as extensions of the human body and nervous system, and Part Two is a series of essays on media beginning with speech and writing, and including sections on maps, clothing, printing, the telegraph, the typewriter, film, television and finally automated electronic systems. Like Baudrillard, McLuhan constructs a historical progression in the development of media as representational systems, in which each epoch is characterised by the modality of human consciousness and potentiality which it stresses. For McLuhan,

the effect of every medium, including language, is to externalise or auto-amputate some aspect of the human totality, so that finally there is no content remaining in the notion of the human. By virtue of automated simulations of the human nervous system in computer models and communication technologies, the category of the human is absorbed by and substituted for these models and media. The significance of his work for my purposes is therefore that he argues for the constitutive role of the media in culture, and deploys numerous examples and references to media technologies and effects in constructing a theory of the contemporary. While his discourse is undercut by technological determinism, a relative unconcern with historical or geographical difference and accuracy of specification, and a certain utopian rhetoric, it has interesting relationships to questions of history, subjectivity and the politics of media culture.

Like Baudrillard's, McLuhan's discourse sets up a series of historical periods. 'Primitive' societies, whose members McLuhan calls 'natives', are characterised by a culture of involvement, of non-alienation, which is exemplified in ritual, and by a symbolic interaction where a medium is not separated from its message. The modern or post-primitive phase is characterised by progressive fragmentation of society into specialised groups and functions, with a concomitant fragmentation of the total human potentiality into abstracted modes of being. This is a culture of progressive alienation which accompanies the development of productivity, and is enabled by the invention of phonetic writing. McLuhan views alphabetic writing as a translation system whose content is speech, but whose form begins the process of distanciation of both subject and referent from the totality of lived experience. The latest phase of culture, the mass age or global village, is closely aligned with more contemporary theorisations of postmodernity, since it is characterised by the primacy of the media in constituting the social order, and the globalisation of culture together with the production of local specificities. The mass-media age is characterised by a return to what McLuhan calls the 'involvement in depth' of primitive societies, and the tactile integration of previously fragmented parts of the human sensorium. This epoch is both signalled and created by the television medium and computer-controlled processes of representation and production.

These new media both evolve into a beyond of language, beyond

writing, and involve a return to integrated lived experience because they mime or simulate human creativity:

> After three thousand years of explosion, by means of fragmentary and mechanical technologies, the Western world is imploding. During the mechanical ages we had extended our bodies in space. Today, after more than a century of electric technology, we have extended our central nervous system itself in a global embrace, abolishing both time and space as far as our planet is concerned.[27]

This apocalyptic discourse contains an internal contradiction, however, because inasmuch as the human is extended by media technologies, the distinction between the human and its technological mediation disappears:

> Rapidly, we approach the final phase of the extensions of man – the technological simulation of consciousness, when the creative process of knowing will be collectively and corporately extended to the whole of human society, much as we have already extended our senses and our nerves by the various media.[28]

The categories of real and representation, production and consumption, consciousness and its objects, are collapsed together. The coherence of a notion of human consciousness must disappear inasmuch as these binary structures of difference which define it against nature them-selves disappear. McLuhan's history ends by announcing the end of history as a consequence of the end of representation as the separation of a medium from its human subject.

The media of film and television are crucial examples in McLuhan's thesis. Film works as a point of transition from one state of develop-ment to another, from the mechanical to the electrical: 'The movie, by sheer speeding up the mechanical, carried us from the world of sequence and connections into the world of creative configuration and structure'.[29] Media technologies, like those of film, are endowed with an agency in the development of human culture, and are argued to provide not only a democratisation of creativity but also the regaining of the lost paradise of 'primitive' symbolic communication: 'When electric speed further takes over from mechanical movie sequences,

then the lines of force in structures and in media become loud and clear. We return to the inclusive form of the icon'.[30] The reference to the 'icon' is a significant one, for it points to the role of the arts, in the liberal sense of beneficial creative work with a socially integrative effect, in McLuhan's utopian vision of the global media village. The figure of the artist is regarded as the potential mediator between the new organisation of culture and old mechanised and fragmented means of perception. McLuhan's work is saturated with examples drawn from modernist art and from earlier literary works, which function as examples and prefigurations of the state of development he describes. The artist is seen as someone who perceives developments in consciousness before their effects are generally recognised, and whose non-alienated activity is an illustration of the inclusive view McLuhan himself espouses. The twentieth-century art which McLuhan refers to is seen as an attempt to present an unrepresentable wholeness. McLuhan's writing, however, cites these artworks as prefigurations of a representational epoch in which a wholeness can become present and presentable. His own book *Counterblast* (1968) is an obvious example of the use of typographic, stylistic and discursive forms deriving from literary modernism, an explicit reuse of the aphoristic writing, and the illustrative and typographic techniques of Ezra Pound and Wyndham Lewis' magazine *Blast*.[31] Forms of artistic production, and especially writing, which carry this modernist avant-garde quality of deformation and revelation belong to phases of production which are in other terms fragmented and alienated, while also being an outside, an instance of a different sensibility into which McLuhan's critical discussion itself attempts to fit. But the new epoch he announces becomes a new totality, in which the reflexivity and deferral of meaning that modernist artworks exhibit, as a symptom of their reaching toward this new culture, is reintegrated into a unified technological culture which has no outside.

With television, McLuhan announces that the social subject has become involved in a process of productive creation of sense which derives from the incompleteness of the image as object. This creativity is the involvement in depth, the tactility of multiple sensual engagement, which he sees in modernist literature and painting, signalled here by unattributed quotations from Joyce's *Finnegans Wake*: 'With TV, the viewer is the screen. He is bombarded with light impulses that

James Joyce called the "Charge of the Light Brigade" that imbues his "soulskin with sobconscious inklings"'.[32] The material form of the technology produces a subjectivity appropriate to itself, for the scanning line of the cathode ray tube is personified, and produces 'a ceaselessly forming contour of things limned by the scanning-finger'.[33] However this viewing subject is regarded as active rather than passive, for television is characterised as a 'cool' medium, requiring the involvement of the viewer's cognitive apparatus in order to construct it, 'the viewer of the TV mosaic, with technical control of the image, unconsciously reconfigures the dots into an abstract work of art on the pattern of a Seurat or a Roualt'.[34] The viewer is then a sort of artist, with a depth involvement in the process of representation, and is no longer the alienated consumer of a fragmentary commodity object. The television viewer, particularly the child who has grown up immersed in television culture, then becomes a new kind of citizen, a citizen of the global village in which social responsibility and involvement in everyone else's life is both necessary and unavoidable because of the disseminating effects of global media systems.

Where Baudrillard proclaims a kind of implosion into hyperreality which has no outside and therefore no critical dimension, McLuhan proclaims an implosion caused by universal translation and inter-involvement in a newly symbolic village society: 'Electric technology does not need words any more than the digital computer needs numbers. Electricity points the way to an extension of the process of consciousness itself, on world scale, and without any verbalization whatever'.[35] He expresses the hope that this universal language will enable the cultivation of microcultures which preserve difference and autonomy, since the new global society offers involvement in depth in unfamiliar modes of experience. The potential abandonment of alphabetic writing with its cultivation of difference as value, hierarchy and mechanical specialisation, would be replaced by a transparency of communication, a truly Biblical return to an unfallen language:

> Such a state of collective awareness may have been the preverbal condition of men. Language as the technology of human extension, whose powers of division and separation we know so well, may have been the 'Tower of Babel' by which men sought to scale the highest heavens.[36]

But while language is established as the first medium to extend human capacities, its 'division and separation' are less to be recommended than the possibilities of digital media, which McLuhan regards as bypassing the problems of difference and hierarchy which beset the actual organisation of societies: 'Today, computers hold out the promise of a means of instant translation of any code or language into any other code or language. The computer, in short, promises by technology a Pentecostal condition of universal understanding and unity'.[37] In a reversal of Baudrillard's thought on the issue, McLuhan sees simulation, or the generation of reality from models, as the liberation of human society from capitalism's generation of artificial needs. Instead, real needs would be knowable, predictable and satisfiable. Therefore it is the intellectual or the artist who should control this epoch, particularly since the global village of electronic simulation has no subjectivity in the usual sense of a separated perceiver or point of view whose rationality could control its effects. Simulation is beyond ideology for both McLuhan and Baudrillard, for similar reasons, but is evaluated in opposite terms, which demonstrates an identity between their approaches to media culture.

Like the figure of the artist in his texts, McLuhan's authorial I belongs to the new inclusive community of the postmodern inasmuch as it is the voice which represents and speaks for it. But this I is split, divided by the necessity of also being the instance which can articulate its essence or form. McLuhan's descriptive historical narrative of the media deploys examples representing the essence of a medium or an epoch. But at the same time it makes an implicit political judgement about the relationship between media effects and a fundamental essence of the human which transcends the instances of the history, and which media represent and also deform. These two discourses of description and judgement give rise to an internal splitting or difference in his texts. It is the slippages between these two subject-positions, the authorial I both inside and outside the text, and between the descriptive and the judgemental discourse, which produce the vertiginous sense of involvement in his work that made him a renowned public figure. But they also produce the tendentiousness and totalising assertion which I have traced in much of the theoretical discourse about media culture.

THE POLITICS OF THE POSTMODERN CONDITION

The move toward considering the status of computer technologies in McLuhan's work, and the invocation of modernist art, forms a bridge into the discussion of the theoretical writing of Jean-François Lyotard, whose writing on the postmodern has been highly influential especially in debates around periodisation, and the role of narrative in aesthetic and political theory. Lyotard's *Postmodern Condition*, first published in French in 1979, begins by stating the hypothesis that 'the status of knowledge is altered as societies enter what is known as the postindustrial age and cultures enter what is known as the postmodern age'.[38] He regards the postmodern as a condition in which the grand narratives of Enlightenment progress, reason and liberation have lost their legitimacy, and calls instead for lesser narratives which value difference, and what is unpresentable by the representational strategies inherited from the Enlightenment. This analysis, however, has been critiqued for its relativisation of political discourses and objectives. Jennifer Wicke notes that *The Postmodern Condition*, by replacing subjective identities, like those of class solidarity, by temporary and contingent positions in language-games, cannot take account of the historical constitution of actual subjectivities (as proletarian or patriarchal, for example) on which feminism has based its political project.[39] Since there are, for Lyotard, no longer dominant powers but instead relatively dominant language-games, there is no hegemonic power for political resistance to confront, and resistance is reconceptualised as the taking up of a new position in a language game. Wicke argues that one exception to this mode of resistance is that of the Third World subject, whose aim is sometimes simply to survive against the hegemony of the First World. For Wicke, the Third World is still struggling against a hegemony of the First World in 'old-fashioned' historical and Marxist terms, while the First World can afford to practice its politics and culture in terms of postmodern language-games. Similarly, bell hooks is concerned precisely with postmodern critiques of the subject like those of Lyotard because 'they surface at a historical moment when many subjugated people feel themselves coming to voice for the first time'.[40] The critique of the subject in postmodern theory represents a potential de-legitimation of the political discourses of some feminists and postcolonial critics because it seems to deny agency and discursive authority to those for whom they speak.

Media culture plays a role in Lyotard's argument, but it is a negative one, since the social form of communications technology is regarded as one of the ways in which power legitimates itself, by storing, working with, and restricting access to information. Media culture, and particularly computerised communications media, are therefore aligned with the modern rather than the postmodern, with order and the potential for totalitarian control, rather than the diffusion and decentralisation of power. On the other hand, Lyotard values the narratives circulated by preindustrial cultures, which legitimate institutions, but are also heterogeneous and whose tellers and listeners occupy interchangeable positions. The postmodern little narratives which he commends in opposition to the grand narratives of modernity would restore something of the lost social bond which he finds in tribal cultures. Here, as in the case of much of the theoretical writing I have discussed so far, critical approaches to contemporary media culture have a tendency to set up anterior and geographically distant cultures, especially ones that are not permeated by the mass media, which function as lost origins, recouperable utopias, or political models. Versions of the postmodern are not only new forms of culture, but recapitulate the forms of 'traditional' culture as part of their project to constitute the new.

Lyotard criticises Habermas for posing the goal of emancipation from the dominance of modern media culture to be achievable by the constitution of an ideal communicative interaction between people, with its goal of concensus. For Lyotard, it is not subjects who communicate, but people positioned within language-games whose rules and aims are perpetually shifting and open to change. For Habermas' ideal communication to take place, the rules of language-games would have to have been established in advance, removing the heterogeneity which inhabits all kinds of communicative interaction. Consensus is not the proper goal of communication either for Lyotard, since he regards the goal of communicative interaction as 'parology', or the search for the unknown. Lyotard does not subscribe to a technological determinism about the media culture made possible by the computerisation of society. It could be an instrument for 'controlling and regulating the market system, extended to include knowledge itself and governed exclusively by the performativity principle', the principle that the maximum efficiency of any action is what makes it legitimate.[41] But on the other hand, computer technology could empower groups to communicate internally and with each other, to engage in political

discussion 'by supplying them with the information they usually lack for making knowledgeable decisions'.[42] The practical path to this goal would be to provide unlimited access to information through the networks of the Internet, thus assisting parology, the search for the unknown, and allowing a potentially infinite set of communicative interactions to occur.

There is almost nothing further in Lyotard's work which makes direct reference to the mass media, but I shall depart a little here from the practice so far in this chapter, in order to consider Lyotard's definitions of the postmodern. While his interest is primarily in aesthetic practice, and in particular the role of visual art to disturb modern forms in order to apprehend the postmodern, his definitions of the postmodern are so influential that they cannot be omitted here. Furthermore, the notions of parology and the unpresentable, which appeared in my brief discussion of *The Postmodern Condition*, are importantly related to Lyotard's notion of the postmodern not as an epoch or set of cultural objects, but as an aesthetic mode.

Lyotard's work of the 1970s, which was not available in English until much later, was concerned with the Nietzschean celebration of unconstrained libidinal energy, which was set against the reflection and intentional action that Lyotard regarded as the stultifying tools of the rationalistic logic of capitalism. The liberation of desiring energy from the solidity of structure thus becomes both an aesthetic and political matter. In this respect, Lyotard's work is parallel to the writing of Gianni Vattimo, who in *The Adventure of Difference* rereads Neitzche's work to separate it from a Heideggerian critique which regards Neitzsche as complicit with the drive to the total technological organisation of the world.[43] The consequence of Neitzsche's thinking, for Heidegger, is the forgetting of the unpredictable, unforeseen potentials of Being in the face of the organised rationalism which Heidegger feared. For Vattimo, Neitzche outlines a liberty of spirit and Dionysian energy equivalent to a will to power, the central force in art (a force not reducible by form) which postmodern aesthetics seek to valorise. In his earlier book *The End of Modernity* Vattimo had accepted that the subject in its classical fullness has become unsustainable in the face of technological dehumanisation.[44] But he argues against the reconstitution of the subject, since this discourse of liberation and resistance would propose a subject fit for a world of mediated objects, and would

not affect that object world of technological mediation. Instead he proposes a 'fictionalised experience of reality', a kind of thought accepting the nihilism he finds in postmodernity but moving on from this to create fictive identities which could negotiate and change it.[45] But if Nietzsche is the founding philosopher of postmodern thought, as Vattimo proposes, it should be remembered that Neitzsche's critique of methodological rigidity and questioning of categories linked the emancipation from the tyranny of reason with the extinction of feminism, a point which recalls the feminist critiques of the attack on the subject in postmodern theory which I have outlined above.

Lyotard argues that desire works against form, but that desire also explains how form becomes necessary. This notion derives from Freud's primary process, and enables Lyotard's valuation of movement, intensity and energy. While no material object can express this primary desiring energy (since objects require form), some of its traces can be found where the figural is evident. In a discussion not of media culture but of painting in *Discours, Figure*, Lyotard argues that the discourse of aesthetics, aiming to evaluate and analyse the visual, can only be freed from a tradition of metaphysical thinking once the visible is freed from the tyranny of the discursive.[46] Discourse must subject the figural to a reading operation which brings it back into the domain of language, vitiating its energy. This argument could provide a suitable starting point for work on media culture, not only because media culture (in cinema, television and computer games, for example) presents a mix of the visual and the verbal, but also because an analytical writing about media culture will necessarily mediate and translate between one and the other. Furthermore, Lyotard argues that discourse itself is never free of the figural, but is disturbed or set in motion by its energy. The texts of media culture, since they are a mix of the discursive and the visual which is continually moving, forming and unforming, would thus show a world in the process of being created, rather than one already fixed in a discursive system. However, Lyotard closes down this avenue of thinking by claiming that contemporary media culture (and consumer culture in general) turns the figural energy he finds in the modernist avant-garde into recycled eclectic products which serve the interests of the commodity economy. Representation, narrative and form are terms with a negative inflection in Lyotard's work, which tends to confine the progressive function of critique to a tiny corpus of

avant-garde art. In *The Differend*, Lyotard argues that narrative organises differends (conflicts which cannot be resolved because of the lack of judgmental rules applicable to them), setting them in a place from which they make sense and providing an end.[47] Narrative forecloses the heterogeneity of phrase regimes (a term equivalent to language-games) and genres of discourse. The analysis of narrative reduces the object to a separable text, which is assumed to be unified and homogeneous, and a discourse on the object is constructed which replaces the energy and indeterminacy of the figural by a writing which draws on metaphors of structured space. Lyotard's work, as may be evident from the caricature of it here, tends to lack the material specificity provided by citation and reference to examples, but there is one example of his writing on cinema which both clarifies the potential (or lack of it) in his thought for work on media culture, and takes my discussion back to the definition of the postmodern.

In Lyotard's article 'Acinema', he aligns cinema with the capitalist mode of production and the regulation of bodily desiring energy. He claims that the procedure of making a commercial film entails the exclusion of any shot, sound or movement which does not conduce to the order of narrative: 'No movement, arising from any field, is given to the eye-ear of the spectator for what it is: a simple *sterile difference* in an audio-visual field'.[48] The reason for this situation is the domination of cinema by capitalism's law of value: 'every movement put forward *sends back* to something else, is inscribed as a plus or minus on the ledger-book which is the film, *is valuable* because it *returns* to something else, and is thus potential return and profit'.[49] All the various components of the film text are ordered by the film narrative, by the imperative to make an economy of sense for the spectator, and this economy is parallel and analogous to the economy of cinema production. Similarly, Lyotard parallels the exclusion of 'useless' audio-visual components with the regulation of the libido toward the goal of reproduction in Freudian psychoanalytic theory: 'The film is composed like a unified and propagating body, a fecund and assembled whole transmitting instead of losing what it carries'.[50] He calls for a cinema which would refuse this ordering process by using either stasis or excessive movement, and parallels this work with abstraction in painting.

The link with Lyotard's theoretical work on the postmodern is that the indeterminate and non-referential images which disrupt and arrest

the economy of sense in film are analogous to the experimentation in painting which attempts to present the unpresentable and the non-recurrent. Referring to the Kantian sublime and to visual art, Lyotard calls 'modern' that art which seeks 'to present the fact that the unpresentable exists. To make visible that there is something which can be conceived and which can neither be seen nor made visible'.[51] Postmodern is the term used of the modern when it is first destabilising or questioning that which preceded it, when the work identifies an existing presupposition and challenges it: 'A work can become modern only if it is first postmodern. Postmodernism thus understood is not modernism at its end but in the nascent state, and this state is constant'.[52] For works he calls modern, the sublime is taken up as part of a nostalgia for a missing totality, and becomes assimilable. On the other hand, postmodern works do not allow themselves nostalgia:

> The postmodern would be that which, in the modern, puts forward the unpresentable in presentation itself; that which denies itself the solace of good forms, the consensus of a taste which would make it possible to share collectively the nostalgia for the unattainable; that which searches for new presentations, not in order to enjoy them but in order to impart a stronger sense of the unpresentable.[53]

Work like this cannot be judged according to the existing criteria, since it does not belong in a currently used category. It is suitable new rules and categories which the work is seeking for, and it aims to formulate the rules of what will have been done, in a future anterior tense: 'Hence the fact that work and text have the characters of an *event*'.[54] An event is something that happens in the now, and cannot yet be described or evaluated. Like the excessively still or moving images of some avant-garde cinema, a postmodern work fulfils the critical function of negation in relation to the modern, and is unassimilable by a consensus of judgement or a set of rules for evaluation.

JAMESON AND THE CLAIMS OF CRITIQUE

For Fredric Jameson, on the other hand, postmodernism is a periodising term, and his use of it in relation to media culture has affinities with

the project of the Frankfurt School, while also marking a departure from their approach to the mass media. Jameson regards postmodernism as the consequence of the assimilation of cultural production into the global capitalist economy, and as a terrain of cultural politics which engages with this cultural dominant. In his recent work *The Geopolitical Aesthetic* (1992), Jameson engages with cinema from a diverse range of societies using a critical procedure he calls 'cognitive mapping'.[55] This procedure is a way for people to make sense of space, and derives originally from Kevin Lynch's work on the understanding of urban space.[56] Its concern is the intersection of the personal and the social, since a cognitive map enables the individual to negotiate a social space, and deals with the particular representation of this space in his or her social experience. Jameson is concerned with the global space of contemporary culture, but also its local specificity, and analyses films comparatively in order to unpack their articulations of cultural power in global and local contexts.

Working from a Marxist tradition, Jameson emphasises the determining force of the economic conditions giving rise to media culture, and introduces the notion of the 'political unconscious' to link this economic base to the production and reception of media products like film and television. Analyses of particular media products reveal that they are necessarily fantasies which, in the displaced and contradictory mode associated with the unconscious of Freudian psychoanalytic theory, articulate the politics of culture. However, the Pakistani poet Aijaz Ahmad, discussing Jameson's book *The Political Unconscious* and its analysis of globalisation via two (Chinese and Senegalese) works, reports that:

> the farther I read the more I realized, with no little chagrin, that the man whom I had for so long, so affectionately, even though from a physical distance, taken for a comrade was, in his own opinion, my civilizational Other.[57]

Ahmad's reaction derives from Jameson's view that the Third World is both homogeneous and constituted by its experience of colonialism, for non-Western cultures are represented by the selection of two examples whose specificity and difference is overridden by a claim for the similarities in the political unconscious which is read off from the

texts. In relation to the role of Western commodities and cultural artefacts in non-Western cultures, Ulf Hannerz has noted that the Western theorist can be beguiled by the presence of the familiar in unfamiliar cultural contexts, with important consequences for the discourse of this theory itself. Referring to the presence of Western products, he writes:

> The idea that they are or will be everywhere, and enduringly powerful everywhere, makes our culture even more important and worth arguing about, and relieves us of the real strains of having to engage with other living, complicated, puzzling cultures.[58]

The discourse which Jameson produces on postmodern media culture in the later book *The Geopolitical Aesthetic* is consequently interesting in its deployment of examples in relation to theory. He begins his 1992 book by stating that: 'The films discussed here have been selected with a view towards an unsystematic mapping or scanning of the world system itself', drawing examples from Western nations, the Pacific Rim, and the Philippines (described as part of the Third World).[59] The book approaches films in terms of their articulation of space, the conditions of representability which they deploy in their versions of the social totality, and the ways in which films allegorise questions of global politics and culture. But rather than reading films as evidence, determined by their relationship to the economics of globalisation, Jameson is also concerned to allow films a role in modifying his theoretical position. However, his final call at the end of *The Geopolitical Aesthetic* is a conventionally Marxist one to reveal the relations of domination which underlie the cultural order, in media culture but also more generally: 'our most urgent task will be tirelessly to denounce the economic forms that have come for the moment to reign supreme and unchallenged'.[60] Finally, his analyses of films function as pedagogical tools which can instruct Jameson and his reader, reminding them that the reification and commodification of culture is 'historical and the result of human actions', and thus open to political struggle and change.[61] As Stuart Hall argues, the relationship between a geographical territory and a particular ethnic culture is not straightforward, but the globalisation of media culture through transnational corporations makes it important to recognise the difference between them when

media products appear to derive from 'outside' the territory or culture which receives them.[62] Both local territories and local cultures may constitute themselves alongside or in resistance to the globalisation process, which becomes a dominant against which this resistance can be organised. This claim of agency was evident in Jameson's formative contribution to the debate on the postmodern, 'Postmodernism, or the Cultural Logic of Late Capitalism'.[63] In order to combat the totalisation of global consumer capitalism, which has appeared to cannibalise the past, emptying it of its historicity, and to reduce the richness of the present by flooding it with media images in a 'hysterical sublime', Jameson advocates his procedure of cognitive mapping.[64] The reality of the global capitalist system is understood imaginarily by the subject via the critique of late capitalism, gaining a 'capacity to act and struggle which is at present neutralized by our spatial as well as our social confusion'.[65] Thus the fragmentation of subjectivity and space in post-modernism is combated by a negative and critical image of itself, for cognitive mapping claims to articulate the local and the global, the technological and the human, in an inverse manner to the system to which it responds.

There is one further publication by Jameson that I want to explore in this chapter, before turning briefly to a discussion of Umberto Eco's contribution to debates on the postmodern and media culture. In 1987, Jameson published 'Reading without Interpretation: Postmodernism and the Video-text', an essay which raises questions of agency, politics and form relevant to my account of his work so far, and whose subject is clearly appropriate to the subject of this book.[66] The term 'video-text' is used in the essay to refer to commercial television, and also to video art, since home videotape technologies had at the time of its writing not become widely available. Discursively, one of the interesting features of the essay is its uncertain pertinence for Jameson to debates on postmodern aesthetics, for while he argues that video is quintes-sentially postmodern, he begins by declaring that: 'This is not a proposition one proves'.[67] The essay is particularly concerned with time, contrasting the 'real' time of video artworks with the manipula-tion of time in film, whose ellipses and manipulations Jameson regards as enabling a forgetting of time. The mechanism for this alteration of temporality in television and video is the ability of the medium to

transform the subject into an apparatus for registering the 'machine time' of the object and of the technological apparatus. In other words video, 'closely related to the dominant computer and information technology of the late or third stage of capitalism', exhibits a materialist temporality or 'real' time which distinguishes it from the illusory time of film.[68] By transferring his materialist commendation of video art to commercial television, Jameson proposes that television contains the same potential. What stops television from becoming as radically postmodern as video art is the breaks in time (like commercial ad-breaks, and regular programme changes) which impose a false closure on its fundamentally materialist temporality.

Furthermore, when any video or television work becomes representational and interpretable by thematic structures, its power to be radically postmodern in this materialist sense evaporates:

> the postmodernist text – of which we have taken the videotape in question to be a privileged exemplar – is from that perspective defined as a sign-flow which resists meaning, whose fundamental inner logic is the exclusion of the emergence of themes as such in that sense, and which therefore systematically sets out to short-circuit traditional interpretive temptations.[69]

There are a number of critical issues raised by this essay which relate Jameson's argument back to the theorisations so far discussed in this chapter. The discursive structure of the essay deploys examples of media culture to elaborate a notion of the postmodern, and does so with a certain violence. First, experimental video art, represented primarily by a single example, is assimilated to commercial television, and to the specific rhythms of American network programming. Second, the privileged term in the union of video art and television is avant-garde work, which, unusually, is attributed a materialist temporality as an index of its postmodern credentials, but which conforms to the priority accorded to the avant-garde that I have noted in many of the formulations discussed in this chapter. Third, the anti-representationalism and modulation of subjectivity identified in Baudrillard's and Lyotard's arguments appears in Jameson's essay, despite his apparent distance from their work in regard to materialism and materiality.

ECO'S NEO-MEDIEVAL POSTMODERN

Eco is a scholar of the culture of the medieval period, as well as a semi-otician and critic of contemporary media culture. Unlike most of the theorists discussed in this chapter, he is not only a producer of academic discourse on the postmodern but also contributes prolifically to media culture through his popular novelistic writing, newspaper journalism, and media appearances. On the issue of the periodisation of the postmodern, his work draws back from specifying points of epistemo-logical breakage, but implies that in media culture it is since the 1960s that postmodernism in the media becomes evident. Before outlining the position of examples of specific media forms in his conception of the postmodern, it is important to note the significant parallel he draws between the medieval and the postmodern: 'we find a fairly perfect correspondence between two ages', he argues, because in each an elite group with access to both knowledge and means to disseminate it, communicates to a mass audience 'the essential data or knowledge and the fundamental structure of the ruling ideology'.[70] The medium of communication in both the medieval and the postmodern age is visual, he argues, although the repository of knowledge is predomi-nantly held in written form. In the medieval period the elite group with access both to knowledge and to the audience is the Church, which also dominates the ideological framework through which culture is produced and understood. The visual medium of communication is the cathedral, 'the great book in stone', whose architectural form, frescoes, coloured statuary and sculpture is 'the advertisement, the TV screen, the mystic comic strip that must narrate and explain everything'.[71] In the postmodern period, the elite group are those who produce and manage media culture, the television, advertising and popular audio-visual print culture with which the cathedral is paralleled.

So what animates Eco's discourse are a series of analogies, parallels and movements of return which depend on historical continuities and breaks. One of its significant absences is a consideration of the European, or at least Western, notion of the postmodern which is constructed, for obviously the Christian Church of the medieval era is limited in geographical reach, and so, therefore, the postmodern must be limited in similar ways. The postmodern is distinguished from the modern by the dominance of visual communication, and by the

erosion or bridging of the gap between an elite written culture and the popular visual culture of the mass audience. In terms of this dissolution of a modern hierarchy between elite and popular, written and visual, the medieval and the postmodern can be aligned. There are two kinds of subject which are necessary to this theoretical discourse; Eco himself as the writing subject, and the abstract subject which constitutes the audience. In his early work, Eco as a writer, intellectual and teacher stands outside the ideological process of postmodern media culture, in order to produce its critique and to liberate the mass audience from its mystification with the aid of those who are enlisted to his position, and 'if the Communications Era proceeds in the direction that today seems to us the most probable, this will be the only salvation for free people'.[72] While Eco recognises that this might be 'another dream of '68',[73] it is nevertheless the utopian politics which underlies his work in the educational and popular cultural fields. The audience as subject is therefore deployed discursively in two related ways. It appears as a mass, subject to the mystification perpetrated by media culture. But it is also potentially remobilisable along the lines of an empowered revolutionary subject, while retaining its character of abstraction.

Eco's critical methodology for addressing postmodern media culture is primarily a semiotic one, and thus his references to, and examples of, postmodern media are largely concerned with issues of reflexivity, intertextuality, and intratextuality. For Eco, the viewer is conceptualised largely in terms of reception as it is conceived in semiotic theory, as a place hollowed out by the codes and signifying processes of texts, which the material person is invited and solicited to occupy. While there is an evident danger in this conceptualisation that the audience member becomes a product of the text, and is deployed by analytic discourse as an abstraction, at least Eco is sensitive to the cultural imbrication of texts and audiences, and the flows of meaning between texts and audiences which constitute each of them. In television, Eco sees the postmodern as the involution of the medium on itself, so that the televising of something or someone becomes its primary purpose. He calls this 'neo-TV', and his examples include chat shows and award ceremonies.[74] In these programmes the personas established by television appear in order to represent themselves as celebrities, in a circulation of star images which continually reinforce themselves. The effect of this, Eco argues, is that neo-TV ends up as an intratextual

television which is parasitic on its own previous and current productions. The history and forms of television become the object of television, so that rather than being a medium of representation it becomes reflexive and non-referential. In a similar way to Baudrillard, then, Eco announces an epoch of simulation which he finds it hard to counter by the demystificatory procedures of ideological analysis.

Some of the same approaches and problems can be identified in Eco's work on film. One of his most well-known pieces of analytical writing is on *Casablanca* (1942), and concerns the film's 'cult' status.[75] Eco's reading of the film is based on dislocating it from its times and spaces of production and consumption, and explaining its effects of meaning by showing how its structural, thematic and character levels draw on a repertoire of codes and references which make it amenable to a potentially infinite number of interpretations. He does refer to anecdotes concerning the film's production (for example, that Ingrid Bergman as Ilse did not know whether it was Rick (Humphrey Bogart) or Victor (Paul Heinried) that she would end up with at the end) in order to explain its affective power. But Eco is mainly interested in the number of filmic genres, myths and folkloric tropes, and elements of conventional historical and geographical knowledge or stereotypes, which can be adduced in decoding particular sequences. Put simply, Eco argues that the film 'works' because it is composed from a hetero-geneous mix of clichés:

> we sense dimly that the clichés are talking among themselves, celebrating their reunion. Just as the extreme of pain meets sen-sual pleasure and the extreme of perversion borders on mystical energy, so too the extreme of banality allows us to catch a glimpse of the Sublime. Nobody would have been able to achieve such a cosmic result intentionally. Nature has spoken in place of men.[76]

He does not explicitly call *Casablanca* a postmodern film, though he does parallel it with more recent self-reflexive and pastiching films. The implication of his analysis is that the meaning of the film is determined not by its director as author, nor by the spectator as interpreter, nor by its conditions of production or reception, but instead by a combination of spectator competence in adducing suitable references and knowledge, with a kind of metatext which supplies them. While this seems to

foreclose agency for the spectator and for the media culture which is finally identical to the metatext of references, it leaves an agency available for the theorist. *Casablanca* may be sublime, and by implication postmodern, escaping the fixing procedures of a mechanistic semiotic-ideological discourse, but there is a subject-position available for Eco to select, disassemble and admire the film as an instance of a larger problematic. In this respect, Eco's work opens the question of the complicity of media culture with postmodern theory, especially since Eco is both a producer of media texts and an academic critic.

DISCOURSES OF DIFFERENCE

This chapter has discussed some of the theoretical writing on post-modern media culture, with attention to the discursive construction of the writing subject, the subjects who interact with media culture, and the construction of media culture as an object of analysis as part of critical discourses which have their own objectives in approaching contemporary culture. It is appropriate at this point to consider the particular version of the theory of postmodern media culture which I have in practice produced. In common with many other assessments of theories of the postmodern, there are significant inclusions, exclusions and linkages which have been established. One of these is my attention to a group of theorists in which white male Western writers figure prominently. In response to the creation of a canon of theorists of the postmodern in a range of academic texts, Meaghan Morris has stated that 'postmodernism as a publishing phenomenon has pulled off the peculiar feat of reconstituting an overwhelmingly male pantheon of proper names to function as ritual objects of academic exegesis and commentary'.[77] This occurs, she argues, 'in spite of its heavy (if lightly acknowledged) borrowings from feminist theory, its frequent celebrations of "difference" and "specificity", and its critiques of "Enlightenment" paternalism'.[78] In writing this chapter, I have been mindful of this criticism, and have sought to draw attention to the ways in which theoretical discourse claims to speak for a subject, or dissolves the agency of subjectivity. Part of this practice of writing has been to make reference to feminist critics who have contributed to debates on the issue of the politics of subjectivity, since Morris has also pointed out that to represent the debates on postmodernism as lacking contributions

by feminist and female writers, is at the same time to reproduce exactly the problem which is being signalled by that protestation of lack.

At the opening of the collection of essays *Feminism and Postmodernism*, from which I have quoted briefly at various points, Jennifer Wicke and Margaret Ferguson argue in their introduction that: 'We approach postmodernism as a moment that, for theory, might be regarded as the critical historicizing of poststructuralisms, in general, the acknowledgement that shifts in theory are also located historically and systematically'.[79] It is certainly the case that the poststructural critique of the subject attains increasing importance in the historical process of theoretical writing about contemporary media culture. After the work of the Frankfurt School, writers like Lyotard and Baudrillard assimilate critiques of subjectivity into their notions of postmodern culture. But this 'shift in theory' poses a challenge to other kinds of thinking which seek to address the contemporary in political terms, and the two (related) strands of thought which I have drawn into this debate, those of feminism and postcolonialism, struggle with this problem. Part of this struggle, which relates to the overall focus of this chapter, is the relationship between totalising theories of the post-modern and particular and local discourses which attempt to claim subjective agency and resistance. When Lyotard discusses injustice in *The Differend*, for example, his paradigmatic instance of injustice is Auschwitz, an event which disenables its victims from speaking about it. The persecution of Jews is an issue of world-historical importance, and is discussed by Lyotard in terms of the function of the proper name of Auschwitz to mark a differend. Wicke and Ferguson contrast the struggles of Jews in this context with the struggles of feminism, which are often about what seem by comparison to be lesser injustices in the lives of lots of people over long periods of time. For Wicke and Ferguson, the daily struggles of feminists in patriarchy do not seem amenable to analysis in Lyotard's terms. The question is how local and specific struggles, oriented around subjective identities, relate to overarching theories of culture and politics which delegitimate subjective agency.

In one of the essays in Ferguson and Wicke's collection, Mary Poovey argues that there is a complicity between the rational human subject (of the law in particular) and the rational empowered subject desired by feminism.[80] Poovey notes that since Western ideology

assigns irrationality and naturalness to women, the attempt to gain rights and power is seen by the law and by society as a usurpation of masculine power. Thus, for men, feminism appears as a threat to their masculinity. Poovey shows that some of the discourses of postmodernism claim a gendered feminine rhetoric, and one of the examples she gives is that, in postcolonial theory, theorists and campaigners on behalf on non-Western subjects have to adopt flexible strategies and the ability to take up new subject-positions as each situation requires. This flexibility of subjectivity would be aligned with the feminine, as against the univalence and logicism conventionally attributed to masculinity. The consequence of this argument is that the same feminisation appears in global capitalism's flexible, adaptable and differentiated methods and also the methods of critical postmodernist theorists. The connection being made here is between the postmodern, the feminine and the postcolonial, in which each of these modes of discourse and of action seem ambiguously positioned both within and against a dominant which they resist. Anne Friedberg, referring to Lyotard's aesthetic theories of the postmodern and thinking of postmodern theory as a diversionary reworking of feminism, writes: 'If a "feminist aesthetic" is one that maintains it is not governed by preexisting rules, cannot be judged by preexisting judgements, or by applying familiar categories, then the coextensivity between feminist and postmodernist aesthetics would seem quite convincing'.[81] However, she continues by associating the postmodern with a colonialist and patriarchal discourse which co-opts and assimilates the Others whose experience it addresses: 'Certainly much of the rhetoric around postmodernity evoked the sense of an unmappable "dark continent" that (like "femininity") needed to be charted, put into the coordinates of Western metanarratives themselves'.[82]

One possible response to this problem is to locate the specificity of the writing subject from which theoretical discourse derives, and indeed for the theorist to situate himself or herself as part of the production of the discourse. One result of this may be that discourse can become obsessed by its status as language, by the literariness of theory (as happens in the later work of Baudrillard), so that the effectivity of the discourse for political practice evaporates. Another option, found in much ethnographic writing on media culture, is to emphasise the particularity of the writer's position. Gayatri Spivak argues that confessing

one's situatedness in this way either ignores poststructuralist prob-
lematisations of identity by assuming an autonomous and disengaged
speaking-position, or, when it recognises the plurality of all identities
and the equality of all differences, it covers over the real inequalities
between cultures, subcultures and between the First and Third
Worlds.[83] The discourse on technological postmodernity (on cyborgs or
virtual reality, for example) can be seen as the opposite of this literary
self-consciousness. What interests these theorists is the possibility of
escaping subjectivity, of making the death of the subject come true in
practice and thus escaping the introspection of literariness through the
'hard' technical matter-of-factness of machines and science. The prob-
lem is that either feminist and postcolonial discourse should uphold
the Enlightenment subject, to gain access to its power and historical
force (but this is complicit with the forces of women's oppression and
colonialism), or it should dissolve the grand narratives of patriarchy
and globalisation in order to fracture and multiply subjectivities (but
this is the local, temporary, 'soft' postmodern position, which is the
weak feminised other to the Enlightenment model). For Spivak, the
solution is to recognise those elements of postmodern discourse which
are part of the co-option of the feminine and the postcolonial Other, to
reject them, and to work with what remains.

The status of theoretical discourse on the postmodern is therefore
politically ambiguous, and depends on a careful assessment of its
relations to the objects and subjects which it adduces. Writing from a
postcolonialist position, Nelly Richard, discussing a Latin American
experience of the postmodern, argues that while the postmodern is
associated with a disintegration of the centralising and homogenising
project of modernity, it reasserts itself as a dominant against which a
periphery's difference is measured.[84] However, the geographical and
epistemological edge of the postmodern:

> has always made its own mark on the series of statements emitted
> by the dominant culture and has recycled them in different con-
> texts in such a way that the original systematizations are subverted,
> and their claim to universality is undermined.[85]

This spatialisation of the postmodern, and the production together of
the global and the local, the universal and the particular, the dominant

and the peripheral, as inter-implicated processes, underlies the discursive structure which I have adopted in this chapter and will continue to develop in the rest of this book. What has and will be at issue here are the kinds of postmodern which are produced by and for subjects, and in relation to which objects, with which theoretical and political objectives.

NOTES

1. Theodor Adorno and Max Horkheimer, *Dialectic of Enlightenment*, trans. J. Cumming (London: Verso, 1997).
2. Ibid., p. 120.
3. Jürgen Habermas, *The Theory of Communicative Action, vol. 2, Lifeworld and System: A Critique of Functionalist Reason* (Cambridge: Polity 1987), p. 390.
4. Ibid.
5. Jennifer Wicke and Margaret Ferguson, 'Introduction: Feminism and Postmodernism; or, The Way We Live Now', in Margaret Ferguson and Jennifer Wicke (eds), *Feminism and Postmodernism* (London: Duke University Press, 1994), p. 1.
6. Walter Benjamin, 'The Work of Art in the Age of Mechanical Reproduction', in *Illuminations*, trans. H. Zohn (New York: Schocken Books, 1969), pp. 219–54.
7. Ibid., p. 223.
8. The phrase 'Arcades Project' is the usual way of referring to an unfinished text by Benjamin called either *Das Passagenwerk* or *Pariser Passagen*. 'Arcades Project' is a translation of these different German titles, since the book was going to be about the shopping arcades (*Passagen*) of Paris. The text was never completed, but was partially published in 1989 by a translator of Benjamin's notes; Buck-Morss, Susan, *The Dialectics of Seeing: Walter Benjamin and the Arcades Project* (Cambridge, MA: MIT Press, 1989).
9. Theodor Adorno, 'Introduction to Benjamin's *Schriften*', trans. R. Hullot-Kentor, in Gary Smith (ed.), *On Walter Benjamin* (Cambridge, MA: MIT Press, 1988), p. 10.
10. Charles Baudelaire, *Art in Paris 1845–1862: Reviews of Salons and Other Exhibitions*, ed. and trans. Jonathan Mayne (Oxford: Phaidon, 1965), p. 153.
11. Benjamin, p. 316.
12. Anne Friedberg, *Window Shopping: Cinema and the Postmodern* (Berkeley, CA: University of California Press, 1993).

13. David Simpson, 'Feminisms and Feminizations in the Postmodern', in *Feminism and Postmodernism*, pp. 53–68.
14. Andreas Huyssen, *After the Great Divide: Modernism, Mass Culture, Postmodernism* (London: Macmillan, 1986).
15. Jean Baudrillard, *America*, trans. C. Turner (London: Verso, 1988), p. 76.
16. Zygmunt Bauman, *Postmodern Ethics* (Oxford: Blackwell, 1993), p. 173.
17. Jean Baudrillard, *In the Shadow of the Silent Majorities*, trans. P. Foss, J. Johnson and P. Patton (New York: Semiotext(e), 1983a), p. 103.
18. Ibid., p. 108.
19. Jean Baudrillard, *For A Critique of the Political Economy of the Sign*, trans. C. Levin (St. Louis: Telos, 1981), p. 132.
20. Ibid., p. 98.
21. Ibid., pp. 151–2.
22. See Jean Baudrillard, *The Evil Demon of Images*, trans. P. Patton and P. Foss (Sydney: Power Institute, 1987), pp. 19–22.
23. Jean Baudrillard, 'The Ecstasy of Communication', trans. J. Johnston, in Hal Foster (ed.), *Postmodern Culture* (London: Pluto, 1985), p. 126.
24. Baudrillard, *Evil Demon of Images*, p. 42.
25. Baudrillard, *In the Shadow of the Silent Majorities*, pp. 101–3.
26. Marshall McLuhan, *Understanding Media: The Extensions of Man* (London: Ark, 1987).
27. Ibid., p. 3.
28. Ibid., pp. 3–4.
29. Ibid., p. 12.
30. Ibid., p. 12.
31. Marshall McLuhan, with Harley Parker, *Counterblast* (Toronto: McClelland and Stewart, 1968).
32. McLuhan, *Understanding Media*, p. 313.
33. Ibid.
34. Ibid.
35. Ibid., p. 80.
36. Ibid.
37. Ibid.
38. Jean-François Lyotard, *The Postmodern Condition: A Report on Knowledge*, trans. G. Bennington and B. Massumi (Manchester: Manchester University Press, 1984), p. 3.
39. Jennifer Wicke, 'Postmodern Identities and the Politics of the (Legal) Subject', in *Feminism and Postmodernism*, pp. 10–33.
40. bell hooks, 'Postmodern Blackness', in Joseph Natoli and Linda Hutcheon, *A Postmodern Reader* (Albany: SUNY Press, 1993), p. 515.
41. Lyotard, *Postmodern Condition*, p. 67.

42. Ibid.
43. Gianni Vattimo, *The Adventure of Difference: Philosophy after Neitzsche and Heidegger*, trans. C. Blamires with D. Harrison (Cambridge: Polity, 1993).
44. Gianni Vattimo, *The End of Modernity: Nihilism and Hermeneutics in Post-Modern Culture*, trans. J. Snyder (Cambridge: Polity, 1988).
45. Ibid., p. 29.
46. Jean-François Lyotard, *Discours, Figure* (Paris: Klinsieck, 1971).
47. Jean-François Lyotard, *The Differend: Phrases in Dispute*, trans. G. Van den Abbeele (Minneapolis, MN: University of Minnesota Press, 1988).
48. Jean-François Lyotard, 'Acinema', trans. P. Livingston, in *Wide Angle* 2: 3 (1978) p. 53.
49. Ibid.
50. Ibid., p. 55.
51. Jean-François Lyotard, 'Answering the Question: What is Postmodernism?', in Thomas Docherty (ed.), *Postmodernism: A Reader* (Hemel Hempstead: Harvester Wheatsheaf, 1993) p. 43.
52. Ibid., p. 44.
53. Ibid., p. 46.
54. Ibid.
55. Fredric Jameson, *The Geopolitical Aesthetic: Cinema and Space in the World System* (London: BFI, 1992).
56. Kevin Lynch, *The Image of the City* (Cambridge, MA: MIT Press, 1960).
57. Aijaz Ahmad, 'Jameson's Rhetoric of Otherness and the "National Allegory"', *Social Text* 17 (1987), p. 4. Fredric Jameson, *The Political Unconscious: Narrative as a Socially Symbolic Act* (London: Methuen, 1981).
58. Ulf Hannerz, 'Scenarios for Peripheral Cultures', in Anthony King (ed.), *Culture, Globalization and the World System* (London: Macmillan. 1991), p. 109.
59. Jameson, *Geopolitical Aesthetic*, p. 1.
60. Ibid., p. 212.
61. Ibid., p. 213.
62. Stuart Hall, 'The Local and the Global: Globalization and Ethnicities', in *Culture, Globalization and the World System*, pp. 19–30.
63. Fredric Jameson, 'Postmodernism, or the Cultural Logic of Late Capitalism', *New Left Review* 146 (1984), pp. 53–92.
64. Ibid., p. 76.
65. Ibid., p. 92.
66. Fredric Jameson, 'Reading without Interpretation: Postmodernism and the Video-text', in Derek Attridge and Nigel Fabb (eds), *The Linguistics*

of Writing: Arguments between Language and Literature (Manchester: Manchester University Press, 1987), pp. 199–233.

67. Ibid., p. 201.
68. Ibid., p. 207.
69. Ibid., p. 219.
70. Umberto Eco, 'Living in the New Middle Ages', in Umberto Eco, *Travels in Hyperreality*, trans. W. Weaver (London: Picador, 1987), p. 81.
71. Ibid., pp. 81–2.
72. Umberto Eco, 'The Multiplication of the Media', in *Travels in Hyperreality*, p. 143.
73. Ibid., p. 148.
74. Umberto Eco, 'A Guide to the Neo-Television of the 1980s', *Framework* 25 (1984), pp. 18–25.
75. Umberto Eco, 'Casablanca: Cult Movies and Intertextual Collage', in *Travels in Hyperreality*, pp. 197–211.
76. Ibid., p. 209.
77. Meaghan Morris, 'Feminism, Reading, Postmodernism', in *Postmodernism: A Reader*, p. 378.
78. Ibid.
79. Wicke and Ferguson, 'Introduction', in *Feminism and Postmodernism*, p. 2.
80. Mary Poovey, 'Feminism and Postmodernism – Another View', in *Feminism and Postmodernism*, pp. 34–52.
81. Friedberg, *Window Shopping*, p. 197.
82. Ibid.
83. Gayatri Spivak, 'Can the Subaltern Speak', in Cary Nelson and Lawrence Grossberg (eds), *Marxism and the Interpretation of Culture* (Urbana, IL: University of Illinois Press, 1988).
84. Nelly Richard, 'Postmodernism and Periphery', trans. N. Caistor, *Third Text* 2 (1987–8), pp. 6–12.
85. Ibid., p. 6.

THE END OF HISTORY AND FILM NARRATIVE

In 1989, Pope John Paul II watched a videotape copy of *The Name of the Rose* (1986), and condemned Umberto Eco, author of the novel on which this film was based, and who had recently published another novel, *Foucault's Pendulum*,[1] as a 'nihilist'.[2] The event might give rise to a number of debates, around the relationship of film and videotape to novel (the Pope did not seem to have actually read either *The Name of the Rose* or *Foucault's Pendulum*), and the relationship of the Church to media culture and issues of censorship and control. But at least, the Pope's reaction to the film signals a perception that it is an index of a crisis of values, and a sense that the film is both about, and part of, a conflict between grand narratives (like Catholicism) and articulations of 'new times' which seem to mark the downfall of the animating concepts of modernity, like progress, emancipation and rationality. This chapter is centred on analyses of the film *The Name of the Rose* and a film released ten years later, *Seven* (1996), which is also a whodunit whose narrative is hung on theological concepts of sin, punishment and apocalyptic judgement.[3] The aim of this chapter is to read these two films against arguments about the end of history which appear in different forms in postmodern cultural theory. In the following chapter I return to these films, and also discuss *Bram Stoker's Dracula* (1992), in relation to issues of judgement, with particular reference to distinctions between, on one hand, high-cultural and literary value, and popular media culture on the other. But before beginning work on these objects of analysis, it is important to revisit questions of methodology

which were raised in Chapter 1. For the status of these films as examples, and their relationship to theoretical work on the postmodern, need to be clarified.

I argued in Chapter 1 that in regard to the object of analysis, theories of the postmodern, and theories of postmodern media culture, suffer from a problem of reference. Postmodern media culture in the often unacknowledged view of many theorists is simply that which corresponds to pre-existing abstract theoretical definitions of the postmodern. In philosophical terms, this is a form of idealism in which the concrete and the material function as a partial instance of an abstract condition. Discursively, this leads to a paucity of close analysis of examples, since examples function as indicators or evidential grounds on which a theory is erected. As Jacques Derrida's work has extensively shown, examples are not random, and do more than represent the class to which they belong.[4] An example brings with it an implicit claim to stand in the place of a larger number of equivalent objects, while also containing within itself the potential to represent not only the features of its class but also a particularity rendering it worthy of selection. The problem of examples is a conceptual problem affecting all theories, but it is especially acute with the postmodern, since the term describes a state of affairs which is claimed to be currently the case. When theories of the postmodern, like those of Jean-François Lyotard and Jean Baudrillard which I discussed in Chapter 1, declare the relativity of metalanguages and thus the impossibility of standing outside what they describe, the legitimation of a discourse which can critique the postmodern becomes problematic. It also becomes difficult to prove the diagnosis of a state of affairs as postmodern, since the referentiality of discourse, its claim on its objects, is also declared unstable. Furthermore, since reflexivity is part of the postmodern, theory and action, and discourse and its object, must be seen as two sides of the same coin, in which each term is mutually constitutive and neither has priority. This issue has important consequences for the relations between cultures of theory and media culture in the discourse of this book. In writing about an object, another critical discourse, or a cultural situation, notions of authority are open to challenge in relation to their adequacy and representativeness. Thus the political and analytical effectivity of this discourse is dependent on the force of an intertextual construction.

Theoretical propositions, including those in this book, cite objects of analysis or other theoretical discourses in order to outline a notion of postmodern media culture. Objects and practices in culture interact with theoretical understandings of culture, feeding back into the loop. Both critical discourse and media culture construct each other by selection, citation or paraphrase, and the citation of one of them constructs the identity of the other, with a certain borrowed status and inflection obtained from the uses they make of each other. Even if texts, objects, and practices are considered unstable and unbounded, there is nevertheless a tendency to consider one of the elements as a fixed unit, which provides the key to the meaning of the other. The 'original' discourse, object or practice cannot be reliably stabilised, and each has been reconstructed by the discourse which cites them, but the interdependence of definitions of postmodern theoretical discourse and contemporary media culture will show how the postmodern is constituted while simultaneously performing the postmodern. With regard to the methodological approach to the object of analysis, there are two possible responses to this problem of critical positioning. One alternative is to begin with the 'texts' of media culture, using the detailed textual analysis favoured by literary criticism and the tradition of film studies based in close analysis. From this perspective, the object is unpacked by an operation in which the critic or analyst submits himself or herself to the operations of the text. The aim is to produce a sensitive reading, which discovers the functioning of the text and its specific effects on its viewer. The potential danger in this procedure is that the text itself becomes a subject which 'reads' the critic as object. What is discovered in the analysis is not a truth about the text as such, as a determinate object, but the production of the critic as an object for that text. The film rewards its critic by producing him or her as a 'knowing subject', whose apparent mastery of its postmodern textuality is already comprehended by the text.

One of the films which might seem an obvious example to cite in a work on the postmodern and cinema would be *Blade Runner* (1992), a film which Mark Bould calls 'quintessentially postmodern',[5] and as Marcus Doel and David Clarke comment, the film has been deployed as evidence for a postmodern condition in range of ways.[6] It may be of interest because it displays the blurring of boundaries between science fiction and film noir, thus suspending its spectator between the

interpretive frames of at least two film genres, and demonstrating a hesitation in the encoding and decoding of the film which could be called a postmodern uncertainty and reflexivity. In its *mise-en-scène*, which is dominated by an urban cityscape of the twenty-first century, the representation of the fractal geography of the future Los Angeles might stand for the centreless and fragmented space of the postmodern. Similarly, the film's confusion of temporality, drawing on buildings, dress codes and film styles from different historical periods, might emblematise the postmodern aesthetic of recycling, parody and pastiche, doing away with notions of historical progress. The dominance of global corporate culture in the film, and its merging with state government, might be read as a prefiguration of the achieved dominance of global capitalism over nationhood and liberal democracy. Related to this interpretation, the presence of a Fourth World underclass population in the interstices of the film's postmodern technoculture might be used as evidence for the uneven and unequal development of global capitalism's apparent utopia. Since the film concerns the lack of authentic subjective identity and the indeterminacy of human and cyborg beings, it can be read as a meditation on the effects of technoculture on the human body, and on the short-circuiting of memory and identity by simulations.

However, Doel and Clarke raise similar objections to my own about this kind of film analysis, for it is constituted by arguments from analogy between the film as evidential object and one or other preconstituted theoretical position. Following Gilles Deleuze's practice in his books on cinema,[7] they argue that work on cinema should not work on film, but alongside it, identifying resonances between films and concepts. *Blade Runner* should not be seen as an instance of postmodern cinema, because this assumes that the film shows a reality which will have been the reality of the postmodern condition, in a circular relation between object and theory. My own aim in the discussion of two films below, is to move back and forth between the film as object or instance, and the theoretical articulations about the postmodern as the apocalyptic. I do not suggest that either of these kinds of work provides a key to the other, but that there are regularities, correspondences, and shared aporias in each, and that these illuminate each other.

This approach should be distinguished from three strands of writing about film which deploy the term 'postmodern' in relation to cinema in

different ways. First, cinema can be seen as an apparatus and institution arising from capitalist modernity which, in its progressive interrelation with other forms of mass culture (television, computing, the toy industry, pop music etc.) becomes part of an ensemble of social technologies and practices which can be termed aspects of a condition of postmodernity. Second, film style can be described as postmodernist when features like reflexive citation and confusion of generic categories (as in *Blue Velvet* (1986), *Bill and Ted's Excellent Adventure* (1988), or *Blade Runner*) contribute to an ironic or pastiching reconfiguration of codes of genre, narrative and spectatorship. I note some of these features in my discussion of the films which appear in this chapter and the subsequent one, though they are not my main focus of interest. These features are seen either as critical attempts to develop an alternative film practice, or as symptoms of a new cultural dominant which is claimed to arise from the conditions of the first category, postmodernity as a social and cultural fact. Third, a certain discourse within film criticism can be constructed which engages in a dialogue with films, weighing the effects of films' associations with postmodern theory, in order to identify the gains and losses entailed in cultural theory's complicity in the production of the postmodern. While aspects of each of these approaches appear in the discussion which follows, my aim is primarily to contribute to the third approach. My contention is that *The Name of the Rose* and *Seven* can be read against some of the concerns of postmodern theory, and that they also repeat one of the structuring absences in one of the most significantly popularised of its theses, the notion of the end of history. The structuring absence which I highlight in my analysis is an ambivalence about gender politics which is expressed as a crisis in masculinity.

THESES ON THE END OF HISTORY

The formulations of postmodernity as a condition in which history ceases to move forward in a progressive way, with the consequent impossibility of improvement of social conditions by rational means, are many and varied. Fredric Jameson conceived of postmodernity as an epoch in which representations, forms and aesthetic codes from the past are perpetually reworked in the present, while 'everything in our social life – from economic value to state power and practices and to

the very structure of the psyche itself – can be said to have become "cultural" in some original and as yet untheorised sense'.[8] Hence Jameson's discussion of the 'retro mode' in films like *American Graffiti* (1973) or *Star Wars* (1977), in which the experience of the culture of a particular epoch is re-presented (the teen culture of the early 1960s, and the science fiction films of the 1950s respectively). The present absorbs the past and the discourses of social and historical analysis into relativised and heterogeneous components of representations, with the consequent loss of an authoritative discourse of social betterment. Jameson's influential essay 'Postmodernism, or The Cultural Logic of Late Capitalism' begins with the assertion that postmodernism can be characterised by 'an inverted millenarianism, in which premonitions of the future, catastrophic or redemptive, have been replaced by senses of the end of this or that'.[9] Jameson suggests that contemporary culture is marked by the sense of reaching the end of a historical trajectory, and by consequent transformations in a wide range of cultural forms including architecture and painting as well as cinema. In this formulation of the end of history, contemporary culture has ceased to innovate or move forward, and the past is being perpetually recycled and reworked in the present. Jameson argues that the result of this process is that 'we' have lost touch with the reality of 'our' history, and with the sense that 'we' are part of a process of historical evolution and progress. I draw attention to this 'we' because I shall argue below that it claims a universality which rests on the exclusion of women, and indeed it could also be demonstrated that it is a normative Western, First World subject, and I also discuss this issue here.

Baudrillard offers several explanations for the end of history. Either the acceleration of modernity has increased to the extent that 'we have flown free of the referential sphere of the real and of history',[10] or because the 'masses' produced by the media have nullified the discourse of history 'by deceleration, indifference and stupefaction',[11] or because events are so imbricated in representation that linear time, cause and effect, and the difference between real and representation become unsustainable, so that *Apocalypse Now* (1979) or *JFK* (1991), for example, become more 'true' accounts of events than non-fictional representations. Baudrillard states that: 'This is our destiny: the end of the end. We are in a transfinite universe'.[12] The function of utopias and dystopias is therefore one of alibi or deterrence, since there cannot be

any imagination of a future which is possible. Once again there is a 'we' which is the subject of this discourse, and as I argued in Chapter 1, this white male subject has his home in the United States, and diffuses Eastwards from there, with less and less purchase as he travels away from what Lyotard called 'the most highly developed societies'.[13]

An especially conservative version of the end of history thesis was articulated by Francis Fukuyama in 1989. Fukuyama's essay 'The End of History?' and his subsequent book argue that 'we cannot picture to ourselves a world that is essentially different from the present one, and at the same time better . . . a future that is not essentially democratic and capitalist'.[14] Fukuyama argued that events were still occurring, 'but History, that is, history understood as a single, coherent, evolutionary process' has concluded.[15] With the near-global dominance of capitalist relations of production, marked by the traumatic collapse of East European states at the end of the 1980s, Fukuyama argued that ideological conflict is now outdated, and the idealisation of a different model of social organisation than consumer capitalism is impossible. Consumer capitalism is the model toward which all societies aspire, because capitalism promises the attainment of material desires, and the accumulation of commodities becomes the form which utopia now takes. But the resulting culture of consumption, although it offers the attainment of material desires, has its own inherent dangers. The 'Last Men' which it produces are in danger of becoming secure, self-regarding, and passive, with little incentive for productive effort, and lessening adherence to the work ethic which provides the motor of productivity. Fukuyama argues that history has stopped because 'we' cannot aspire to a future which is better than the present. Jameson argues that history has stopped because 'we' cannot relate authentically to our past. While these commentators have quite different explanations for the end of history, they both agree that 'we' inhabit a distinctively new kind of moment.

Fukuyama's version of the end of history thesis draws on a Hegelian tradition. Hegel's lectures on the philosophy of history (1822–31) definitively established world history on a linear model, drawing on the philological study of Sanskrit and the diffusionist view of the connections between Indo-European languages and peoples.[16] He eliminated Africa from his universal history, and presented human development as an organic process which mirrored the movement of

the Sun across the skies. The childhood of humanity was in the East, and its maturity and old age in the West: 'Europe is absolutely the end of history, Asia the beginning'.[17] Old age, represented by Western civilisation, was the period of self-consciousness and self-understanding which laid the foundations for the fulfilment of human achievement. America lay further West than Europe, and due to the spherical shape of the Earth, connected with the East, but Hegel rejected the circularity and reflexiveness which this implied, and regarded Western Europe as the summit of human history, as its linear end. Hegelian thinking in the twentieth century is represented by Oswald Spengler's *The Decline of the West* (1918–22), titled in suitably Hegelian fashion *Der Untergang des Abendlandes* (the decline of the evening lands), and by interpretations of Hegel by Alexander Kojève. Fukuyama draws explicitly on Kojève in *The End of History*, rejecting Spengler's pessimism about the fate of the West and locating its culmination in the USA.

This discursive construction of history as the history of the West, finding its culmination in the United States, links the theoretical and philosophical work on history that I am considering to the globalisation hypothesis in relation to cinema. For a strong formulation of globalisation in relation to cinematic media culture is that to globalise is to Americanise. It is true that the global economy of cinema is dominated by films financed by corporations operating in America, which make much of their revenue from overseas markets.[18] In the sixteen Western European countries, just under 60 per cent of all films released in 1992 were American in origin, with American films taking a share of box-office revenue ranging from 54 per cent (France) to 87 per cent (Greece). In a sample of twenty-one countries from all continents, representing a total population of about 950 million people, the ten most widely seen films in 1993 were all American. The most popular film was *Jurassic Park* (1993), seen by over 144 million people, with over 60 per cent of its total revenue earned outside the United States. But the absorption of Hollywood studios by multinational conglomerates brings cinema further into a global (not simply American) complex of consumer industries. Furthermore, the predominance of films which are made in the United States in the cinema market is far from new (at least in Europe), so that American domination of world cinema can hardly be called postmodern in the sense of a distinctively new historical stage. Instead, it should be seen as an intensification of

modernity's characteristic technologisation and standardisation in the field of consumption as well as production. The products of the contemporary cinema industry may take on American ideological myths (with their attendant contradictions) at the level of content, but it would be erroneous to neglect the influence of, for instance, Japanese investment and hardware on the software (films and associated entertainment products) which bears an American imprint. Sony has invested heavily in US film production, though so far without significant profit, and wrote off $3.2 billion in losses in 1994. The reason for this financial commitment is that cinema is only one of a number of image-based technologies which are being brought together as integrated commodity products. The prospect of linking film software properties with interactive video hardware promises to increase global hegemony over entertainment media to an unprecedented degree, with cinema as only one aspect of an integrated marketplace. Hegel's version of the end of history thesis could be extended from his stopping-point in Western Europe to America, and then rejoin its starting-point at the Pacific Rim. So too, the thesis that the end of cinema consists in its assumption into American cinema, shifts further west to link up with the Japanese corporate culture which dominates the production of consumer products in the arenas of many interrelated media.

Fukuyama's version of the end of history is interestingly gendered. What lies unacknowledged in Fukuyama's version of postmodernity is that the 'Last Man' is no longer a man, in the sense that the activity which defined masculinity in the past – work – and the productive effectivity which conferred social value on men, are no longer available or no longer appealing. So the end of history threatens to be an end of masculinity, and 'Last Men' become feminised both by lack (lack of masculine productiveness) and by their compensatory activities (shopping, gazing, and other forms of consumer behaviour). This seems to amount to a feminisation of society, in the sense that shopping, consuming and passivity or non-productivity are practices and identities conventionally attributed to women. Fukuyama's diagnosis of sociopolitical change is marked by (perhaps even the result of) an unstated theory of gender crisis in contemporary culture. In this formulation, the postmodern alienates men from themselves, wounds masculinity, and puts the social meaning of masculinity into crisis. This current of thinking is based then on a highly negative view of the feminine. The

end of history is both a recognition of a crisis in masculinity and a refusal to recognise the gender terms of this crisis. For Fukuyama at least, what is worrying is passivity, which elides into emasculation and then feminisation.

GENDER AND APOCALYPSE

As well as demonstrating a common set of concerns in these films and in theoretical writings on the postmodern, this chapter aims to show that an attention to issues of gender in both the films and theoretical texts will reveal that the end of history announced in postmodern theory can elide into, and be a symptom of, the perception of a crisis of gender identity, and in particular an anxiety about the end of a certain conception of masculinity. In making this case, questions of selection and representativeness inevitably arise, and link back to my earlier discussion of the status of examples. There are differences in tone in *The Name of the Rose* and *Seven* as apocalyptic fictions. Whereas *Seven* uses apocalypse rather contingently (I have been told that its script is the butt of screenwriters' jokes because of its obviousness), *The Name of the Rose* derives its apocalypticism from Umberto Eco's background as a cultural historian. Eco is aware that the apocalyptic feeling is historically relative, and both the film and the novel argue for some kind of faith in order to work against it, hence their religious setting. Initially however, a brief outline of the common concerns of these films is required in order to establish the ground of this discussion.

Both *The Name of the Rose* and *Seven* are films whose narrative world is proto-apocalyptic. Crimes happen on successive days in both films, corresponding to the seven Last Days of the Book of Revelation. In *The Name of the Rose*, seven monks in a Franciscan abbey in 1327 are killed, and their nervy brethren interpret the disposition of the dead as signs of the apocalypse as prophesied in the Bible. The first dies in a hailstorm, the second is found in a vat of blood, alluding to the signs of the imminent Last Judgement in Revelation. The film recounts the struggle between a theological discourse and a 'modern' rational deductive process to take precedence in the unravelling of the crimes. But the theological narrative of punishment and redemption is refused, for the killings are not indices of an imminent last Judgement, but a means to conceal the true motives of the killers, which are to protect

'forbidden' knowledge in the Abbey's library. In the contemporary setting of *Seven*, there are seven victims (both male and female) of John Doe's (Kevin Spacey) plan to enact the Biblical Seven Deadly Sins as a demonstration of the ills affecting modern American culture. *Seven*'s serial killer sets himself up as a prophet of a coming Last Judgement on American culture, in which he is using his crimes and the dissemination of news about them to the populace at large as warnings to the people to mend their ways in anticipation of catastrophic divine punishment. But again the theological narrative is not fulfilled, for Doe's premonitory killings are used to force confession of sin from the victims rather than contrition of their own free will (this forcible production of confession is termed 'attrition' in Catholic theology, and does not guarantee absolution). On the other hand, the narrative closure of *Seven* is produced by Doe, not by the police who are pursuing him. Indeed the mass police raid which discovers the victim punished for sin of Sloth (Michael Reid Mackay) is based on a mistaken belief that Sloth himself is the killer, and this failed closure part-way through the film is explicitly a refusal of the success of conventional procedures to put a stop to the murders by rational means. In each film, there is a contest between a theological apocalyptic narrative and a 'rational' detective narrative, but each of these, I shall argue, are narrative schemas which operate by an exclusion of the feminine.

The Christian apocalypse is of course a Western narrative, and both *The Name of the Rose* and *Seven* are predicated on a Western structure of explanation, and especially an American one. As Mary Wilson Carpenter has described, apocalyptic discourse has been pervasive in the United States at least from the 1960s to the present, with huge sales of popularising books about interpreting Revelation and the end of the world.[19] She mentions, for example, Hal Lindsey's *The Late Great Planet Earth* (1970), a fundamentalist Christian text interpreting Revelation and other Biblical texts, which sold 28 million copies from 1970–90, and was the best-selling non-fiction work of the 1970s. President Ronald Reagan frequently alluded to apocalyptic imagery in his speeches in the 1980s, and to Revelation in particular. The sales of Lindsey's book almost doubled in the second half of 1990 in anticipation of the Gulf War. Popular apocalypticism in the United States has divorced the prophecy from its Biblical context as a military and religious narrative, and made it into a universalising vision separated

from the politics, and especially the gender politics, on which it is based. However, Carpenter also describes a feminist apocalypticism which used the discourse as a means of pushing for change, and a feminist theological and scholarly discourse which questioned gender itself by using apocalyptic imagery and interpretation. While apocalyptic thought has been contested as to its gender politics, Carpenter demonstrates that popular apocalypticism constructs a paranoid male reading subject, and this paranoia is displaced on to the figure of the woman, specifically the Whore of Babylon. The body of the male is positioned as vulnerable, while the female body, established as the locus of the sexual, becomes the site of terror, horror and repudiation, or conversely of reverence, purity and beauty. Carpenter's work could be interestingly related to other research on the relations between the body, gender and cinema in contemporary culture, like that of Andrew Ross,[20] and further analysis of *The Name of the Rose* and *Seven* illuminates the consonance between the apocalyptic motif in film narrative and apocalyptic writing in postmodern theory.

GENDER AND THE SERIAL KILLER

Both *The Name of the Rose* and *Seven* are 'serial killer' films. In a discussion of several contemporary films, Richard Dyer has recently noted that serial killing is often taken to be 'the crime of our age',[21] because it occurs in alienated mass societies, is facilitated by rapid transportation, and responds to media objectification of women, the most frequent victims, and of killers themselves as seekers of media fame. Furthermore, the seriality of murders is parallel to the seriality of commodity production and its stimulation of the desire and pleasure in repetition. The production and consumption of serial killer films could be taken as a support for an argument that cinema is part of a postmodern cultural situation. But by contrast the structure of almost all serial killer narratives in film cannot be described as postmodern, if we use the common formulation that postmodern works eschew narrative closure in favour of fragmentation and repetition. This is what Dyer describes as 'the spectre of endlessness, forever trapped by the compulsions of serial watching, engulfed in repetition without end or point',[22] and which he ascribes to television soap opera and to only a very few serial killer films (especially *Henry Portrait of a Serial Killer*, 1989). The case of the

serial killer film draws, then, on a conception of contemporary culture which parallels the structures and the subject of the films with mass society, media culture, and the gender relations of capitalist societies, but the narrative form of the mainstream Western narrative film seems to militate against a simple description of the films as postmodern works.

As Richard Dyer has noted, *Seven* draws attention to the seven deadly sins of Gluttony, Sloth, Greed, Lust, Pride, Envy and Wrath, and links the number seven with other apocalyptic groups of seven including the seven terraces of Dante's Purgatory, and the seven Last Days of Revelation.[23] The Book of Revelation is permeated by more than fifty groups of sevens, like angels and trumpets, and the seven deadly sins were listed prominently on the film's publicity poster and television advertising. In both *Seven* and *The Name of the Rose* the male killers are finally discovered by a two-man team of detectives, and Dyer notes that: 'Serial killers are not only men, they prey specifically on women or socially inferior men (young, black, gay). The serial killer's maleness is misogyny and male supremacism writ large'.[24] In discerning a pattern and an explanation of the crimes there is an assertion of order in the narrative world, entailing a resolution usually constituted by the removal of the killer. Furthermore, the assertion of narrative order in resolution is parallel to the assertion of social and ideological order within the narrative, since the victims of the serial killer function as others to a dominant masculinity. This patriarchal order is represented by institutional male figures like policemen, detectives and lawyers, although in some films these functionaries are occasionally women co-opted into the system of the patriarchal law. What must be protected from the serial killer is the home, family and 'normal' heterosexuality: concepts in which the feminine is a foundational component. In *Seven*, Doe kills only white people, of which four are male and three female. But in line with the 'male supremacism' of the genre, the women victims are 'punished' in line with patriarchal assumptions which associate the feminine with bodiliness and sexual appetite. The victim of the sin of Lust (Cat Mueller) is a prostitute who is apparently punished for her willingness to engage in the sex industry. But the film never questions this reading of her motivation, and gives considerable prominence to the distress of the man (Leland Orser) who is forced to kill her by penetrating her with a strap-on steel-bladed dildo. Similarly,

the model whose face is slashed for the sin of Pride (Heidi Schanz) is forced either to telephone for help and suffer lifelong disfigurement, or end her own life by taking an overdose. But again, whether this punishment is appropriate is never questioned. The reason for these uninterrogated elements is that both these films in their different ways are about the instability of masculine identity, where sexuality and desire are taken as symptoms of social decay and disorder, precisely the sense of pre-apocalyptic decadence which prompts John Doe to commit his crimes.

The peasant girl (Valentina Vargas) with whom Adso (Christian Slater) has his first (hetero)sexual experience in *The Name of the Rose* survives death to become the object of his sexual and romantic fantasies, thus establishing heterosexuality as a positive value for the film. The Girl is dependent on the monastery and accidentally becomes accused of witchcraft, narrowly escaping being burnt at the stake. What remains in the monastery's kitchen when the Girl leaves Adso is a heart, signifying both flesh and the material, and the heart as emblem of love. The association of the heart with the Girl signals the ideals of romantic love and sexual fulfilment which Adso desires and momentarily attains, but also the fleshly and material which must be repudiated for the sake of the maintenance of patriarchal authority. She functions as a sign for the heterosexuality which is both presented as a norm and as that which must be denied for the monks to function. Similarly, home and family survive only as lost ideals in *Seven*, since Mills' (Brad Pitt) wife Tracy (Gwyneth Paltrow) and their unborn child are killed, and the film ends with the lone figure of Somerset (Morgan Freeman) whose chance at family life was lost years before. Somerset reports to Tracy that he failed to sustain a relationship with the one significant woman in his past, because of his fear that he could not protect her from the chaos of urban life. It seems that the masculine effectivity of Adso and William (Sean Connery) in *The Name of the Rose* and of Somerset in *Seven* can only be salvaged if each of these central male characters are shorn of heterosexual romance and sexual activity. Mills' wife Tracy is the vehicle for Doe to commit his own sin of Envy, 'I tried to play husband . . . It didn't work out . . . Because I envy your normal life, it seems that envy is my sin'. He fails to rape her, and Doe uses this as evidence of his own apparent sexual inadequacy. While it is not clear that Doe is either gay or impotent, his own sin is defined

against a heterosexual normality which mobilises women and femininity as others that he both stigmatises and aligns himself with by failing to fit into that heterosexual norm. Retrospectively it is clear that the blood all over Doe when he gives himself up to the police is Tracy's blood, and she represents virtue or the possibility of goodness in the film. Just before Mills kills Doe, a very short, almost subliminal close-up shot of her face appears, standing for a memory of her in Mills' mind and the fact that she is a token for the people who the (male) police are supposed to protect, and more generally for goodness. Tracy in *Seven* is the killer's last victim and an intermediary between Mills and his partner Somerset, fulfilling a conventional role as victim of violence, representative of the domestic world, family, normality, and heterosexual partnership. But while women characters have conventional functions as other to the professional and procedural worlds of the men, the relationships between men are more ambiguous.

THREATENED MEN

The gendering of apocalypse has important consequences for the representation of masculinity as well as femininity. Mary Wilson Carpenter is concerned to point out in a discussion of the Biblical Book of Revelation and its apocalypse, that:

> the violence of Revelation is *male* violence and that it is a violence *between* men and *to* women. The Book of Revelation does not represent violence between women, nor violence by women to men. The violence of Revelation is a gendered violence that puts a certain kind of sexual politics into discourse and effects a certain kind of sexual power . . . this is a text that, as Eve Kosofsky Sedgewick has demonstrated in the case of certain Gothic novels, makes instrumental to power the male homosocial bond that is maintained by culture.[25]

The solving of the crimes disconfirms apocalypse and simultaneously restabilises masculinity, and this process depends in part on the exile or death of the white women who represent the feminine in each film. In these apocalyptic scenarios, the struggle represented is a struggle between men, in which the rational forces of the law are all but defeated.

Both *The Name of the Rose* and *Seven* centre on a homosocial bond between characters of different generations, and these relationships are modulated across key female characters who are not motors of the plots but are significant in establishing the nature of the gender identity of the main characters. In postmodern apocalypse, a struggle against passivity for the male protagonists goes along with a fear of feminisation and a narrative focus on violence toward women. While Biblical apocalypse represents this as a reassertion of difference in which women become victims, Fukuyama's postmodern apocalypse predicts the effacement of difference with the feminisation of men, and presents this as a potential auto-destruction of society.

In *The Name of the Rose* the victims of the killer Jorge de Burgos (Feodor Challapin, Jr.) are male monks seen as 'perverse' by Jorge, because they are entranced by comedy, which threatens the attitude of fear and awe on which faith is based, and some of them have been engaged in homosexual activity. Adso in *The Name of the Rose* is an object of sexual desire for some of the monks, and is compared to the sublimely beautiful form of a statue of the Virgin Mary. He is not only feminised as an object of desire but also infantilised since he is the naive young assistant to William, and is shown progressing through the film from this position of relative powerlessness to sexual knowledge and active participation in the solving of the crimes. What William desires is Adso's desire to know, and Adso's desire is also the desire to know and to be William. It is Adso's voice, as an old man, which narrates the opening and closing of the film, noting that he now wears the eyeglasses given to him by William, signifying not only the inheritance of an adult masculine role but also the mastery which the eyeglasses represented as an index of the masculine gaze of detection and wisdom. On the other hand, William's myopia, sexual inexperience, and vulnerability from other powerful male figures in the film (notably Bernardo Gui (F. Murray Abraham) leader of the Inquisition, and the Abbott (Michael Lonsdale)) do not establish William as an archetypal male hero or as the subject of a masculine mastery over knowledge. Indeed, the figure in the film who does represent mastery by his authority over the library's texts is Jorge, who seeks to incarnate the patriarchal Word by literally ingesting the pages of Aristotle's lost book on comedy around which the film's mystery revolves. The association of William's masculine mastery over knowledge with Jorge's competing

desire to control knowledge prompts the questioning of patriarchal authority, especially in combination with the emasculation of William and his homosocial relationship with Adso.

Somerset is the Holmsian detective in *Seven*, who his boss calls a 'great brain'. Like William in *The Name of the Rose*, he has claims to be the subject of mastery, the one who knows. But on the other hand, he is paralleled in various ways with John Doe, the cold and sexually ambivalent killer whom he seeks. Like Doe, Somerset sees the world as a corrupt and sinful place, explaining to Tracy that he asked himself at the time of his own partner's pregnancy 'How can I bring a child into a world like this?'. Like Doe, Somerset is familiar with the apocalyptic tradition, using his knowledge of literary and religious texts to discover the motivations for his crimes. The film draws parallels between Somerset and Doe in visual terms, as Richard Dyer has noted.[26] *Seven's* opening credit sequence shows Doe turning the pages of books, and sewing together the sheets of his extensive hand-written journals into volumes. This focus on writing, research and assembly parallels Somerset's research at a public library, where an extended sequence of shots often focus on the pages he is looking at, photocopying and collating. The parallels between Somerset and Doe in this respect are reinforced by the contrasts with Mills' research, which involves looking at photographs of the crime scenes for clues but eventually giving up and watching football on TV. Each of these films draw on the misogynist premises of the serial killer film and the Biblical apocalypse, aligning apocalypse with violence against women. Along with this consonance between film form, postmodern discourse and a politics of gender, the films also draw attention to Fukuyama's concern for the withering of masculine effectivity, for the place of the masculine in postmodernity is assailed by dangers of isolation, emasculation, failure, ineffectuality and self-absorption.

VISIONS OF APOCALYPSE

In contrast to the utopian characteristics of Fukuyama's endless stasis of consumer paradise, *The Name of the Rose* and *Seven* use *mise-en-scène* to represent the non-arrival of a revelatory Last Judgement as a far from satisfactory state. As Amy Taubin writes of *Seven*, 'cities are cesspools of contagion, spreading sin faster than TB. Forget inequalities of class or

race, we're all sinners, and urban blight is the Lord's decor for the gates of Hell'.[27] This injunction to 'forget inequalities' points to the film's implicit assumption that there is nothing to be done about the condition of contemporary society. Somerset opines that things have 'always been this way', and it is suggested that he will return to his policing duties at the end of the film, despite his intention to retire and the destruction of his partner Mills who was to inherit his mantle. *Seven*, like many contemporary thrillers and science-fiction films, borrows the darkness, rainy streets and decay of film noir to present a cityscape which is both out of time and rooted in a stasis of unredeemable corruption. The cinematographer of the film, Darius Khondji, had employed high contrast effects in *Trésor des îles chiennes* (1990), *Delicatessen* (1991), and *La Cité des enfants perdus* (1995). By means of high contrast techniques, the visual look of *Seven* is made almost uniformly dark. Strong light is occasionally evident, often at times when the audience sees Doe's face, associating light with bleakness rather than virtue, whereas the use of silver print film gives the black skin of Somerset more depth and texture. Somerset has not a clock beside him in his bedroom, but a metronome, thus drawing attention to the passing of time but without fixing time by hourly measurement or offering progression towards a particular moment. The sense of enclosure signalled by this motif is supported by mysterious off-screen sound, very low lighting and deep pools of darkness, together with the labyrinthine dynamics of space which Fincher had previously deployed in *Alien 3* (1992), seen in the dark alleyways, corridors and dim apartments of *Seven*. In *Seven* the wait for the Last Judgement is infinite, and filled with a directionless accumulation of signs of decay which do not arrive at a moment of renewal, since even the bright wasteland setting of the film's final scene is a desert of despair in which Doe achieves his final humiliation of the detectives.

In *Seven*, the physical space of domesticity is far from idealised. The Mills' apartment is periodically shaken by the subway which runs underneath it, and while Somerset jokes about 'the vibrating home' in a brief moment of humour, the shaking of the apartment seems calculated to signify the destabilisation of the notion of family. What Mills refers to as his 'kids' turn out to be pet dogs, which the camera shows penned up in an empty room, and while Mills drinks beer while watching football, with the coffee table strewn with photographs of

Doe's mutilation of his first victim, Tracy looks on from behind the barred frame of an internal window. The visual barring of Mills from Tracy, and the dogs from the domestic space, introduce the separation and containment which will figure again at the end of the film when Doe is confined in a police car on the way to seek Doe's remaining victims. While Doe is penned up in the back of the car, he is nevertheless able to taunt and enrage Mills, to master him, prefiguring Doe's manipulation of Mills into acting out the sin of Wrath by killing Doe. What is contained within the box delivered in the final scene is Tracy's head, and opening up the box prompts Mills' vengeance. Spatial containment or imprisonment are used as figures of separation or non-communication, as well as simple restriction and control. But going along with the despairing isolation between people which this represents, is the sense that all space is imprisoning, for the space of the apocalyptic scenario is not one that can be escaped, as the open wilderness of the film's final scene demonstrates.

Given that *The Name of the Rose* is set in 1327, the parallels with *Seven*'s *mise-en-scène* are striking. The abbey is surrounded by a snowy waste from which the characters emerge and to which they return. The building itself is composed of small and dark monks' cells, and underlain by dark tunnels containing the bones of generations of its inhabitants. Its library is a labyrinth, which Eco (referring to the novel) describes as 'mannerist', since it contains false trails but a possible escape route, in contrast to a rhizome space in which 'every path can be connected with every other one. It has no center, no periphery, no exit, because it is potentially infinite'.[28] The labyrinth in the film is a spatial metaphor of narrative complication, but like the narrative it offers an exit, just as the film arrives at a solution to the killings in the abbey. But as Eco has pointed out, 'the world in which William realizes he is living already has a rhizome structure: that is, it can be structured but is never structured definitively'.[29] Just as *Seven* represents a version of postmodern endtime without the resolution of an apocalyptic Last Judgement which would fix its meaning, *The Name of the Rose* represents a struggle between different social groups and discursive communities to structure the film's world. Rational and 'scientific' thinking (represented by William himself) compete with religious orthodoxy (Jorge de Burgos and his attempt to delimit the canon of philosophical and religious texts), oppressive theocracy (Bernardo Gui and the

Inquisition) and popular rebellion (the peasants and their rescue of the Girl, killing of Gui and sacking of the abbey). The film's dramatisation of this struggle for meaning and power derives from Eco's own writing about postmodernity, and his thesis that postmodernity is a 'new medievalism' in which a ferment of orthodoxies, heresies and popular movements struggle for dominance in a rapidly changing economic and geopolitical environment. The postmodern becomes not only an unresolved epistemological crisis but also a involution of history on itself, with the implication that teleological progression and the ambition of modernity are no longer tenable. The spatial dynamics of the film's settings, together with its use of shadow, tolling bells and music in minor keys, support the parallels between the proto-apocalyptic exhaustion of medieval culture, and the exhaustion and emasculation of projects of mastery which Eco has explored in contemporary culture.

Apocalypse functions in both films as the ultimate point at which judgement is made, and when a final closure and fixing of meaning is to be imposed. In both *The Name of the Rose* and *Seven*, the apocalyptic mode has already begun at the moment of the first in the series of seven murders. As soon as the first sign of apocalypse is read, the narrative opens the expectation that the remaining signs will be presented, as the prelude to the end which apocalypse represents, and which will be the end of the film's narrative process. Indeed the narrative function of John Doe and Jorge de Burgos is not simply to channel an apocalyptic expectation but to create and hasten it by committing the murders. Both Doe and Burgos are seducers, seducing the detectives into their plan for the completion of their prophetic series of crimes, and seducing them with the possibility of solution to the crimes, but also seducing apocalypse itself, attempting to bring about the conditions of a final judgement. As Baudrillard notes of the apocalyptic literary and theological tradition,

> there has always been this desire to anticipate the end, possibly by death, by a kind of seductive suicide aiming to turn God from history and make him face up to his responsibilities, those which lie beyond the end, those of the final fulfilment.[30]

Both Doe and Burgos commit a form of suicide at the culmination of their murderous activities. For Baudrillard this kind of activity 'attempts

to entrap the powers that be by an immediate, total act. Without awaiting the final term of the process, it sets itself at the ecstatic end-point, hoping to bring about the conditions for the Last Judgement'.[31] While the effort of the detectives and the audience is to become subjects of knowledge, to unfold and solve the crimes, the role of the killers as seducers of the detectives and the audience renders each the objects of the narrative control held by the killers. To return to gender terms, the struggle is between the masculine detective/spectator and the feminised killer/seducer. To be seduced is to occupy a feminine position, in which the detective/spectator becomes an object worked-upon by the narrative process. So despite the removal of the killers at the climax of the films, which would seem to signify the reinstatement of masculine order, the figures representing that order have been significantly emasculated by the process of arriving at the end.

TIME AND SPACE

If apocalypse itself, as a punctual moment of fixity and judgement, can be characterised as a phallogocentric imposition of closure, then the continual endtime of postmodern apocalypse, which does not arrive at this closure, must be seen as a feminised form of temporality. This explains the different gender terms of biblical apocalypse and Fukuyama's end of history thesis. The biblical apocalypse is a phallogocentric narrative, while Fukuyama's vision of postmodern time beyond and after the closing of linear history is not end-directed (since the end has already taken place). For this reason the end exhibits a lack of masculinist characteristics, which Fukuyama deplores as the emasculation of society but which can instead be seen as a symptomatic repudiation of femininity. Whereas Biblical narrative situates apocalypse as the awful destruction of the world, it is also the moment at which a revelation of God's plan for the world occurs, and a salvation from time and an access to grace for those who are saved at the Last Judgement. By contrast, postmodern theories of the end of history present this as a perpetually unfinished narrative, since there is no retrospective revelation of the meaning of history, no Last Judgement, and therefore no redemption.

Both Jewish and Christian texts on apocalypse refer to it as both destructive and revelatory: the revelation of a transcendent reality,

another spatial realm, and another temporal realm, since the time of the apocalyptic judgement is the end of time and the salvation from time and history. Walter Benjamin announced the end of history in the description of the Angel of History in his 'Theses on the Philosophy of History', written shortly before his suicide in 1940:

> His face is turned toward the past. Where we perceive a chain of events, he sees one single catastrophe which keeps piling wreckage upon wreckage and hurls it in front of his feet. The angel would like to stay, awaken the dead, and make whole what has been smashed. But a storm is blowing from Paradise; it has got caught in his wings with such violence that the angel can no longer close them. This storm irresistibly propels him into the future to which his back is turned, while the pile of debris before him grows skyward. This storm is what we call progress.[32]

In *The Name of the Rose* and *Seven* the disaster takes place against the still present hope of putting the world to rights, of regaining Paradise. Jonathan Boyarin notes that Benjamin's text is a version of apocalypse which has been read as a denial of teleology and progress.[33] But Boyarin also draws attention to a positive reading: that the angel (because he is outside linear time) is always at a point just after the loss of Paradise, so that humankind is always close to Paradise because it has always only just been lost. Paradise and Apocalypse become mutually interdependent terms.

Time leads up to apocalypse, and apocalypse retrospectively gives meaning to human history. The postmodern version of apocalypse includes the assertion that humankind inhabits a perpetual state of being at the end, in an endtime without revelation or judgement, and therefore without hope for the fixing of meaning. The apocalyptic end of history is always imminent, but this temporality is also outside of the exhausted linear history which precedes it. As Fukuyama and Jameson have argued, the time of the postmodern end of history is bracketed off from both the past and the future, it is a continuous present absorbing the images of past and future. In *Seven*, Detective Somerset claims that things have always been this way; he can imagine neither a past nor a future different to his present. While *Seven* is set in the present, aspects of its *mise-en-scène* refer us back to the film noir genre of the 1940s, or

forward to the urban dystopias of science fiction, so that the film seems less than usually fixed in a particular historical moment. *The Name of the Rose*, like many medieval films, necessarily historicises its setting but also interprets it through modern characters and discourses, so that past and present intersect and become confused. While both films have a fairly precise historical setting, temporality in both of them is confused and suspended.

In *The Name of the Rose* and *Seven* the premonitory deaths take place against the still present hope of putting the world to rights, following our expectations of resolution in detective fictions. In *The Name of the Rose* the expected apocalypse is disconfirmed by a modern Sherlock Holmes figure. However, Jorge de Burgos does succeed in destroying Aristotle's book on comedy, and the library is consumed in a blazing inferno which mirrors the end of the world and consumes the very books on which William's and the film's intellectual power are based. William's novice assistant Adso is haunted by his guilt at an illicit sexual liaison, leading him to write the film's story as a final attempt at contrition for his sin. So despite the closure of the film and the unmasking of the killer, there is both a failure to prevent some kinds of end, and a residue of guilt which remains. The pervasive darkness of *Seven*'s *mise-en-scène* eventually lightens at the end, suggesting emergence into the light of salvation. However the last sunlit sequence shows that Mills (and everyone else, it is implied) is and has always been in Hell already, since the sinfulness brought to light by John Doe has been passed on to Mills when Mills commits one of the seven deadly sins himself (Wrath) by killing Doe. The punishment for society's sin is an endless process which the end of the film does not close off. *The Name of the Rose* and *Seven* offer loss of mastery in the seductive relationship between subjects of knowledge and objects of knowledge, together with the positionality offered by progression toward resolution and the multiplication of clues which invite both detectives and audience into an adventure of reading. This tension between mastery and incoherence can be read as a postmodern destabilisation of masculine positionality and fixity, since such a fixity is barely achieved. I explore issues of mastery, certainty, hierarchy and tradition in the following chapter, by discussing *The Name of the Rose* and *Seven*, together with *Bram Stoker's Dracula* (1992), in relation to counterpositions of high and popular culture. At this point, however, I

offer the temporary conclusion that both theoretical elaborations of postmodern apocalypse and related examples in contemporary media culture are engaged in a partial dialogue around the same concerns. The relations between theoretical writing and particular films are not those of illustration or proof, but of consonance, interimplication and shared aporias.

NOTES

1. Umberto Eco, *Foucault's Pendulum* (London: Secker & Warburg, 1989), first published in Italian 1988.
2. The Pope's condemnation is reported in Barry Smart, *Postmodernity* (London: Routledge, 1993), p. 112.
3. Some of my ideas about these films and postmodern versions of apocalypse were first published in Jonathan Bignell, 'The Detective at the End of History: Postmodern Apocalypse in *The Name of the Rose* and *Seven*', in Dominique Sipière and Gilles Menegaldo (eds), *Les Récits Policiers au Cinéma, la licorne Colloques* 7 (Poitiers: University of Poitiers Press, 1999), pp. 195–203.
4. See for example Jacques Derrida, *Signéponge/Signsponge*, trans. R. Rand (New York: Columbia University Press, 1984).
5. Mark Bould, 'Preserving Machines: Recentring the Decentred Subject in *Blade Runner* and *Johnny Mnemonic*', in Jonathan Bignell (ed.), *Writing and Cinema* (Harlow: Longman, 1999), p. 169.
6. Marcus Doel and David Clarke, 'From Ramble City to the Screening of the Eye: *Blade Runner*, Death and Symbolic Exchange', in David Clarke (ed.), *The Cinematic City* (London: Routledge, 1997), p. 141.
7. Gilles Deleuze, *Cinema 1: The Movement-Image*, trans. H. Tomlinson and B. Habberjam (London: Athlone, 1986), and Gilles Deleuze, *Cinema 2: The Time-Image*, trans. H. Tomlinson and R. Galeta (London: Athlone, 1989).
8. Fredric Jameson, 'Postmodernism, or The Cultural Logic of Late Capitalism', *New Left Review* 146 (1984), p. 87.
9. Ibid., p. 53.
10. Jean Baudrillard, *The Illusion of the End*, trans. C. Turner (Cambridge: Polity, 1994), p. 1.
11. Ibid., p. 4.
12. Jean Baudrillard, *Fatal Strategies*, trans. P. Beitchman and W. Niesluchowski (London: Pluto, 1990), p. 70.
13. Jean-François Lyotard, *The Postmodern Condition: A Report on Knowledge*,

trans. G. Bennington and B. Massumi (Manchester: Manchester University Press, 1984), p. xxiii.

14. Francis Fukuyama, *The End of History and the Last Man* (New York: Free Press, 1992), p. 46. His earlier article was Francis Fukuyama 'The End of History?', *The National Interest* 16 (1989), pp. 3–18.

15. Fukuyama, *The End of History*, p. xii.

16. Georg Willhelm Friedrich Hegel, *The Philosophy of History*, trans. J. Silbee (New York: Dover, 1956).

17. Ibid., p. 103.

18. The following statistical information derives from David Robinson, 'Hollywood Rules', in *Chronicle of Cinema 1895–1995*, supplement to *Sight and Sound* 5: 1 (January 1995), pp. 126–7.

19. Mary Wilson Carpenter, 'Representing Apocalypse: Sexual Politics and the Violence of Revelation', in Richard Dellamora (ed.), *Postmodern Apocalypse: Theory and Cultural Practice at the End* (Philadelphia: University of Pennsylvania Press, 1995), pp. 107–35.

20. Andrew Ross, 'Wet, Dark, and Low, Eco-Man Evolves from Eco-Woman', in Margaret Ferguson and Jennifer Wicke (eds), *Feminism and Postmodernism* (London: Duke University Press, 1994), pp. 221–48.

21. Richard Dyer, 'To Kill and Kill Again', *Sight and Sound* 7: 9 (1997), p. 14. On *Seven* and serial killer films, see also Richard Dyer *Seven* (London: BFI Modern Classics, 1999), pp. 35–49. My analysis of the film relies on this latter analysis in particular, which in its turn takes account of my own earlier work on this topic.

22. Dyer, 'To Kill and Kill Again', p. 17.

23. Dyer, *Seven*, p. 8.

24. Ibid., p. 38.

25. Carpenter, 'Representing Apocalypse', p. 110.

26. Dyer, *Seven*, p. 11.

27. Amy Taubin, 'The Allure of Decay', *Sight and Sound* 6: 1 (January 1996), p. 23.

28. Umberto Eco, *Reflections on The Name of the Rose* (London: Secker & Warburg, 1985), p. 57.

29. Ibid., p. 58.

30. Baudrillard, *Illusion of the End*, p. 8.

31. Ibid.

32. Walter Benjamin, 'Theses on the Philosophy of History', in *Illuminations*, ed. H. Arendt, trans. H. Zohn (New York: Schocken Books, 1976), pp. 257–8.

33. Jonathan Boyarin, 'At Last All the *Goyim*: Notes on a Greek Word Applied to Jews', in *Postmodern Apocalypse*, pp. 41–58.

3

WRITING, JUDGEMENT AND CINEMA

This chapter concerns problems of judgement and evaluation in a range of different senses. In the previous chapter I considered the notion of an apocalyptic end of history in postmodern theory and in films, and opened a question of gender around this, and I return in this chapter to different but related issues around history, with a different critical focus. The main aim of the chapter is to explore the postmodern intertextuality which challenges the separation between high and low culture, and between the central and the marginal. Fredric Jameson noted that versions of postmodernism efface the 'frontier between high culture and so-called mass or commercial culture', and one of the characteristic features noted in writing on the postmodern is a fragmentation of culture.[1] Jim Collins writes that: 'Culture is no longer a unitary, fixed category, but a decentred, fragmentary assemblage of conflicting voices and institutions', and argues that it is no longer clear how to evaluate one discourse as more true, worthwhile, or effective than another.[2] This chapter will argue that the postmodern is characterised by problems of judging the relative value of heterogeneous discourses, especially those identified as 'high' as opposed to 'popular' culture. I follow Collins' view that the binary division between high and popular culture is destabilised by what he describes as postmodern textuality, because in the same discursive object the juxtaposition of the codes of high and popular culture 'forces a reexamination of their interrelationships and a reconsideration of how both function as types of discourse'.[3] Collins' work was undertaken in the context of a book on detective fiction, and I both continue this by focusing on both

written and cinematic detective narratives, and extend it through comparisons and contrasts between literary and filmic examples.

The claim of Collins' book is that the postmodern 'provides not only a way of understanding the disintegration of culture as Public Sphere, but also a theory of the formation, deformation, and reformation of such spheres in present and future cultures'.[4] Collins proposes that rather than producing a coherence of discourses (high or popular, dominant or resistant, for example), the discourses of popular culture are engaged in processes of self-legitimation necessitated by the absence of an orchestrating hierarchy of value which would assign them each specific places in culture. I test this claim against the different connections with high and popular culture of five objects: three films and two novels, discriminating the different ways in which these five cases deploy high and popular cultural reference. Following from the emphasis in Chapter 2 on apocalypse as the sign of a Western anxiety about the grand narrative of history, and the primacy of the masculine, I continue to focus on Western films, returning to *The Name of the Rose* and *Seven*, and also discussing *Bram Stoker's Dracula*. These films, in different ways, deploy written texts from a European tradition, alluding to or adapting them in the context of 'mainstream' commercial cinema. One of the primary issues discussed here is the relationship between an anterior text, tradition or authority, and a film which makes use of it. The second and interrelated issue is the consonance or complicity between cinema and postmodern theory's preoccupations with discursive heterogeneity and the indeterminacy of spectacle. Each of these issues is concerned with judgement, with the purchase of an evaluative discourse, and involves the overlap between a critical discourse and the objects which it seizes as its referent or proof.

The chapter therefore returns to the question of the status of theory and criticism as privileged forms of discourse about postmodern media culture, since critical discourse takes unto itself the power to judge by selecting representative examples. I have chosen to refer to three films in this chapter which foreground their relationships to canonical traditions, most often literary ones. *The Name of the Rose*, *Seven* and *Bram Stoker's Dracula* engage with the past, with history and with value, and therefore allow me to situate my argument about judgement. In the previous chapter my analysis of *The Name of the Rose* had little to say about the novel on which the film was based, and here this

question of origins is dealt with in combination with the related ques-
tions of pre-texts and authorities which are raised by *Seven* and *Bram
Stoker's Dracula*. *Bram Stoker's Dracula* is a film based on a late nine-
teenth-century Gothic novel, enabling me to consider distances and
consonances between this form and its contemporary reworking in
the film medium, while *Seven* is not an adaptation of a pre-existing
text, but draws significantly on allusion to religious and literary sources.
I argue that each of these three films engages in the kind of reconsider-
ation of the past which Umberto Eco has noted as one of the concerns
of his novel *The Name of the Rose*: 'The postmodern reply to the modern
consists in recognising that the past, since it cannot really be
destroyed, because its destruction leads to silence, must be revisited,
but with irony, not innocently'.[5] The 'irony' referred to here in revis-
iting the past signals the hesitation in the postmodern about the
status of this past, and the problem of judgement in the postmodern.
Furthermore, the revisiting of an antecedent tradition or text is an
essential component in the clearing of a space in culture for the films
and novels which I discuss, though I also draw attention to the
problematic status of these objects in relation to the spatiality and
temporality of culture.

ADDUCING A PAST

The textual structure of *The Name of the Rose* is one of the means by
which the novel raises issues of value and authority, but at the same
time avoids them. The author of the prologue is anonymous, inviting
the reader to align this author with Eco, and I thus refer to this author
as 'Eco'. 'Eco' is handed a manuscript by an unnamed person in 1968.
The manuscript is an 1842 French translation of a seventh century Latin
text. This Latin text is an edition of a manuscript originally written by
Adso, a German monk, near the end of the fourteenth century. 'Eco'
leaves Prague and meets his ungendered 'beloved' in Vienna, from
where they go to the monk's place of origin, the town of Melk. The
original manuscript cannot be found there, and the beloved disappears
with the French translation. In 1980 'Eco' publishes his own Italian
translation of Adso's memoirs, as 'an act of love. Or, if you like, a way
of ridding myself of numerous, persistent obsessions'.[6] 'Eco' writes the
text as an 'act of love' for he lost the text on the same night that he lost

his 'beloved', and this mirrors Adso's loss of the Girl in the story. I have already noted in Chapter 2 that what William desires is Adso's desire to know, and Adso's desire is also the desire to know and to be William. This transference is displaced onto the desire for the text, the object transferred to 'Eco', whose writing of the text is also a transferral of his desire for his beloved. Adso's memoirs are a tale of transference, and the text is framed by further transferrals and transferences in the account of its origins. As Teresa DeLauretis has argued, the authority of *The Name of the Rose* to teach, to play with knowledge, is 'an authority bearing the weight of the obsessions of a great, millenary, and moribund patriarchal tradition', in which the paternity and value of the knowledge of the past is questioned by the erotics of its production.[7] For DeLauretis, the text's authority disguises itself as a reflexive play with tradition, but nonetheless aspires to the lost but nostalgically desired high culture of books around which the story revolves. The powers of writing are signalled by the Latin hexameter at the end of the novel, 'stat rosa pristina nomine, nomina nuda tenemus', which is by Bernard of Morlay, a twelfth-century Benedictine, and is a variation on the 'ubi sunt' theme where poems meditate on the passing of, for example, great men, beautiful women, great cities, or flowers. Bernard adds that although things pass away, their pure names remain, and Abelard used the sentence 'Nulla rosa est' to demonstrate that language can speak of non-existent and destroyed things. The fictional or destroyed things of the past (like the rose) can be both resurrected and conjured up by language, so that despite decay and death, language ensures the survival of the valued things of the past. It is already clear from this short summary, perhaps, that *The Name of the Rose* situates itself as a meditation on the representability of the Western tradition, raising the question of its status and its accessibility in a different historical or post-historical moment.

The title of the novel is itself an invitation to call on intertextual knowledge drawn from literary history including Dante and Gertrude Stein, from a children's rhyme, and from the history and theology of European culture. Referring to the title of his novel, Eco explained that he chose *The Name of the Rose* because:

the rose is a symbolic figure so rich in meanings that by now it hardly has any meaning left: Dante's mystic rose, and go lovely

rose, the Wars of the Roses, rose thou art sick, too many rings around Rosie, a rose by any other name, a rose is a rose is a rose is a rose, the Rosicrucians.[8]

For Eco, the effect is that the title 'disoriented the reader, who was unable to choose just one interpretation'.[9] DeLauretis argues that Eco is working with his theory of the 'open text' outlined in order to deal with texts by Joyce, Mallarmé or Dante, which involve indeterminacy, for *The Role of the Reader*[10] suggests that an open text must nevertheless propose a model reader, able to read its maze-like structure:

> Much like Althusser's account of the subject's relation to ideology, Eco's recent theory of textuality at once invokes a reader who is already 'competent', a (reading) subject fully constituted prior to the text and to reading, *and* poses the reader as a term of the text's production of certain meanings, as an effect of its structure.[11]

Thus she argues that the text is both an open text which thematises postmodern indeterminacy, but also leads and creates its reader in a way that allows the text to finish its puzzle and get out of its maze. While the ironic revisiting of the past is signalled by the text in a way which conforms to a postmodern hesitation about the status and value of that past, the novel is nevertheless able to complete itself as a narrative, and to master the discourses and their histories on which it draws.

However, in Jean-Jacques Annaud's film version the title is never explained, and this closes off the possibility for the title *The Name of the Rose* to open a heterogeneous field of discourses in which the priority of one over another is in question. Jim Collins has argued of postmodern fiction like *The Name of the Rose* that:

> the ideology that Post-Modernist texts promote is a greater sensitivity to that heterogeneity, as if it were only through the consideration of a multiplicity of discourses that we may recognize both the primacy of discourse and impossibility of a central hierarchy or master-system that might coordinate their differences.[12]

This problematisation of judgement and value is dealt with primarily

by the narrative of the film, rather than in medium-specific ways. In the film, as in the novel, Jorge de Burgos excludes from the canon those works which open the monastic enterprise of textual interpretation to new attitudes of inquiry, defining scholarship in a sermon as recapitulation rather than discovery, and comic writing or humorous illustration of manuscripts, because they encourage the questioning of spiritual truths, are equally dangerous. In a sense this conservative enterprise succeeds, because the majority of the monastery's library is destroyed at the end of the film. A lengthy sequence showing the blazing library from within and from outside emphasises the threat it poses to both the lives of the protagonists and to the texts it contains. But the film and the novel engage in a dialogue with this high-cultural written tradition in several ways. Familiar aspects of the detective genre as a form of modern popular cultural discourse are invoked, in particular the English monk William of Baskerville is paralleled to Sherlock Holmes (via Conan Doyle's *The Hound of the Baskervilles*). The film's detection-investigation plot structure derives from popular fiction and popular cinema, and the film could be seen as a confrontation between the conservatism of high literary culture, personified by Jorge de Burgos, whose name hints at the labyrinthine fictions of Jorge Borges, and popular culture in the figure of William/Sherlock Holmes. William uses deductive logic and observation, adopts the phrase 'My dear Adso, it's elementary' when addressing his naive young assistant, and like Holmes, William's chief pleasure is in following the thread of the enigmas which structure the narrative, rather than capturing his quarry.

In the film, the use of point-of-view shots when William sorts through the contents of the library, together with confirming cuts back to Adso's reactions, establish the significance of texts and knowledge as the treasures at the heart of the labyrinthine library. The canonical high-cultural discourse is most importantly represented by translations of Aristotle, but the first 'masterpiece' which William identifies in the abbey's library is the Book of the Apocalypse annotated by Beatus of Liébana, 'with a commentary by Umberto of Bologna'. This text bridges the medieval and the modern, the historical and the fictional, since Umberto of Bologna is Umberto Eco. William reads the autograph of his twentieth-century creator, just as the film shows him 'reading' in the snow the 'autograph' footprint of a monk suspected of murder. The

film's close-ups on physical clues like the footprint, and on the pages of illuminated manuscripts, draw each of these together as the keys to a promised ordering of the worlds of human relations and of textual relations, assimilating the social and textual together as semiotic systems. The key to the film's mystery is a debate over the future course of cultural history, because the librarian-killer wishes to banish frivolous texts and subjects from the library and thus from culture itself. His method is to poison the pages of the forbidden book, so that its readers commit unintentional suicide when crossing the border between legitimate and illegitimate knowledge. The questions raised by the film are who controls what can be read, and who has the knowledge and skill which will allow him or her to read signs correctly.

Seven shows canonical literature and other 'serious' works being misread by John Doe, as guides to the pattern of his murders, and justifications for his crimes. The visions of apocalyptic judgement he draws on derive, among others, from Milton's *Paradise Lost*, Dante's *Inferno* and *Purgatory*, and Chaucer's *Canterbury Tales*. It is Somerset's familiarity with, and reading of, these texts which uncovers the pattern of Doe's crimes. But the identification of Doe himself as the killer is accomplished not through Somerset's knowledge of this literary tradition, but by gaining access to the CIA's high-tech surveillance methods, whereby library records are computer-searched to identify dissidents and subversives through their reading-habits. There is a contest, then, between the powers of the library and the database to solve the film's enigma, where the film brings these two modes of knowledge together. Nevertheless, the cultural value of books remains, and Mills' ignorance of the literary canon is an occasion for the film to make fun of him: Somerset's attempt to educate Mills, by providing details of the literature Doe had been reading, leads Mills only to buy Cliff's Notes on the texts rather than to read them in the original. Mills' reaction to Somerset's library research is to exclaim (to himself) 'Fuckin Dante! Goddam poetry-writing faggot piece of shit!', and the obliviousness to books of everyone except Somerset (even the library's guards, who prefer to play cards than to notice the texts surrounding them) confuses any simple reverence for the tradition. Alongside the references to canonical literature are an allusion to Andy Warhol's pop art images (in the stacked cans in the Gluttony victim's (Bob Mack) apartment), a soundtrack by Nine Inch Nails and other contemporary

musicians, and the use of shadow and composition which borrows techniques from graphic novels by Gaiman, Mackean and Sienkiewitz.[13] While canonical high-cultural texts from the past are narratively significant in solving the crimes, these texts are counterpointed ironically by contemporary cultural references: Mills pronounces the Marquis De Sade's name as Sade, the chanteuse made famous by the pop single 'Smooth Operator', and an English shopkeeper (Ron Blair) who supplied the phallic steel-bladed leather body-harness used in the Lust murder says he thought John Doe must be one of New York's more avant-garde performance artists. Doe's use of high culture as a pattern and justification, together with the counterpointing of these elements with contemporary popular cultural allusions and forms, enacts a critique of the aim to civilise and humanise which has functioned in liberal enlightened cultural policy as a justification for the dominance of the canon. In this respect, the film supports Collins' argument that a heterogeneity of discourses, and a confusion as to their relative claims for precedence and social effect, calls for a reconceptualisation of culture as represented by an evaluative hierarchy of texts.

During his library research into the seven deadly sins, Detective Somerset is not seen reading reference books but rather 'high' literature, accompanied by Bach on the soundtrack. Somerset's search through library books allows the camera to show pages from Dante's *Purgatorio*, diagrams of Dante's Hell and Purgatory, and some of Gustav Doré's illustrations (one of which is a severed head, hinting at the beheading of Tracy later in the film). The pages are not all from one edition, so Somerset reads at least three editions of *Inferno* and *Purgatory*. It even appears that Somerset can read Middle English, since translations of the *Canterbury Tales* into modern English usually omit the section on the seven deadly sins in *The Parson's Tale*, one of the books we see him select. This research sequence therefore shows a version of high culture from the Middle Ages to the present, and Somerset's familiarity with that history. The film aligns the audience with high culture by the mastery which Somerset exhibits and which we are encouraged to admire, while making jokes at the expense of Mills' ignorance. However, Richard Dyer shows that this is an address to an elite audience whose knowledge is rewarded by the film, together with a confirmation of the lack of effect this knowledge has on culture in general: '*Seven* addresses us as people familiar with high culture and

in its bleakness provides us with the complacent consolation of pessimism'.[14] The religious texts used in the film are concerned with sin rather than either crime or virtue. There are no references to the four Gospels in the film, except in the red neon cross in Doe's apartment, which is associated with Christ's expiation of sin. Doe claims to do God's work, so it is not virtue which is associated with faith but rather violence and death. Among Somerset's pile of library books, which the camera dwells on enough for the spectator to read their titles, is a Penguin edition of the *Divine Comedy* by whodunit author Dorothy L. Sayers, an example of a crossover between high and popular culture. This detail is a concrete support for the argument made by Dyer that the film is both an art movie with intellectual credentials, careful structuring, striking visual design, and a downbeat ending, and also popular cinema, being a serial-killer film, a star vehicle and a police thriller. If the film is art, so is Doe's murderous scheme, so that culture itself is aligned with violence. For instance, the first clue to the pattern of murders is a note quoting the lines 'Long is the way/And hard that out of Hell leads up to the light' from Milton's *Paradise Lost*, and the second victim dies after removing a pound of his own flesh as in Shakespeare's *The Merchant of Venice*. Culture, and high culture in particular, are mobilised in ways that are precisely contrary to humanising or pacific aims. In *Seven* the confusions around the value of culture, and of high culture especially, undercut the canon as a repository of value. But the film's view of the present as a perpetual endtime in which that canon is revalued and associated with violence, indeed an apocalyptic moment as discussed in the previous chapter, offers nothing beyond this state of confusion. The postmodern moment entails at once a revaluation of the past and the impossibility of judging the value of the objects in which value has been invested.

NOSTALGIA AND VALUE

As part of the procedure which I am arguing for throughout this book, I would like to read the evacuation of the grounds for judging high culture as implicitly superior to popular culture in *Seven* back into postmodern theory. In particular, the work of Fredric Jameson in essays on postmodern cinema provides a suitably parallel but also distinct approach to issues of temporality and value. The trajectory of

Jameson's thinking is useful in showing that the postmodern becomes regarded as not simply a set of features of particular films, but one of the properties of cinema itself. He moves in these works from discussing postmodernism as a stylistic and formal matter, to an account in which postmodernism becomes virtually synonymous with the postmodern as a discursive and experiential field. In 'Postmodernism, or the Cultural Logic of Late Capitalism', postmodern cinema is a symptom and a reflection of an alienated, schizophrenic subjectivity produced by US domination of the global economic and military system. So postmodernism is produced by and is a reflection of postmodernity. His examples of postmodern cinema in the first essay are 'nostalgia films', including *Chinatown* (1974), *American Graffiti* and *Body Heat* (1981). Jameson's critique of nostalgia films derives from a materialist concern for cultural products to advance the dialectical progress of history, so that the represented past offers a way of thinking critically about the present and material reality. He contends that nostalgia films use narrative structure and *mise-en-scène* to confuse temporality for the spectator, evoking the past and mythologising it as 'beyond real historical time'.[15] For Jameson, this 'mesmerising aesthetic mode itself emerged as an elaborated symptom of the waning of our historicity, of our lived possibility of experiencing history in some active way'.[16] Nostalgia films become an index of the end of history as a mode of experiencing, so that the present itself becomes unrepresentable. Thus postmodern cinema lacks a critical function, since it does not engage with the teleological movement of the dialectic in a grand narrative of progress, and it is this lack of a critical function which separates it from experimental work in cinema and other modern and modernist representational forms. The problem for Jameson then is that postmodern cinema takes away the grounds for an evaluative judgement of the present by invoking history but at the same time dehistoricising it.

While *The Name of the Rose* and *Seven* are not nostalgia films in Jameson's sense, the past is particularly significant to their diegetic present. The meaning of the present in each film is both more fully and affectively articulated because of its sharing of structures and motifs which are borrowed from another time. In *Seven* the other time is a diffuse and extended past made up of a canonical literary and religious tradition, while in *The Name of the Rose* this past is at once the inheritance of classical authority in the medieval world of the story, and also

the anachronistic invocation of the Conan Doyle detective stories. Jameson's early work on nostalgia films links history to judgement by the assumption that the materialist history of culture provides the appropriate grounds for assessing the value of a cultural product, in terms of the film's contribution to a critical understanding of the past which can be mobilised in a politics of the present. Nostalgia films mystify and dehistoricise the past, and thus take part in a removal of the grounds for judgement of the present. From a different set of examples, and different senses of what history means to the films I have discussed, I have arrived at some similar conclusions. In *The Name of the Rose* and *Seven* the invocation of the past is a means of destabilising the present, and confusing the separations and continuities between a postmodern moment and what is anterior to it. Indeed, a postmodern moment is constituted by this confusion of boundaries.

However, despite the superficial parallels between Jameson's analysis and my own, I would like to follow the course of his work on postmodern cinema rather than dwelling on its details, since his trajectory moves from films as objects to work on cinema itself as a medium. This is especially of interest to me because it represents a move from objects as examples to cinema itself as an example for postmodern media culture in general. In 'Postmodernism and Consumer Society', Jameson shifts the focus of his argument from stylistic features to the historical thesis that the postmodern is not a style but a dominant discursive and epistemological force field.[17] He loosens the determining influence of macro-economic factors on his argument, and allows for both modern and postmodern regimes to exist at the same time, although the postmodern is still seen as a shift or break with the past. In 'Postmodernism and Utopia', Jameson develops his notion of nostalgia as a form of forgetting 'real' history, arguing that postmodern works exhibit a nostalgia for nostalgia, for the 'deep memory' that modernist works explored.[18] The formal techniques of an oppositional modernism are now co-opted and contained in the canon, and their formal strategies become adopted widely by postmodern works which cannot have the same critical or oppositional force. So postmodern cinema has lost its connection with history and with modernist critique. Not only is historicity something which is lost and can be nostalgically longed-for, but critique also becomes a lost and desired object in the postmodern. The final result of this strand of thinking is that it is impossible to

regard films as critical judgements on contemporary culture, and also that theoretical discourse loses its power to judge cinema. This conclusion obviously affects the discursive position of the analyst himself or herself, for the relation between object and critic has been destablised in Jameson's account. The loss of history as temporal logic has shifted into a loss of the spatial coherence which separates the critic from the film. The difference and different value of the object and the theory have become confused, and I would like to take this positional or spatial notion back into further discussion of films. What is at stake is the potential dissolution of the relation between observer and observed, critic and text, analytical discourse and the object discourse on which it works. I have argued that in the film version of *The Name of the Rose* and in *Seven* the problematisation of a high-cultural past does not affect the mastery of the film as narrative over its uses of tradition, and this mastery over narrative derives largely from the formal structures of the detective story.

FIXING POSITIONS

Both *The Name of the Rose* and *Seven* are detective films, and Bram Stoker's novel *Dracula*, on which Coppola's film is based, is also a kind of detective story. In *Dracula*, the journal kept by Jonathan Harker begins as a simple record of his impressions and tourist insights into his travels, but gradually all the various textual forms presented in the novel (journal, newspaper story, ship's log, diary, phonograph recordings) become partial accounts of the central mystery of Dracula himself. Dracula is not assimilable by the particular discourses which the characters produce, but rather it is the Gothic combination of the texts included in the novel as a whole which is the key to mastering Dracula as a topic for writing, and mastering him as threat by destroying him.[19] Dracula is afraid of precisely this containment of him by the discourse, and at one point succeeds in burning one of the only two copies of the weave of texts which makes up the novel. The eventual plan to capture and destroy Dracula is made possible by the reading of the complete assembled manuscript by the main characters, after it has been transcribed. Once they have read it, they have sufficient mastery over the situation to destroy Dracula. The legitimacy of Gothic writing as the discourse of truth, and thus the production of the reader of the text as

a sufficient subject for its fictional narrative, is produced by the text's thematisation of the power of writing as witness to truth, and its effectivity as a weapon and an adequate medium for the mysteries with which the novel deals. Heterogeneity of discourse in the novel both defers the encounter with the mystery of Dracula and is also the resource for mastery once this heterogeneity has been given order. As in *The Name of the Rose* and *Seven*, then, the form of the text is still able to master the heterogeneity and problematisation of discourse which *Dracula* takes as its subject.

Stoker's novel begins with a preface which presents the text as a truthful witness. The novel is presented as a series of fragments, each the testimony of a particular character:

> All needless matters have been eliminated, so that a history almost at variance with the possibilities of latter-day belief may stand forth as simple fact. There is throughout no statement of past events wherein memory may err, for all the records chosen are exactly contemporary, given from the standpoints and within the range of knowledge of those who made them.[20]

The purpose of this is to present the writing as transparent, realistic and truthful, but it also generates suspense in the gradual assembly of the novel's heterogeneous discourses. The identity of the text as a unified object, and of characters as psychological identities, is challenged by this play of signs and reinscriptions. The mystery of character identity is not confined to Dracula, for Lucy Westenra, Dracula's first victim, marvels at the power of her suitor Dr Seward in reading the surfaces of her face: 'I can fancy what a wonderful power he must have over his patients. He has a curious habit of looking one straight in the face, as if trying to read one's thoughts'.[21] Mina, Harker's fiancée, writes her self-revelations in her journal, by means of shorthand: 'I am anxious, and it soothes me to express myself here; it is like whispering to one's self and listening at the same time. And there is also something about the shorthand symbols that makes it different from writing'.[22] Writing is too transparent for the revelation of her inner thoughts, while hieroglyph-like shorthand symbols divide Mina into speaker and listener, split her subjectivity. Seeing, reading, writing and deciphering are not used to reveal a truthful depth, but instead to multiply fascinating and

ambivalent surfaces. Thus the Gothic as a textual mode has close con-
nections with the version of the postmodern outlined by Eco in relation
to *The Name of the Rose*, since a similar problematisation of interpretation
of clues, signs and texts occurs in *Dracula*, and also a similar mastery
over this indeterminacy by the discourse of the text itself, which pur-
ports to decode, order and produce the solutions to the enigma around
which it revolves.

The status of the detective story, as centred on doubt or conjecture,
but at the same time offering a mastery over this uncertainty, relates
back to the questions of judgement and value which are the main topic
of this chapter. Stephen Neale has argued that the narrative process of
detective cinema is the paradigmatic model for all narrative, because
its giving and withholding of information is an extreme case of the
containment of the spectating subject's desire and pleasure, which all
narratives engender by their tension between narrative process and the
fixing of meaning:

> What the enigma-investigation structure serves to effect is an
> amplification of the tension inherent in all 'classic' narratives: the
> tension between process (with its threat of incoherence, of the
> loss of mastery) and position (with its threat of stasis, fixity, or of
> compulsive repetition, which is the same thing in another form).[23]

The process of solving the enigma which structures a detective film or
novel is a paradigm of sense-making in general, since the spectator is
aligned with the detective in solving the mystery, and therefore 'the
detective film and the thriller are genres which, so to speak, actively
acknowledge and inscribe within their structures the practice of read-
ing'.[24] Thus *The Name of the Rose*, *Seven* and *Dracula* as detective fictions
would function as examples representing the whole class of ' "classic"
narratives', and offer a reflexive meditation on the subjective processes
of reading or spectatorship. This makes detective films paradigmatic
examples for the demonstration of classical film theory's semiotic-
psychoanalytic approach to the cinematic apparatus, for the fixing of
the subject in relation to the institution of cinematic representation
is parallel to the fixing of the subject by the closed structure of the
detective story.

I shall therefore give a brief and necessarily crude summary of

apparatus theory in film analysis, before considering how the stress on spatial positionality of subjectivity and temporal processing by the apparatus might be problematised in the postmodern. The cinematic apparatus has for a long time been described as an ensemble which positions the spectator as transcendent subject but also subjects him or her to the order of the world which it produces. As a physical apparatus, cinema shares this dislocation and detemporalisation of spectatorship with the panopticon. Jeremy Bentham's plan for a panoptic prison, as Jean-Louis Baudry argued, is a metaphorical model for cinematic spectatorship.[25] Like the guard in the centre of the panopticon, the film spectator is unseen both by himself or herself and by what he or she observes. The spectator's invisibility is the precondition for his or her confusion between being the source and subject of the representation (projection) and being subject to the representation. But the film spectator is not in the centre of a circular space laid out for his or her surveillance, nor does he or she have a full circular range of vision. The film spectator's omnipotence is of an imaginary order and in fact the cinema spectator is 'imprisoned' in the imaginary disposition of the cinematic apparatus. Cinema proceeds from a 'wish to construct a simulation machine capable of offering the subject perceptions which are really representations mistaken for perceptions'.[26] The panoptic model of the cinematic apparatus depends on belief, the spectator's belief that what is seen may as well be real. A virtual gaze supplants the real gaze, and the pleasure of this (following Lacan's account of the mirror phase) comes from the spectator's primordial psychic wish to return to a time in which all his or her desires were satisfied: it is an imaginary temporal return to an earlier phase of psychic development, facilitated by the spectator's physical immobility in the cinema, and the predominance of visual perception in the cinema, which allows a dream-like or hallucinatory experience. Similar accounts of the apparatus occur in Christian Metz's work, where the spectatorship which the apparatus produces is described as working an imaginary time-shift back to a pre-Oedipal state of being: the film is a representation which works by invoking another representation (a virtual childhood) in the imaginary.[27] Thus the spatial disposition of the spectator in the cinema produces a virtual temporal shift to an imaginary anterior psychic state.

 In a reconsideration of cinema and other contemporary media, Anne

Friedberg has argued that film spectatorship as an experience rooted in a specific time and place of viewing is less and less the defining relation of the spectator to the film, thus increasing the significance of temporal and spatial mobility as features of a postmodern subjectivity linked to film but not exclusive to it. For Friedberg:

> The cinema functions as a machine for virtual time travel in three ways: first, as a theatrical 'set piece', set in a period in the past or in the future; second, in its capacity, through montage, to elicit an elliptical temporality; and third, in its ability to be repeated, over time, imparting to each spectator a unique montage-consciousness.[28]

I have argued that Jameson's work on nostalgia films, and my analyses of films which draw on and volatilise canonical textual traditions, share a conception of the postmodern which emphasises the destabilisation of the past and the hierarchy of objects which allow that past to provide criteria for judgements of value. Friedberg's work on the cinematic apparatus and the institutions of film presentation adds to this by stressing the virtualisation of time which was already present in classical film theory's conception of the cinematic apparatus as a mechanism for shifting the subject in imaginary space and imaginary time. Friedberg claims that:

> Cinema and television – mechanical and electronic extensions of photography's capacity to transform our access to history and memory – have produced increasingly detemporalized subjectivities. At the same time, the ubiquity of cinematic and televisual representations has fostered an increasingly derealized sense of 'presence' and identity. Seen in this context, descriptions of a decentred, derealized and detemporalized postmodern subject form a striking parallel to the subjective consequences of cinema and televisual spectatorship.[29]

In the context of these approaches to cinema as postmodern, the historicisation of this mode of spectatorship and its evaluation become problematic. Indeed, as my analysis of Jameson's argument reveals, it can become impossible to judge cinema in relation to imperatives of

critique. If temporality and subjectivity are detemporalised by the cinematic apparatus, and in film narratives themselves, the postmodern becomes a name for the invocation of historicity and its possibilities of comparative evaluation and judgement, and at the same time a name for the virtualisation of history and judgement. This issue returns me to *Bram Stoker's Dracula*, and the question of how to judge it.

REFLEXIVE INSCRIPTION

Bram Stoker's Dracula is a film which is both conscious of the historical traditions which precede it, and also dehistoricises this history by turning it into spectacle. The film's settings (late-medieval, nineteenth century, Transylvania, London) are all three-dimensional studio sets, and the acting is melodramatic, but this is reflexively historical and 'authentic', recalling early cinema's dependence on Victorian stage melodrama.[30] Indeed theatre versions of Stoker's *Dracula* were performed on stage both in London and on Broadway, using the elaborate theatre machinery of the time. The stage machinery of trick coffins, trapdoors and smoke effects link with the cinematic special effects in the many film versions and this one in particular. The film offers a possible response to the dehistoricisation of the past noted in Jameson's work, in that it explicitly cites the textual form of the novel on which it is based, and also the literary, theatrical and cinematic heritage of Dracula films. Therefore the film could be argued to expose its own historical determinants reflexively, providing the grounds for an evaluation both of the film as a historicising discourse, and an evaluation of the cultural and political epoch to which it returns. The film includes references to writing and recording that are central to the narrative structure of the novel, which is told by a number of different narrators in the form of diary entries, journals and logs. A variety of modes of inscription are shown in the film, including the writing of letters and diaries, typing and voice recording on phonograph cylinders. Particular shots present the spectator with newspaper stories or maps, and the film introduces references to *The Arabian Nights*, as well as newspapers and ancient books on vampires, to point out aspects of nineteenth-century sexuality, media culture and atavistic, imperialist fears of the Other. In many respects, Coppola's film recasts the textual construction of the novel in cinematic terms, and draws attention to

the culture which has produced it. Coppola remarked that: 'Usually Dracula is just a reptilian creature in a horror film. I want people to understand the historical and literary traditions behind the story'.[31]

However, the traditions behind the story are much more ambiguous than the play with high-cultural texts which I have examined in *The Name of the Rose* and *Seven*. The Athenaeum reviewed *Dracula* in 1897, concluding that the novel:

> is highly sensational, but it is wanting in the constructive art as well as in the higher literary sense. It reads at times like a mere series of grotesquely incredible events . . . Still, Mr. Stoker has got together a number of 'horrid details', and his object, assuming it to be ghastliness, is fairly well fulfilled. Isolated scenes and touches are probably quite uncanny enough to please those for whom they are designed.[32]

Apparently, readers of the novel are both likely to be seduced by its 'ghastliness', and unable to judge its failings in literariness, while the sensational and spectacular in the writing produce narrative incoherence. The pleasure of this was described by the *Daily Mail's* reviewer in the same year:

> By ten o'clock the story had so fastened itself upon our attention that we could not even pause to light our pipe. At midnight the narrative had fairly got on our nerves; a creepy terror had seized upon us, and when, at length, in the early hours of the morning, we went upstairs to bed it was with the anticipation of nightmare.[33]

The seduction of the text is pleasurable here, and produces both the loss of control which reading produces, and the thrill of the emotions generated. The discourses in terms of which the novel is evaluated are those of popular culture, and also concern anxieties about the deleterious effects of the novel on its readers. When *Bram Stoker's Dracula* was released on videotape (1993), the publicity copy on the Columbia video proclaims the authenticity of the film, doubly authorised by the auteur status of its director: 'Coppola returns to the original source of the Dracula myth, and from that gothic romance, he creates a modern masterpiece'. But the film is at once a return to Stoker and singularly

'modern', it engages with a history in order to transcend and surpass it. James V. Hart, the screenwriter of Coppola's film, co-wrote a novelisation of the film with his own preface, an afterword by Coppola, photographs from the film, and extensive re-use of Stoker's text. The publicity copy on the back of the book draws on the same discourse as the videotape:

> A legendary evil inspires a motion picture event. The ultimate retelling of a story that has mesmerised readers for more than a century . . . Here is the extraordinary story of a creature possessed of an irresistible sexuality and a powerful evil as old as time itself. This unforgettable classic of darkly erotic horror is now a magnificent motion picture from Francis Ford Coppola, featuring an internationally celebrated cast.

The 'legendary evil' of Dracula is lost in 'legend' and 'as old as time itself', while the story's origins are specific, having existed for 'more than a century' in Stoker's 'unforgettable classic' version. There is a confusion between the desire to attribute value by assimilating the film and Stoker's text to a literary canon, and to attribute value by stressing the cultural authority of the film and its director as surpassing the literary tradition from which the film derives. The sober authority of the 'classic' also combines with the seductive fascination of 'erotic horror', recalling some of the terms of the novel's original reception. What is happening here, then, is a confusion of discursive legitimations, and of the boundaries between high and popular culture, and the boundaries between the written and the cinematic. The imbrication of the contemporary with the historical, and the high with the popular, is not only an example of the heterogeneity which Collins would identify as postmodern. It is also an example of the problem of locating an evaluative discourse of any kind, for the contemporary discourses produced around *Bram Stoker's Dracula* are themselves peculiar hybrids of several different evaluative schemas.

This confusion of discursive legitimation could be glimpsed when some of the female members of the Vampyre Association in Britain were interviewed on television in *The South Bank Show*'s Dracula special (1993), produced to mark the British release of Coppola's film. Their comments suggest that, for some women viewers and readers at least,

Dracula is a fantasy figure through whom they can enjoy romance, eroticism, exoticism and role-playing, precisely the shifting of identities which Friedberg's comments on postmodern subjectivity proposed: 'What vampires offer is sex, death, and fancy costumes and who could ask for more', as one of them said. The Dracula mythology offers nostalgia, eroticism, and a sense of literary seriousness which contrasts with much of contemporary popular culture, and provides a feeling of community, shared knowledge, and insider status as a negotiation with it.[34] One member of the Vampyre Society explained that vampires 'are erotic but in a sort of romantic sort of way. It's not like the cheap sort of sex that gets sold these days – it's more romantic, more Victorian'. The appeal of the past legitimates eroticism for contemporary women, and thus draws on and also defends against the commodification of sexuality. The Victorian heritage can be judged romantic and authentic, but as Victor Sage has shown, Stoker's work already drew on the codes of Victorian pornography and its fascination with sexual excess.[35] It is precisely this reworking of the codes of nineteenth-century sexuality which the film draws on in its connection between the cinematic and the erotic, picking up twentieth-century readings of the gendered and sexual subtext of the novel which enable one of the Vampyre Society members to comment enthusiastically that 'Mina and Lucy to start off with didn't have much personality at all until they turned into vampires, and then they became exciting and sexual and absolutely fantastic!'. The double movement here is to both stabilise the past as different from the contemporary in order to legitimise reinterpretations of *Dracula,* and at the same time to reread the cultural history in which *Dracula* was produced so that the novel becomes assimilable into contemporary understandings of identity and sexuality. The historicity of history is both retained as a legitimating instance but also denied by the possibility of rendering the past the same as the present. In this respect, the postmodern quality of Dracula stories (in both novel and film forms) is to defeat a hierarchy of value by placing Stoker's Victorian Gothic as both 'classic' high culture and sensational popular culture at the same time. This is made possible by the displacement of the texts which constitute the Dracula mythology out of their historical position, but also the invocation of this historical position as part of their legitimacy.

The key scene in *Bram Stoker's Dracula* where Dracula (Gary

Oldman) meets Mina (Winona Ryder), and recognises that she is a reincarnation of his dead wife of 400 years before occurs at the cinematograph, a location never used in Stoker's novel. Behind her on a makeshift screen are images of partly clothed women replaying over and over. Stoker's novel was published the year after the Lumière brothers opened their first cinematograph in London in 1896, and at the cinematograph, both 'real' and simulated early films (including a striptease, and the Lumières' *Arrival of a Train*) are being projected. Ken Gelder notes that the film:

> situates almost everything that happens under the umbrella of the Hollywood romance genre – drawing romance and the experience of (going to) the cinema together. Dracula, in Coppola's film, is a romantic and 'naturally' cinematic hero who sweeps Mina off her feet.[36]

The film returns to Victorian London and the cinematograph to establish its historical setting and its reflexivity as an adaptation, and returns to a cinematic romance narrative to secure its focus on the romantic couple. The cinematograph scene begins with the opening of an iris diaphragm, as in an early twentieth-century film, revealing a street of shops. The scene and its cinematic realisation link shopping, seduction and cinema together both structurally and visually. This reflexivity is not simply a clever way of ironically revisiting the past, qualifying the film as postmodern according to Eco's sense of the term quoted near the beginning of this chapter. It also alerts the spectator to the self-consciousness of a temporal slippage from the 1990s back to the 1890s, and Friedberg's virtual temporal movement which characterises the postmodern qualities of the cinema medium. But in addition, it returns me to questions of the relationship between the film as critique and the purchase of critical discourse upon the film.

SPECTACLE AND THE POSTMODERN

The film is itself a rereading of the *Dracula* novel and of the culture in which it was produced, including the importance of the cinematic and its gender politics to that culture. Furthermore, the film's fragmented

narrative (produced in part by allusion to the novel's discursive heterogeneity) and its emphasis on spectacle and sensation produce the visual excess that has been called 'engorgement' by Richard Dyer.[37] The film delights in its ability to show visual transformations, and among these are Dracula's metamorphoses to and from human, animal, mist and monstrous creature, and uncanny effects including droplets of liquid falling upwards, vampire women emerging out of a bed, and Dracula's shadow moving when he does not. The narrative is held together by making visual links, for instance superimposing one image on another, or matching one shape within the frame to another different object which has the same form. Connections between shots, sequences and story elements are based on resemblance and equivalence. *Bram Stoker's Dracula* keeps returning to particular patterns and images, like the circular forms of an eye, the moon, or the 'eyes' on peacock feathers, or the circular image in an iris diaphragm. The narrative of the film, then, is structured by returns to images which can be exchanged for each other. Like money in the commodity economy, and like the figure of the vampire, cinematic representations in Coppola's film mutate and change their form by posing equivalences. The drawing together of the past and the present by the film, and its assimilation of cinema to the gendered economy of consumption (in shopping, in the viewing of films) either overdetermine the meanings of the film, or render these meanings in such an accumulated and unhierarchised way that they become spectacle.[38] The question in analysing the film becomes how to judge it, whether as spectacle or as critique.

For Dana Polan, spectacle is an exaggeration and intensification of the premises of fiction in general, and 'fictionalizing is actually a larger process that substitutes the instantaneity of sight, observation, a whole complex of looking, for analysis, commentary, distanced criticism. The limit-form of such fiction, I will suggest, is the form of spectacle'.[39] Spectacle disempowers critique because it is a free play of signification which does not expose the constraints and restrictive economy of representation in order to deconstruct them. Spectacle itself becomes institutionalised as the condition in which a critique based on contradiction or dialectic is irrelevant as a political intervention, since this critique appeals to a truth of things, an adequacy of representation to

the real, which is what spectacle has left behind. For Polan, the effect
of a postmodern cinema of spectacle is the impossibility of judging the
image against an anterior real:

> The image shows everything, and because it shows everything it
> can *say* nothing; it frames a world and banishes into non-exis-
> tence everything beyond that frame. The will-to-spectacle is the
> assertion that a world of foreground is the only world that matters
> or is the only world that there *is*.[40]

This will to spectacle 'asserts that world only has substance – in some
cases, only is meaningful – when it appears as image, when it is
shown, when it exists as phenomenal appearance, a look'.[41] In this
account, spectacle is an apocalyptic moment for photographic modes
of representation like cinema, for it has no duration, no cause in
relation to a narrative flow, and places itself and its subject of percep-
tion outside of time. Therefore the moment of spectacle is not part of
the order of communication, since spectacle does not allow for a time
in which communication's deferral, interval, and spacing exist.[42]
Spectacle can refer to any moment in which a fetishised image stops
narrative flow, and suspends the time of narration in favour of con-
templation, though the possibility of the arrest of time in the spectacle
may not last. The spectacular moment depends on an element of
surprise and over-investment in the image, so that if a spectacular
moment becomes expected or anachronistic, its power wanes.
Furthermore, since spectacle is the other of narrative, each is depen-
dent on the other. Just as there is no apocalypse without history and
time, there can be no spectacle without the possibility of narrative to
enfold, contain and process it. The argument that cinema has died and
become spectacle is itself a historicising narrative, and relies on the
invocation of film narrative in order to then subordinate that narrative
to spectacle as a symptom of the loss of a cinema which is projected
into the past. That loss is also the loss of a cinema which can stand as
the object for critique, and problematises the relation between critical
discourse and cinema.

I would argue that writing about cinema as spectacle is a means of
addressing the perception that the orders of space, time, subjectivity
and narrative have become destabilised in the postmodern. The

regularities of the disposition of the subject in the space of the cinema are challenged, and the disruption of narrative order and temporality by spectacle and reflexivity, point to inadequacies in theoretical models for addressing cinema. For this reason there has been increasing interest in models of subjectivity and meaning in cinema which depart from the semiotic-psychoanalytic traditions and the materialist or Marxist cultural critique associated with them. I have argued that the postmodern, in relation to citations of tradition and value, is in part constituted by problems of establishing hierarchies of value and the theoretical and discursive means to confirm them. The elaboration of alternative theoretical discourses on cinema can also be regarded as a function of this problem of the relations between film-critical discourse and its objects, and thus as much a part of the postmodern as a response to postmodern films. A brief outline of what these alternative discursive addresses to cinema include may help to substantiate this point. Paul Virilio, in *The Vision Machine,* argues that the technological mediation of perception destroys 'natural reality'.[43] Following Husserl's phenomenological opinion that the perception of the real and the consciousness of the real occur together, with no mediating instance, Virilio sees technological mediation as destructive of this immediate relation between perception and consciousness. The acceleration which Virilio credits cinema with, in delivering a perception without a temporal gap between this perception and its presentation, is the beginning of the substitution of a mediated and technological perception for human perception, which therefore divorces that mechanical perception from human consciousness. What follows is a generalised divorce of perception from consciousness. Virilio's approach to film therefore rests on the valorisation of speed and instanteaniety, with the effect of reformulating the subject of cinema in a way which does not rely on the regularities of narrative or the semiotic-psychoanalytic tradition of film theory. These attempts to rethink the relations of the object to the subject are concerned with a dynamics of eruption, heterogeneity and the disruptions of order at the levels both of theory and the objects which it addresses.

A similar problem of the relationship between structure and a disruptive force is outlined by Gilles Deleuze in *Cinema 1* and *Cinema 2*.[44] For Deleuze, cinema is the union of force and form. This analysis derives from Henri Bergson, who Deleuze sees as offering the possibility of

thinking of an originary world in which images are in a perpetual state of movement and collision. The material world is conceived as one in which movement exceeds all closed systems, traversing systems and parts of systems, mixing and shifting them. Bergson's movement-image entails movement in physical reality and in the mind, thus removing the distinction between real and mental movement. The movement toward, away from and around things in film thus suppresses the fixity of the subject and the boundedness of the physical world, recapturing something of Bergson's originary state of flux. While Bergson saw cinema as a false movement constructed by mechanical means, Deleuze argues that each film frame is inhabited by force and movement, and is always in a process of movement and modification. Form is seen as a temporary receptacle which is repeatedly blasted apart by force. In the postmodern, the subject dislocates and destructures itself in the final move toward the overthrow of structures of domination (the subject being the last and most powerful of these structures), revealing that values are really only relations of force, with no transcendent authority. Force is not a value in itself, but is always to be thought (or deconstructed) in relation to form, its other. Deleuze in *Cinema 2* argues that movement in most films is still in the service of invariant and independent things, settings, or people, which are assumed to be there even if the camera could not see them. But in the cinema of the Time-Image, temporal, spatial, causal invariants become mobile, discontinuous, and the real and the imaginary change places with each other. Cinema can therefore no longer represent truth, and shows the power of the false to be the principle of the production of the image, and that perspective mimeticism is just one among many modes of appearance. As in other kinds of postmodern thought, the relation between subject and object, viewer and viewed, is made to destabilise, and thus destabilises these binary pairs. While I do not claim to have given a full account of Deleuze's or Virilio's theoretical discourses on cinema, I would argue that even this brief sketch shows that the orders of temporality, space, narrative and subjectivity are being addressed in ways other to those of the hitherto dominant semiotic-psychoanalytic tradition. The postmodern does not only involve the formal and conceptual matter of films themselves, but also the theoretical discourses which seize cinema as their object and discriminate significance. Judgement and heterogeneity are postmodern concerns

in films, as the first half of this chapter aimed to show, but also arise in the discourses which address and rearticulate cinema in terms of space, time and subjectivity, as the chapter has increasingly demonstrated.

NOTES

1. Fredric Jameson, 'Postmodernism, or the Cultural Logic of Late Capitalism', *New Left Review* 146 (July/August 1984), p. 54.
2. Jim Collins, *Uncommon Cultures: Popular Culture and Post-Modernism* (London: Routledge, 1989), p. 2.
3. Ibid., p. 26.
4. Ibid.
5. Umberto Eco, *Reflections on The Name of the Rose* (London: Secker & Warburg, 1985), p. 67.
6. Umberto Eco, *The Name of the Rose* (New York: Warner, 1986), p. xviii.
7. Teresa DeLauretis, 'Gaudy Rose: Eco and Narcissism', in Rocco Capozzi (ed.), *Reading Eco: An Anthology* (Bloomington: Indiana University Press, 1997), p. 251.
8. Eco, *Reflections on the Name of the Rose*, p. 3.
9. Ibid.
10. Umberto Eco, *The Role of the Reader* (Bloomington: Indiana University Press, 1979).
11. DeLauretis, 'Gaudy Rose', p. 247.
12. Collins, *Uncommon Cultures*, p. 64.
13. On graphic novels, see Claudia Springer, *Electronic Eros: Bodies and Desire in the Postindustrial Age* (London: Athlone Press, 1996); and Roger Sabin, *Adult Comics* (London: Routledge, 1993).
14. Richard Dyer, *Seven* (London: BFI Modern Classics, 1999), p. 73.
15. Jameson, 'Postmodernism', p. 69.
16. Ibid.
17. Fredric Jameson, 'Postmodernism and Consumer Society', in Hal Foster (ed.), *Postmodern Culture* (London: Pluto, 1985), pp. 111–25.
18. Fredric Jameson, 'Postmodernism and Utopia', in Fredric Jameson, *Utopia Post Utopia: Configurations of Nature and Culture in Recent Sculpture and Photography* (Boston: Institute of Contemporary Arts, 1988), p. 12.
19. I have discussed Coppola's adaptation of *Dracula* in relation to the Gothic in Jonathan Bignell, 'Dracula Goes to the Movies: Cinematic Spectacle and Gothic Literature', in Dominique Sipière (ed.), *Dracula: Insemination-Dissemination* (Amiens: University of Picardie, 1996), pp. 133–43.

20. Bram Stoker, *Dracula* (Oxford: Oxford World's Classics, 1983), unnumbered preface.
21. Ibid., p. 55.
22. Ibid., p. 71.
23. Stephen Neale, *Genre* (London: BFI, 1980), p. 26.
24. Ibid., p. 42.
25. Jean-Louis Baudry, 'The Apparatus: Metapsychological Approaches to the Impression of Reality in the Cinema', in P. Rosen (ed.), *Narrative, Apparatus, Ideology* (New York: Columbia University Press, 1986), pp. 299–318.
26. Ibid., p. 315.
27. Christian Metz, *The Imaginary Signifier: Psychoanalysis and the Cinema*, trans. B. Brewster (Bloomington: Indiana University Press, 1982).
28. Anne Friedberg, *Window Shopping: Cinema and the Postmodern* (Berkeley: University of California Press, 1993), p. 103.
29. Ibid., p. 2.
30. I have discussed Coppola's adaptation in relation to earlier film, television and theatre versions of the Dracula story in Jonathan Bignell, 'A Taste of the Gothic: Film & Television Versions of *Dracula*', in Erica Sheen and Robert Giddings (eds), *The Classic Novel: From Page to Screen* (Manchester: Manchester University Press, 2000), pp. 114–30.
31. Francis Ford Coppola, 'Afterword', in Fred Saberhagen and James Hart, *Bram Stoker's Dracula* (London: Pan, 1992), p. 301.
32. Anonymous review of *Dracula*, *The Athenaeum*, 26 June 1897, reprinted in Bram Stoker, *Dracula*, ed. A. Auerbach and D. Skal (New York: Norton Critical Editions, 1997), p. 364.
33. Anonymous review of *Dracula*, *Daily Mail*, 1 June 1897, reprinted in Stoker, *Dracula*, ed. Auerbach and Skal, p. 363.
34. On vampire fans, see Nori Dresser, *American Vampires: Fans, Victims and Practitioners* (New York: Vintage, 1990).
35. Victor Sage, '*Dracula* and the Victorian codes of pornography', in Sipière, *Dracula*, pp. 31–47.
36. Ken Gelder, *Reading the Vampire* (London: Routledge, 1994), p. 90.
37. Richard Dyer, 'Dracula and Desire', *Sight and Sound* 3: 1 (January 1993), p. 10.
38. I have addressed questions of spectacle in contemporary cinema in Jonathan Bignell, 'Spectacle and the Postmodern in Contemporary American Cinema', *la licorne*, special issue 'Crise de la représentation dans le cinéma américain', 36 (1996), pp. 163–80.
39. Dana Polan, '"Above All Else to make You See": Cinema and the Ideology of Spectacle', in Jonathan Arac (ed.), *Postmodernism and Politics* (Manchester: Manchester University Press, 1986), p. 56.

40. Ibid., p. 61.

41. Ibid., p. 60.

42. These points about spectacle and time are made in Sean Cubitt, 'Introduction: Le réel, c'est l'impossible: the sublime time of special effects', *Screen* 40: 2 (1999) pp. 123–30.

43. Paul Virilio, *The Vision Machine*, trans. D. Moshenberg (New York: Semiotext(e), 1991).

44. Gilles Deleuze, *Cinema 1: The Movement-Image*, trans. H. Tomlinson and B. Habberjam, London: Athlone, 1986), Gilles Deleuze, *Cinema 2: The Time-Image*, trans. H. Tomlinson and R. Galeta (London: Athlone, 1989).

4

CHILDREN'S MEDIA CULTURE AS POSTMODERN CULTURE

There are two main emphases in this chapter: the construction of the child as the object of a critical discourse, and the question of what the object of research in children's media culture may be, for example a toy, a game narrative, an institutional structure, or an audience member or group. I argue that both the concept of the child and the object of analysis are constituted by the critical discourse which mobilises them, and that this interrelationship is part of a postmodern problem of reference which I have identified in other contexts in the earlier chapters of this book. Children's media products have until recently been thought to be grossly manipulative texts producing retrograde ideological positionings and subjective identities, and the children's media industry is global, massive and economically powerful. These characterisations make children's media culture a paradigm case for an analysis of debates in theories of the postmodern about subject-formation, the purchase and relevance of ideology, and the globalisation of the media economy. This chapter addresses the multinational and global commercial institutions which produce media products and toys for children, leading to a study of the toy as object, considering questions of the determinacy and indeterminacy of the object in relation to gender and ideology. There is also a section on computer games, addressing the relationship between the game and its players, in terms of the difficulty of adducing theories of subject-positioning familiar from, especially, the study of cinema. Further, I also consider the status of ethnographic work on the child as consumer and audience

member, to consider debates on the formation of subjectivities and ideological positions from a non-text-centred perspective, and to open up questions of audience research which are considered in the following chapter.

Childhood is constituted in distinction to adulthood, and for adults childhood is that epoch of their own lives which is inaccessible to them except in the distorted versions available in memory or imagination, and which is constructed through the diverse and often contradictory cultural understandings of the child.[1] On the one hand, the child has been seen (in the Christian tradition) as predisposed to immorality and sin, irrational and incomplete, and requiring to be trained by adults in socially sanctioned behaviour. On the other hand, the Romantic child is regarded as uncorrupted, innocent, authentic and contrasted with an adult world of guile, artifice and the 'civilisation' underpinned by capitalist industrialism. This Romantic child is a sign of loss and nostalgia, regarded as a potential and an origin which is always already lost, and thus desired. So while there are children, there are many different, competing and contradictory discourses of childhood, and there is no necessary link between actual young people and the mobilisation of children and childhood in discourse. This constructivist position is taken by Judith Butler in her work on the body, which, like the child, has too often fulfilled the function of an extra-discursive object which is mobilised as the ground for an aesthetic, political or theoretical discourse:

> to 'refer' naively or directly to such an extra-discursive object will always require the prior delimitation of the extra-discursive. And insofar as the extra-discursive is delimited, it is formed by the very discourse from which it seeks to free itself. This delimitation, which often is enacted as an untheorized presupposition in any act of description, marks a boundary that includes and excludes, that decides, as it were, what will and will not be the stuff of the object to which we then refer.[2]

I return explicitly to the body as an object of discourse in relation to the bodies of toy figures, drawing together the indeterminacy of the body as object with the indeterminacy of the figure of the child as subject. But the chapter begins with an analysis of how the child is mobilised

in texts by Walter Benjamin and Jean-François Lyotard, whose work offers related but contrasting addresses to the child in work on the culture and politics of modernity and the postmodern.

THE FIGURE OF THE CHILD: BENJAMIN AND LYOTARD

Benjamin broadcast a series of radio talks for children, *Aufklarung fur Kinder*, from 1929–33, while Lyotard[3] has published a collection of correspondence titled *The Postmodern Explained to Children*. Each of these writers is interested in the child as a figure for the political subject in modernity, and also as the object of a political discourse. Each of them positions childhood in relation to notions of process, the constitution of the subject, and the relation between a subject and an object, event, or experience. Each of them is interested in the problem of teleology, which is connected to their writing on childhood. For the child is that which will become an adult, and the adult is produced against the retrospective invocation of the child. Similarly, for Lyotard, a work is 'modern only if it is first postmodern',[4] and Benjamin's discussion of the flight of the backward-looking angel of history (in Paul Klee's 1920 painting 'Angelus Novus')[5] shows that the movement of history is retrospective and continual, rather than progressive and developmental. For Benjamin and Lyotard, a completed state (of adulthood, or the modern) is constituted by a moment of formation (childhood, the postmodern) which is retrospectively constructed. What is of interest for me here then, is a parallel between discursive structures in writing about childhood and the postmodern.

Benjamin wrote critically about the authoritarian and colonial impulses behind the moral education of children, and was an avid collector of children's books and toys. He regarded play with toys as a site where the intimate exchanges between child and object produced and communicated culture, since play with toys concerns the child's negotiations with representations of an adult world. It was this ideological function of play which Roland Barthes drew attention to in the 1950s when he critiqued French toys in *Mythologies*, regarding toys as a means to prepare the child to become a consumer of meanings and products, so that toys perpetuate the terms in which society is structured as meaningful:'the child can only identify himself as owner,

as user, never as creator; he does not invent the world, he uses it: there are, prepared for him, actions without adventure, without wonder, without joy'.[6] For Benjamin too, the child as player with toys and desirer of toys in shop windows, is already a consumer, but a key feature of his conception of the child is that he or she is in a process of self-discovery, of becoming a subject. Benjamin's discourse contains some of the emancipatory certainty of Marxism, for the child, as a playful and sensual being, disrupts the regime of use-value by engaging in fetishistic relationships with objects, valuing immediate genuineness more than inherited tradition. Benjamin draws here on German Romanticism with its notion of transcendence, for Romantic notions of childhood tend to abstract it from political and social contexts. But this kind of exclusion can also work rhetorically to establish the child as a subversive model of subjectivity, or of new configurations of the political. As Erica Burman has shown, the figure of the child can be used in a discourse which attempts to break free of the past.[7] Benjamin's talks for children represent childhood as an encounter with culture and politics through investment in and engagement with culturally produced materials. Childhood is a time when culture is produced, so that children are part of culture and also transcend it because they are not yet fully integrated into it. While theories of the postmodern have claimed that the subject is withering away, the place of the child as a residual subject, or subject in formation, problematises the claim that there are no longer any subjects.[8] If the postmodern subject is split and deconstructed, the options which remain for subjects are either schizophrenic disintegration or regression, and each of these possibilities resonate with notions of childhood as a state of fragmented, unintegrated and originary subjectivity.

Lyotard's *Postmodern Explained to Children* has a significant relationship with his theories of narrative as the means to secure legitimacy. He claims that narrative 'secures mastery over time and therefore over life and death. Narrative is authority itself. It authorizes an infrangible we, outside of which there is only they'.[9] Lyotard regards all emancipatory narratives as tied to symbolic or physical violence. Nazism is a prime example, but any narrative will be prone to totalitarianism because of its totalising character, and for Lyotard the event of Auschwitz is both 'the crime opening postmodernity'[10] and 'a paradigmatic name for the tragic "incompletion" of modernity'.[11] Auschwitz is a rupture which

shows how the teleological, rational and technological narrative of modernity reaches the point of totalitarianism which was always implicit in it. In posing an alternative and positive reading of the event, Lyotard refers to Benjamin's writings on childhood, which he claims:

> do not describe events and inscribe childhood but capture the childhood of the event and inscribe what is uncapturable about it. And what makes the encounter with a word, smell, place, book or face into an event is not its newness compared to other 'events'. It is its very value as an initiation. You only learn this later.[12]

In a move characteristic of other aspects of his thought, childhood's value is retrospectively constructed. Childhood shields the event from its containment in narrative and the dead weight of customary thinking, and thus childhood represents the possibility of the production of the event. The child is the sign that events are what is not initially containable by the legitimating authority of narrative. He draws on the notion of the child as parallel to the unpresentable, parallel to the philosophical writing and thinking which is in a state of becoming:

> We write before knowing what to say and how to say it, and in order to find out, if possible. Philosophical writing is ahead of where it is supposed to be. Like a child, it is premature and insubstantial. We recommence, but we cannot rely on it getting to thought itself, there, at the end. For the thought is here, muddled up in the unthought, trying to sort out the impertinent babble of childhood.[13]

Lyotard's text consists of edited letters to individuals, none of whom are children. These are not elaborated philosophical and critical writings, and their relative simplicity and partiality repeats their subject, which is that childhood is uninhibited, a celebration of partial rather than totalising statements. Thus children also represent hope, and adults retain a portion of childlikeness which is a sign of this hope. He recommends that his addressee should

> bear witness to what really matters: the childhood of an encounter, the welcome extended to the marvel that (something)

is happening, the respect for the events. Don't forget, you were and are this yourself: the welcome marvel, the respected event, the childhood shared by your parents.[14]

The child is the marvel, and also experiences the world in terms of the marvellous and unexpected. However, this discursive construction of the child all too easily slips back into a liberal valuation of creative play and uninhibited freedom, and the risk of the text is that the child becomes a normative category, rather than the more fully realised social subject of Benjamin's discourse. But for both Benjamin and Lyotard, childhood can be described as a postmodern state of possibility. Benjamin addresses his discourse to children, enlightening them via a modern educative rhetoric presented on the relatively new medium of radio, with the underlying assumption that childhood as becoming represents a valued openness. Lyotard's text is about children rather than actually addressed to them, but invites its adult readers to become like children, and adduces childhood as a metaphor for the openness of philosophical work in a postmodern moment.

The homology between the figure of the child and the postmodern can also be followed through in Lyotard's *The Inhuman*,[15] as Dan Fleming[16] has pointed out, quoting Lyotard's questions:'what if human beings, in humanism's sense, were in the process of, constrained into, becoming inhuman...? And..., what if what is "proper" to humankind were to be inhabited by the inhuman?'.[17] Fleming argues that the inhuman in the human can be understood as the child, before its own development, and the postmodern capitalism which provides it with a place in culture, have processed it as human. The inhuman is also the postmodern technoculture which renders the human body and subjectivity inhuman, by entangling it and penetrating it. Thus one way of understanding the postmodern end of history and the end of the human is to read it as the end of the child, conceived as the origin of the human before culture intervenes. At the same time, the child as origin of the human is inhuman itself, because the child is not yet an adult subject, along the lines of the rational human subject of modernity. The figure of the child can be deployed discursively to deconstruct the notion of the subject, and can be connected to the technological media culture which similarly borders and challenges human subjectivity. To explore this issue further, I consider the

multinational industry of toy production, and the relations between the human body and the machine in toys, before discussing approaches to computer games and children.

PRODUCTION OF TOYS, PRODUCTION OF THE CHILD

While the design and the rights to toy designs are largely controlled by Western companies, much of the production of toys is done in China, specifically around the city of Guangzhou, in Guangdong Province where two enterprise zones have been established. Toys are mass-produced using low-paid labour, and transferred mainly on the Kowloon-Canton Railway to Hong Kong, where they are exported to Western markets. Sixty per cent of Hong Kong's annual toy exports, worth more than $3 billion, come from Chinese producers, and this trade accounts for about 80 per cent of the world's total toy business (excluding computer games).[18] The American Mattel and Hasbro corporations are the largest in the toy market, with a 30 per cent share of the $13 billion per year US market and 25 per cent of the UK market. While the dominance of large American corporations, and the export of work to Asian producers, seems like a post-colonial arrangement that could be called modern in character, particular features of the toy market produce an instability and unpredictability of production and consumption which can be called postmodern. Growth is unstable because of largely unpredictable crazes for toys, destabilising small companies and resulting in mergers and acquisitions, so that in 1996 Mattel-Fisher Price (owners of Barbie and Scrabble) launched a hostile $5.2 billion takeover bid for Hasbro (owners of Action Man, Cabbage Patch dolls and Monopoly).[19] However, the drive to maintain market dominance in the face of risk depends on massive investment, often tied to licensing agreements for toy spin-offs from film or television. Hasbro and Galoob, makers of toys for the first three *Star Wars* films, were engaged with Mattel in a bidding war for the character licensing rights to *Star Wars, Episode 1: The Phantom Menace* (1999) in 1998 when their original licence expired.[20] Mattel offered $1 billion for the rights over a ten-year period, hoping that one of the toys will become an enduring brand. Toys themselves are not the only source of income, for the last major licensing success, *Mighty Morphin' Power Rangers* (1992) was used in Britain by ninety companies to endorse 350 product lines.

The licensing of the first set of *Star Wars* toys was worth $500 million per year, and franchises to associate products with its characters were worth $1.5 billion per year.[21] But the commitment to produce *Star Wars* toys for at least six years represents a major risk for any toy company, even one as large as Mattel. The threat to economies of scale by ever-present risk, the interrelation of products in transmedia brands, and the global distribution of production and consumption, enable the toy industry to function as an example of postmodern commerce.

In relation to a particular toy, the move from a single white Western image of the feminine to a diversity of representations can also be cited as evidence of postmodern fragmentation and the relativisation of dominant ideologies. The Barbie doll was launched in 1959, with more than one billion dolls sold in the range, which remains the best-selling girl's brand with sales in 1997 exceeding $1.2 billion.[22] Early Barbies had blue eyes, gently arched eyebrows, and fair skin, matching contemporary images of American health and beauty, and her clothing and accessories represented an ideal middle-class suburban lifestyle. The first Barbie wore a swimsuit and high heels, with gold loop earrings, scarlet nails, and wingtipped sunglasses, in the image of a beauty queen. Other early costumes were titled Commuter Set, Cheerleader, Garden Party and Dinner at Eight Barbie, and in the early 1960s, dolls were sold wearing clothes inspired by the Paris fashion houses Dior, Balenciaga and Givenchy, with suitable hair styles. So although her hair is made in Japan, and the plastic resins for her vinyl body in Taiwan, Barbie's early history appears to provide evidence for an ideological critique of Americanisation and patriarchal values. From such a perspective, Barbie is an emblem of American middle-class suburban white culture, in which consumption, narcissism and display are clearly evident. However, Barbie is now sold in more than 140 countries worldwide, and many dolls in the range represent black or Hispanic women. Teresa is Barbie's Hispanic friend, and she also has a disabled friend called Becky who (unusually) has bendable legs so she can sit in a wheelchair. Mattel's *Girls' Toys '98* catalogue features black, Asian and Hispanic dolls, each with 'a unique remodelled face'[23] representing racial features and colouring, and similarly the Collectible range includes Chilean, Native American, Thai Barbies in national costumes with 'educational information'[24] about these countries or ethnic groups. Mattel's licensed version of Mulan, from the Disney film of

that name, enables 'the transformation of Mulan from a beautiful Chinese village girl into a Military trainee . . . through an outfit change and stylable hair'.[25] The sensitivity of both Mattel and Disney to feminist and postcolonial critiques, coupled with a desire to address a multicultural American and worldwide market, produces an uneasy but significant recognition of difference. The Barbie range becomes a possible example for a discourse on postmodern relativisation of racial and gender identities, while retaining and concealing the economic determinants of this process. I am not suggesting that this ethnic and cultural broadening of the Barbie range has done away with the ideological problems in its earlier history. But I regard the articulation of racial, national and gender difference in limited ways as the sign of an anxiety about the mastery over such differences. While the effort is still to subsume difference under the sign of Barbie, and to tolerate difference by expressing it in partial ways, the extension and fragmentation of the brand resonates with the extension and fragmentation of the toy market, of gender identities and of cultural hegemony.

However, Barbie's status as a set of objects processing versions of the feminine for the child must be read in relation to versions of the masculine, and I agree with Dan Fleming that masculinity is the central term around which various kinds of toy body and identity are constellated, a

> structure of meanings within which toys appear to 'test' the nature of male identity by pulling it first in one direction, then in another, in relation to animality or the machine, in relation to the aestheticised female or the orgiastic beast.[26]

Male identity relies on the Others of child, woman, machine and animal, and is always in danger of finding its centrality deferred and dispersed. Fleming argues that all toys can be disposed on a grid whose four axes are the Organic, Mechanical, Rigid and Non-Rigid.[27] A second set of poles represent ascetic, non-ascetic, orgiastic and non-orgiastic. These enable toys to embody features of contemporary culture, including the notions that mass-industrial society takes the organic and processes it mechanically, that children are desired to be ascetic but might be orgiastic, and that animals are orgiastic and machines are not. For Fleming, toys dramatise the unstable relations between these poles,

testing and blurring their limits. So machines (rigid, non-orgiastic) can simultaneously be animals (organic, orgiastic) in transformer toys, and mild-mannered teenagers like the heroes of children's television programmes (organic, ascetic, non-orgiastic) can become cyborgs (rigid, mechanical, non-ascetic). The same patterns can be found in, for example, *Star Trek: The Next Generation*, where Captain Picard is an ascetic human, Worf the orgiastic animal, and Data the machine, since here too a stable structure is subject to deferral and disturbance as the roles merge. The machine Data wishes to be human, Troi explores her 'animal' desire in a relationship with Worf, Picard becomes a cyborg when captured by the Borg. The child is therefore presented with objects and fictional characters which simultaneously dramatise the conflict between opposed desires, identity formations and conceptions of the world, and also bring these conflicting elements together. I have already argued in relation to the work of Benjamin and Lyotard that childhood is where culture is both produced but also opened to the possibility of difference, and that the postmodern is a term for this retrospective and prospective process. The links between the transformations of toys and the transformation of identities in *Star Trek: The Next Generation* show that the postmodern as mutation, confusion and multiplication of identities goes beyond toys and childhood into media culture more widely.

The model developed by Fleming can also be adduced to explain the functioning of non-Western toys and television which have successfully penetrated Western culture. Japanese television has since the 1960s developed animated and live action shows combining traditional Japanese martial arts themes with science fiction, drawing on imagery also apparent in *anime* (animated films) and *manga* (comics). The television series *Mighty Morphin Power Rangers* draws on elements from *Mobile Suit Gundam* (1979) a film and TV series where robots are armoured body suits for human fighters, and *Bubblegum Crisis* (1987) where four female warriors fight evil in post-apocalyptic Tokyo.[28] Mechanisation of the body has a very complex set of determinants and intertexts. Mechanisation is part of an adult world of mastery and control over technology, and is also associated with war, violence and the destruction of the environment. The cyborg bodies of toys are both a foregrounding mechanism for the aggression which machines seem to display, and also a fantasy of mastery over violence, fear and

destructiveness through the additional power over others and the world which technology provides. Hard external skins or body coverings relate to object-relations theory's explanation of behaviours connected to phantasies of protective armour, where the self is identified with this tough external layer protecting an inner self which suffers anxieties of fragmentation and vulnerability to catastrophic collapse. As Claudia Springer has discussed, the heightened physicality of cyborgs culminates in acts of violence, distancing it both from sexual activity and the passivity of being an object of erotic desire.[29] The violent destruction of the Other is a substitute for sexual activity, and externalises the feared dissolution of the self whose threat is represented by the feminine. Saban Entertainment, makers of *Power Rangers*, adapted it from the action TV series *Kyoryu Sentai Zyuranger* by inserting live action sequences filmed in the United States into the effects and model sequences of the Japanese series. The story features teenagers (helping the magician Zordon) who control robot fighting machines (Zords), set against the evil forces of the witch Repulsa and her five assistants (combinations of human, reptilian and mammalian characteristics). The fetishism of the Zord machines and the identically costumed male and female Rangers, suggest for Fleming that a masculine scopophilic look has been replaced by an ambiguously gendered one directed at machines.[30] For the child viewer, the stability of modern dominant ideologies of gender or the rational human has been displaced by a shifting set of determinants in which the inhuman and the machine take part in a destabilisation of gender, ascetic rationalism, and the subject-positions necessary to them. Going beyond simply American or Western children's cultures, and linking these to Asian examples, provides the possibility of extending arguments about postmodern slippages between human and inhuman, masculine subject-position and feminine subject-position, into a broader cultural frame.

TECHNOLOGIES OF PLAY

One of the problems in addressing the relationship of the child to computer games is the collapse of the child's subjectivity into the properties of a game narrative. The fragmented and intertextual character of games and children's television programming, can appear to produce a fragmented postmodern subjectivity. The drift of this

argument is to attribute determining effects to particular objects, games, or television programmes, whereas I want to suggest, as this chapter proceeds, that the postmodern is a term for representing the problematisation of determination on which such an argument rests. Marsha Kinder's work in *Playing with Power* tends to suffer from this problem, in attempting to describe the fluctuating relationship between stability (spectatorship) and flexibility (postmodern media consumption) in relation to the cognitive activity of the player of games and viewer of children's television.[31] Television depends on the combination and repetition of cultural forms and contents, Kinder argues, thus diminishing the relevance of theories of spectator positioning developed in film theory. The unstable systems of point of view, narrative form and identification in television, leave room for the methods of film theory in identifying the gaps and resistances in subject-positioning to be supplemented by work on more mobile forms of pleasure and activity. For Kinder, the role of the game-player is to construct sense out of a collection of diverse fragments of narrative, character, visual pleasure and intertextual relationship. She describes the alternation between a unifying spectatorship and a relatively unbounded movement between fragments of signifying material. Her discussion of video games emphasises the extended middle in the narratives of games, and the deferral of closure in favour of the negotiation of middle passages. This deferral of closure and of stabilised spectatorship, seems to match the proclamation that postmodern media culture is fragmentary, unclosed and not determined by the arrival at the end for the achievement of meaning. Similarly, identity becomes mobile and fluid, being composed on the basis of partial fragments. Kinder reads back the fragmentation and mobility of the player and the intertextual mobility of contemporary media culture into the narratives themselves, so that the player's fragmentary subjectivity and the transmedia flexibility of postmodern media culture become textual features. As Fleming notes:

> The price is a relocation of the 'player' inside the text as well; which reactivates the theories of subject-positioning that were applicable to cinematic texts and runs the risk of relocating the 'player' within those theories as merely a new variant.[32]

If this approach to children and computer games is inadequate because of its collapse of subjectivity and narrative into each other, a second possibility is offered by a cultural and sociological analysis.

As Valerie Walkerdine shows, work on the suggestibility of crowds in the late nineteenth century led the way toward the sciences of social psychology and the beginnings of the study of the media under the name of mass-communications research, now associated primarily with Theodor Adorno and the Frankfurt School.[33] One of the assumptions in this tradition was that the population were irrational and prone to shared reactions as a suggestible group. Questions of what children should watch, and the regulation of the products and technologies which deliver material to them, are parallel to and based on these discourses of control. The objective is to produce the masses, and later children, as rational civilised subjects, and similarly women and colonial peoples become the objects of this discourse in which difference is to be recuperated into the project of modernity. The mapping of developmental theories of childhood onto children's relationships with technology and onto anthropological and economic theories of cultural progress can thus assume the developmental superiority of children in the First World, accustomed to computers and technology, over the children of the technologically deprived Third World. The contrasting modes of discursive address to children's play with interactive technologies have their roots in this background, and can be broadly regarded as on the one hand, a utopian discourse in which the use of computers is the route toward the development of rational and civilised children, and on the other the characterisation of computer technologies as addictive, and productive of irrational and violent children. As sociological work on moral panics has shown, the status of the child is often that of a discursive marker which carries the load of an ideological conflict for adults. What is particularly relevant, in this approach, to my own argument is that computer games themselves are not determining of cultural effects, but that computer technology, the figure of the child, and the geopolitics of media culture each become discursive objects which are adduced in multiple and conflicting ways, demonstrating the problem of determination for which I think the word postmodern is a symptomatic and relevant term.

The politics of 'real' and 'virtual' space are also addressed by Walkerdine in relation to a history of the discourses of Modernity. She

argues that the natural environment and such public spaces as parks and playgrounds were thought to be the places for acculturation and learning by doing. The child would encounter concrete things and experiences, rather than being taught about them abstractly. But if public space is now regarded as dangerous and full of threats from adult abuse or environmental hazards, the interior space of the home and the virtual spaces of technology seem to offer alternative spaces where children play autonomously and in safety, and where they are engaged in rational processes. As Helen Cunningham's interviews of her younger sister and her sister's friends showed, computer games become a substitute for the pleasures of 'real' social space: 'Sarah: "Games are good to play when you're bored". Alison: "It's good to play [computer games] when it's raining or late [at night] and you can't go out"'.[34] This 'move to "bedroom culture"' was welcomed by many parents who were relieved that their children had taken up home-based activities rather than "hanging around" in the streets'.[35] Furthermore, the virtual representational space of video games is commonly presented as a 'new frontier', an exciting series of environments to be explored, a process intensified by the relative marginalisation of character and plot in contemporary games. Public space and its exploration is replaced by the spectacle of virtual spatial exploration in private space, where spatiality is represented like the narratives of colonising journeys to the New World at the beginning of the modern period. On one hand, the child thus becomes a discursive Other analogous to the colonised Other, and the economic and class Other of the rational discourse of control in modernity. On the other hand, the child is represented as the coloniser of virtual space, where knowledge and experience are gained by encounters mediated by media technology.

Walkerdine's research found that, in the opinions of adults, less privileged children were assumed to dominate 'real' public space, along with the irrational, violent and addictive behaviour with which they are stigmatised, thus constituting a threat to the evolving rational subject of modernity represented by middle-class children. Where less privileged children have access to computer technologies, they are claimed to be the children most likely to indulge excessively in solitary play, falling prey to addiction to mindless games and learning violent behaviour from them. Small-scale research by Walkerdine showed that both parents and children allude to the stereotype of the addicted

child, always stigmatising this child as other, and never being able to actually name a real individual with this problem. While popular media mythology claims that working-class children play games the most, and are least regulated and most addicted, it is middle-class children who have the most games and the latest games. Walkerdine found that both working-class and middle-class children are regulated in their game playing by their parents, most often by time constraints, and that in re-enacting the violence of computer games the children themselves stopped short of hurting anyone. For the children, the advantages of the games were that they gave them training in the management of anxiety and panic, and that the games allowed them to experiment with ordered and disordered behaviour in ways they could not in real life. Childhood and the play associated with it function as locations for struggles over the evaluation of media culture, with repeated efforts by adults to discriminate between positive and negative evaluations based on class, and theories of development and enculturation. In common with my own approach to children's media culture, Walkerdine is interested not only in the objects of play (toys, computer games, etc.) but also in the agencies of children and adults in relation to them, as expressed by their discourses about these objects and relations. But I am more concerned than Walkerdine seems to be with the question of how an analytical discourse deals with this shift from object to subject, from determination by an object to determination by a subject as agent, since I regard the postmodern as a way of describing and analysing these shifts.

What motivates both Kinder's and Walkerdine's analyses, despite their different approaches, is a claim for the progressive agency available to the child subject as player of games. In response to discourses associated with modernity, which construct the child as object, theories of the child in contemporary media culture reverse this approach by producing the child as subject. I would like to extend the debate on subjectivity and space by considering research on the SimCity 2000™ computer game, which models a virtual city administered by the player in the role of Mayor. The game was a sequel to the highly successful SimCity™ (1985), produced by Maxis software, and was released in 1993. It begins with a simple grid representing a rural landscape, and invites the user to build on this landscape, demolish, divide into zones and set up the infrastructure of a city, including roads, hospitals, tax

regimes and local by-laws. The 'success' of the user's city is measured by the willingness of a population, 'Sims', to come and inhabit it, and their views are expressed in a local newspaper, or by actions including parades or riots. While the game is structured to encourage growth and the geographical expansion of the city, alternative teleologies including ecological harmony and balance between the rich and the poor can also be pursued. The game represents public space as a resource for the creation of a relatively autonomous community, based on a consumer capitalist system, but a community whose physical and economic existence is fragile and rendered ultimately uncontrollable by the complex mathematical algorithms which underlie the game. Incidents like a plane crash or a fire will disturb the running of the city, and environmental disasters, or the arrival of an aggressive alien lifeform, may throw it into turmoil. While planning, management and the setting of goals suggest the utopianism of modernist architects and urbanists, the game's incorporation of mathematical rules mimicking natural growth, uneven development and chaotic change, resonate with postmodern unpredictability and contingency.

SimCity 2000™ is not only played by children, but it is an interesting case in which educational aims to produce the child as rational subject interact with the stigmatised forms of purposeless or violent play attributed to commercial children's culture, as Mitsuko Ito's research on children's use of the game shows.[36] Both SimCity™ and SimCity 2000™ were marketed as entertainment/educational products, eschewing the label of 'educational software' because of the perception that potential customers regarded educational software as unexciting. Ito studied child users of the game (aged between seven and thirteen) in a California after-school club, where children, assisted by undergraduate students, interact with each other and with computer technologies. The mix of subject-positions available in the game, in interacting with a student assistant, in being a member of the club, and in relation to a wider set of cultural values around cities, the environment, social status and success, results, Ito argues, in a child 'being drawn into a particular cultural nexus, a cyborg subject whose identity is partially, and at least momentarily, contingent on a coupling with a social and technical apparatus'.[37] In other words, Ito's research supports the argument that children's play with this computer game is a postmodern scenario in which subjectivity, technology and the multiple determinations of each

of these, question the use of the child as a discursive marker for the nostalgically desired pre-technological origin of the human. Ito's research, taking the form of ethnographic observation of play, belongs to a tradition of social science research which carries a legacy of instrumentality, where it might be used to master and improve educational software, or extra-curricular educational provision for example. But what Ito finds is instead a set of challenges to the notions of the child, play and learning on which such aims are based.

Ito observed (supporting work by Sherry Turkle),[38] that the computer apparatus and the design of the software structuring the game exerted their own fascination for some users. Furthermore, mastery of game was the most significant feature of the children's relationship to it. Taken together, the game and the computer on which it was played seemed to be producing a technologically adept subject. But another, competing mastery surprised Ito, which derived from the 'tangled webs of referentiality that might arise as much from other computational worlds as from newspapers or suburban life'.[39] In particular, children's pursuit of action and spectacle in the game (like the wanton destruction of the city, or invasions by the alien lifeform) showed how their knowledge of commercial action games bordered their use of SimCity 2000™, and persistently leaked into it. The after-school club in which Ito worked tried to combine the entertainment aspects of computer games with a socialising and educational project, but Ito's concern with the children's enthusiasm for destructive and irrational uses of the game demonstrates the ambiguous consequences of attributing a positive value to the subjective agency of children. While Ito values players of the game as 'cyborg subjects', with the resistance to both Romantic notions of the child and to technological determinism which this term implies, the Other of this process resurfaces in the portrayal of children as violent, irrational and susceptible to market forces. As soon as a notion of the child or of children's media culture is pinned down by a discourse which seems competent to master it, that object of analysis shifts elsewhere, repeating the impossibility of establishing borders (like those between child and machine) which Ito has noted. Children and children's media culture become retrospective constructions which, like the notion of the postmodern itself, stand for both possibility and a crisis of determination.

THE OBJECT AS AGENT: TOYS' BODIES

Just as the child is objectified by critical discourse, so are toys. Inasmuch as they are regarded by adults as objects which take part in a construction of childhood, toys can be regarded as signifiers of the child, as objects exchangeable with the imagined or desired qualities of the child, allowing nostalgia for a desired childhood to be figured by toys. Rather than children, therefore, it is toys which appear to have agency in the production of the child. The object of study in media culture, if it is a textual or material object, presents the problem of the determinacy of its significance, which is either an additive result of its surface characteristics, or of a depth analysis of its structural and economic position within culture, but in either case the object appears to possess an autonomous ability to carry meaning. In this section, I discuss the problem of determinacy of meaning of the toy as object, with particular attention to issues of gender, focusing on dolls representing the human figure.

The Action Man toy figure was introduced in 1966 in the form of three figures: soldier, sailor and pilot. Since then he has appeared in more than 350 incarnations of heroic masculine identities, mainly military ones, but also as a polar explorer, footballer, space ranger, or lifeguard, while his body shape has remained largely unchanged. Barbie was the first teenage fashion doll, and originally had joints only where her head, arms and legs join her body, though later Babies had more moveable joints. Judy Attfield has argued that: 'Charting the different types of joints incorporated into the design of Barbie and Action Man illustrates how the cliché of "feminine" as passive and "masculine" as active is literally embodied in the design of the toys'.[40] For Attfield, Barbie's joints are 'accessories to facilitate dressing, posing and the display of her various lifestyles. They were never designed at the expense of breaking the smooth contours of her legs or arms', but for Action Man, 'anatomical realism was abandoned by including an additional joint to the biceps in order to give maximum flexibility'.[41] In this kind of analysis, the material features of the object determine its meaning, but as I have argued, children's media culture demonstrates the problematic nature of such an approach. Children, toys and play are always to some extent distant from the critic analysing them, and function culturally in part because of this distance from adulthood and

its rational critiques. While the material form of the body of a toy is not blankly indeterminate, neither is it determining of that object's significance. Furthermore, the analysis by adults of toys as material objects neglects the possibility of children's relation to toys as precisely those objects which mark a difference from the evaluative terms of adult culture. Thus trashyness, tastelessness, or violence can become valued qualities in children's toys and uses of toys, since these characteristics are of what adults disapprove. Inasmuch as they concretise and express social meanings for children, toys are therefore available as totemic objects around which children's difference from adults can be organised.

But children's knowledge of and desire for particular toys is part of their socialisation into consumer culture, a mark of grown-upness which Ellen Seiter has argued 'signals a mastery of the principles of consumer culture, that is, the accurate perception by the child of a system of meaningful social categories embedded in commodities and sets of commodities'.[42] Consumption and the promotion of consumable objects creates a vast object-world for the child, but only some of these objects can be desirable because only some of them are comprehensible as desirable in the terms of the child's experience. One of the functions of toys is to provide a range of objects which can be meaningful and so provide a bridge to, and means of dealing with, the object world which surrounds children and the adults they will become. Inasmuch as toys signify childhood, they are available to be cited as determinants of what childhood is, from a critical perspective in which the meanings of toys can be specified as politically progressive or pernicious. But for children, the significance of toys may rest either on their assimilability into an adult world (of consumption, or gender identities) or on their difference or resistance to adulthood. Not only is there a problem of determination at the level of the toy as object, but also at the level of its relation to the cultures of adulthood and childhood. The fact that childhood is both an anterior prefiguration of adulthood and an other to it, as Benjamin and Lyotard's work suggested, means that toys and children represent, at the same time, boundaries, others, prefigurations, and confusions of the categories they are used discursively to produce. Returning to specific issues of gender determination in toys, this problem of adducing a property of the object as the precondition for a critical analysis can be pursued in relation to the problematic relationships between the sex differences of male and female toy figures and

the gender differences between them, where the body is elided into an indexical sign of a socialised gender identity deriving from cultural norms regarding the representation and meaning of bodies. In this analysis, the meaning of the object is repeatedly deferred and displaced.

Gender representations in toys have been the subject of debate from several points of view. Graham Dawson notes that: 'Since the 1930s, a movement for educational toys informed by psychoanalysis has criticised a general tendency towards increasingly representational toys. The argument goes that non-representational toys without a fixed form allow freer reign to the child's creative imagination . . .'.[43] Non-educationally marketed toys like Action Man (as opposed to Lego for instance) are seen as ineffective contributors to child development, or as negative in their passivity of enjoyment and their encouragement of anti-social activity.[44] From a feminist perspective (deploying educational and psychoanalytic approaches), strong gender differentiations in toys can be critiqued as valorising and perpetuating bad versions of gender-stereotyped identities, or less evaluatively as potentially functional in securing a child's identification with a gender identity through identifications. The negative discursive role of Action Man in discourses around children's culture mirrors the role of Rambo, for instance, in adult mass culture, and coverage of Michael Ryan's 1987 'massacre' in the English village of Hungerford used 'Rambo' as shorthand for him, at the same time as making connections with his childhood enthusiasm for war toys. From these various discursive positions, the adult is the product of the child, and the child is the product of the toy. Adult interventions in the representations of adulthood in toys are justified by the retrospective construction of the child as object produced by the toy. The toy becomes the object of a discourse in search of an agent which it can both locate and change. The human, represented by the adult, is argued to be the product of an inhuman determinant, a toy or type of toy. The inhumanity of this toy is meant first at the simple level that it is a non-living entity, a material object produced by manufacturing processes, and therefore appears to be resistant to rational control although it also calls for such control by the political and legislative means that can be exercised by rational human subjects. Second, the toy is inhuman in that it appears to pervert the human, turning the child who plays with it into a less than human adult, into a violent, immoral, irrational, but also infantile human. In the case of Michael

Ryan or Rambo, the inhuman human is specifically masculine, and inhumanity takes the form of an excessive masculinity.

Judith Butler has worked extensively on the body as a discursive object, arguing that sexual difference is not a function of bodily differences, for these differences are marked and formed by discourse. The discourse of sex demarcates and differentiates bodies; and 'is not a simple fact or static condition of the body, but a process whereby regulatory norms materialize "sex" and achieve this materialization through a forcible reiteration of those norms'.[45] The reiteration of norms signifies that the materialisation of sex is never complete, and that sexual organs will never be sufficient to stabilise sexed identity. The absence of a penis for both Action Man and Barbie is a recognition that the symbolisation of sex does not rest on its presence or absence, for the indeterminacy of Action Man's and Barbie's genital sex co-exists with the overdetermination of gender identity in other forms, and derives from the displacement of sex into gender. The ability of Action Man to function as a signifier of a male and masculine body comes not from his penis, but from the displacement of phallic symbolisation onto other attributes. Clothing, hair, colour choices, body shapes, or eye sizes in dolls are read, not as disguises or problems in relation to the sexed body, but as evidence which substitutes for the invisibility or lack of a distinguishing signifier of sex. Barbie and Action Man expose a relativity of gender, for outward appearance may express or disguise a body coded as either male or female, and the play roles of the dolls may also either contradict the clothes or fit them, and may either express or contradict the active-male and passive-female social roles expected of the sexes. The gendered and sexed identities of toys, like the figure of the child in the various discourses of culture and the cultures of theory, become subject to the surprising and contradictory displacements for which the postmodern is a suitable term.

Recognising a sex and a gender involves both identification, where the discourse of sexual difference enables some identifications and not others, and abjection, where some bodies form the constitutive outside which borders the domain of the subject. The zone of abjection incorporates those who are not subjects, but who provide:

that site of dreadful identification against which – and by virtue of which – the domain of the subject will circumscribe it own claim to

autonomy and to life. In this sense, then, the subject is constituted through the force of exclusion and abjection, one which produces a constitutive outside to the subject, an abjected outside, which is, after all, 'inside' the subject as its own founding assumption.[46]

This abject being, repudiated as the other which guarantees gendered subjectivity, is created when children de-humanise the bodies of toys, de-sexing and de-gendering them. The abject toy's body is no longer a representation, thus opposite to the conventional role of dolls to simulate subjects available for identification, and to frame gender identities. But toys' bodies are sexed and gendered bodies both by virtue of their ability to symbolise, and by their 'negative' ability to become abject, since each function is necessary to the system of symbolisation. In Freudian theory, identification is not only an imitative activity involving one subject and another, but also the process by which an ego first emerges and establishes the sexed body. In Lacan's account of the mirror stage, the ego is first a bodily projection, an imaginary morphology. As a projection, the body is not only a source from which projection issues, but is also a thing in the world which is estranged from the subject, and thus substitutable with the bodies of Action Man or Barbie. Projective desires and anxieties can be attached and displaced on to the doll, producing the toy's body as an other with which to identify, and producing the child's body as already other to itself. So far from the toy being a determinant, with material properties which determine its effects on the culture of childhood, the toy and the child are the locations of a series of displacements. Sex, like gender, becomes a cultural construct, and both sex and gender are changing norms by which Action Man and Barbie are imaginable as subjects in play, with bodies which qualify them for multiple intelligible roles. Judith Butler has argued this position in relation to human bodies, but inasmuch as toys signify human bodies, the material appearance of the toy's body is open to her critique of its originary sexed identity. The production of the body as sexed, and the production of the child as the determinant of the adult, are both determined by a discourse which establishes the extra-discursive in order to then bring it into discourse. This is a retrospective construction which produces the body, child, toy, object and agent, as the condition of its own discursive effectivity and purchase. But as I argued above in relation to the

deployment of the child in Benjamin's and Lyotard's writing, this leaves the body and the child as the inhuman, which both come before adult subjective agency, and also inhabit it as the sign of its own possibility. Body, child and toy occupy the same discursive position as the postmodern, with the same problems of identifying the determining properties which establish the postmodern as either that which is not yet determined, or that which marks an impossibility of determination.

The child is both an object and a subject in postmodern media culture and in the theoretical work which adduces and addresses him or her. Because the child is regarded as that which comes before the adult, and which either determines adult subjectivity or offers a legacy in adulthood which can be claimed as other to a norm, he or she is of interest to political and social theories which describe and promote particular understandings of media culture. And because children's media culture, in toys, television and computer games, seems to present a case study of the globalisation, consumer capitalist organisation and confusions of identity, ideology and gender which are claimed as hallmarks of the postmodern, children's media culture also seems to anticipate and model postmodern media culture in general. I have argued in this chapter that discourse on children's media culture, in both theory and media culture itself, exhibits a problem of determination. Determining instances include textual positioning by an object, relational dynamics between adult and child, and between an object and other objects or texts, and the totemic evocation of power structures like gender relations and consumerism. This complex of determinations, in which the child and his or her media culture are adduced by discourse, shares the properties and problems of critique, judgement and politics which I have outlined in earlier chapters. But the figure of the child has the special problem of determinacy which derives from childhood's ambiguous bordering relation to the human, the rational and the adult, whose concerns are retrospectively projected onto the child as an object of discourse.

NOTES

1. For a more nuanced discussion of the concept of the child, see Karín Lesnik-Oberstein, 'Childhood and Textuality: Culture, History, Literature', in Karín Lesnik-Oberstein (ed.), *Children in Culture: Approaches to Childhood* (Basingstoke: Macmillan, 1998), pp. 1–28.

2. Judith Butler, *Bodies that Matter: On the Discursive Limits of Sex* (London: Routledge, 1993), p. 11.

3. Jean-François Lyotard, *The Postmodern Explained to Children: Correspondence 1982–1985*, trans. D. Barry, B. Maher, J. Pefanis, V. Spate and M. Thomas (London: Turnaround, 1992).

4. Jean-François Lyotard, 'Answering the Question: What is Postmodernism?', in Thomas Docherty (ed.), *Postmodernism: A Reader* (Hemel Hempstead: Harvester Wheatsheaf, 1993), p. 44.

5. Walter Benjamin, *Illuminations*, ed. H. Arendt, trans. H. Zohn (New York: Schocken Books, 1969), p. 259.

6. Roland Barthes, *Mythologies*, trans. A. Lavers (London: Granada, 1973), p. 54.

7. Erica Burman, 'The Pedagogics of Post/Modernity: the Address to the Child as Political Subject and Object', in Lesnik-Oberstein, *Children in Culture*, pp. 55–88.

8. See Erica Burman, 'Developmental Psychology and the Postmodern Child', in Joe Docherty, Edward Graham, and Mhemooda Malek (eds), *Postmodernism and the Social Sciences* (Basingstoke: Mamillan, 1992), pp. 95–110.

9. Lyotard, *Postmodern Explained to Children*, p. 44.

10. Ibid., p. 31.

11. Ibid., p. 30.

12. Ibid., p. 106.

13. Ibid., p. 119.

14. Ibid., p. 112.

15. Jean-François Lyotard, *The Inhuman*, trans. G. Bennington (Cambridge: Polity, 1991).

16. Dan Fleming, *Powerplay: Toys as Popular Culture* (Manchester: Manchester University Press, 1996), p. 194.

17. Lyotard, *The Inhuman*, p. 2.

18. On the international economics of the toy industry, see Fleming *Powerplay*, pp. 110–12.

19. Nigel Cope, 'Barbie eyes up Action Man in Toytown battle', *The Independent*, 26 January 1996, p. 6.

20. Mark Tran, 'Toy soldiers vie for Star Wars', *The Guardian*, 26 August 1997, p. 15.

21. Graham Dawson, 'War Toys', in Gary Day (ed.), *Readings in Popular Culture: Trivial Pursuits?* (Basingstoke: Macmillan, 1989), pp. 104–5.

22. I am grateful to Judith Stonebanks for providing me with the Barbie Information Pack produced by Mattel. Factual information here is taken from this source, and from Dea Birkett, 'I'm Barbie, buy me', *The Guardian*, Weekend section, 28 November 1998, pp. 13–19.

23. Mattel UK Ltd., *Girls' Toys '98* (Maidenhead: Mattel, 1998), p. 5.
24. Ibid., p. 30.
25. Ibid., p. 44.
26. Fleming, *Powerplay*, pp. 50–1.
27. Ibid., pp. 158–61.
28. Ibid., pp. 19–20.
29. Claudia Springer, 'The Pleasure of the Interface', *Screen* 32: 3 (1991), pp. 303–23. Springer draws on Klaus Theweleit, *Male Fantasies*, vol. 1 and 2 (Minneapolis: University of Minnesota Press, 1987, 1989).
30. Fleming, *Powerplay*, p. 24.
31. Marsha Kinder, *Playing with Power in Movies, Television and Video Games* (Berkeley: University of California Press, 1991).
32. Fleming, *Powerplay*, p. 172.
33. Valerie Walkerdine, 'Children in Cyberspace: A New Frontier?', in Lesnik-Oberstein, *Children in Culture*, pp. 231–47.
34. Helen Cunningham, 'Moral Kombat and Computer Game Girls', in Cary Bazalgette and David Buckingham (eds), *In Front of the Children: Screen Entertainment and Young Audiences* (London: BFI, 1995) p. 193.
35. Ibid., p. 194.
36. Mitsuko Ito, 'Inhabiting Multiple Worlds: Making Sense of SimCity 2000™ in the Fifth Dimension', in Robbie Davis-Floyd and Joseph Dumit (eds), *Cyborg Babies: From Techno-Sex to Techno-Tots* (London: Routledge, 1998), pp. 301–16.
37. Ibid., p. 307.
38. Sherry Turkle, *The Second Self: Computers and the Human Spirit* (New York: Touchstone, 1984).
39. Ito, 'Inhabiting Multiple Worlds', p. 314.
40. Judy Attfield, 'Barbie and Action Man: Adult Toys for Girls and Boys, 1959–93', in Pat Kirkham (ed.), *The Gendered Object* (Manchester: Manchester University Press, 1996), p. 85.
41. Ibid.
42. Ellen Seiter, *Sold Separately: Parents and Children in Consumer Culture* (New Brunswick: Rutgers University Press, 1993), p. 205.
43. Dawson, 'War Toys', pp. 98–9.
44. I have discussed the many possible interpretations of Action Man toys in Jonathan Bignell, '"Get Ready For Action!": Reading Action Man Toys', in Tony Watkins and Dudley Jones (eds), '*A Necessary Fantasy?': The Heroic Figure in Children's Popular Culture* (New York: Garland, forthcoming).
45. Butler, *Bodies that Matter*, p. 2.
46. Ibid., p. 3.

5

NEWS MEDIA AND THE POSTMODERN

———— ◦⊂⊃ ————

Theories of the postmodern have made much of the absorption of
events by representational technologies, and the ways in which rep-
resentational technologies have themselves produced or determined
events. An example commonly used in these arguments, and whose
function as an example will be assessed in this chapter, is the photo-
graphic and television coverage of the Gulf War. This chapter will debate
the relations between media images and the real, and the status of a
media news event posed in critical writing on the postmodern. As well
as discussing the theoretical discourses which refer to these issues, the
chapter will make use of some of the empirical research on media
audiences for news coverage, and refer to claims for the supposed effects
of media coverage. Counterposing theoretical discourses and empirical
research will allow a discussion of the problems of representing evidence
and justifying argumentation which have been considered throughout
this book, with the special focus which the deployment of the photo-
graphic image as an evidential object can provide. There are a number
of news events covered by contemporary media which can be cited as
evidence for a postmodern news media culture. The characteristics
which such events require in order to function discursively as examples
in this discourse include their simultaneous or near-simultaneous
dissemination transnationally, their reliance on a certain reflexivity
where the media event draws on codes of news value established
already in news coverage, the preponderance of global or transnational
media networks in disseminating the news, and the significance of
visual images (most often moving video images) as the centre of the
coverage.

PHOTOGRAPHY, THE POSTMODERN AND EVIDENCE

The evidential status of the photographic image is one of the primary foundations of news discourse. In theories of modernity, the circulation of the image object, and its separation from the specifics of its social production, provide the basis for the citation of the photograph as a media object appropriate to mass society. Benjamin argued that photography and cinema as mechanical reproduction processes substituted 'a plurality of copies for a unique existence'.[1] Though the copies are not fakes and do not replace an original by counterfeit, they are the result of a mechanical process remote from the physical body of their producer. With the use of serial mechanical mass production, the copies can be distributed widely to different places, and can be seen at the same time by a diverse audience. The tendency of serial mechanical reproduction is to free the image-object from its social, class and historical determination by institutions like the church or the state and from control by elite groups like the aristocracy as patrons, owners and audiences for unique artworks. The object's interpretation is not controlled by these determining contexts and social relations, and it can be compared with other objects in the same space and time. Three of the effects of this way of addressing photography are that the photograph seems to float free of its determinations, to circulate in culture as a commodity, and to become separated from the subjects which have been photographed despite the iconic relationship between those subjects and the photograph itself. Each of these factors has a different force according to the social uses to which photography is put. For instance, art photography has played with these questions in the use of photomontages by modernist producers, both to critique photography's iconism, and also to attempt to surpass photographic versions of the real by enhancing, manipulating and juxtaposing photographic images in order to achieve a more 'accurate' rendering of the real. In relation to journalistic photography and photography in military culture, however, the iconism of photographs, the institutional forms of their circulation, and the controls on the production and dissemination of photographs are perhaps the most significant features. Arguments about representations of the Gulf War as a postmodern 'media war' certainly revolve around these issues, but they are not in themselves recent issues of debate.

Paul Virilio and his co-authors argued that the photographic image has been associated since its invention with military power and surveillance, with vision being used as a weapon.[2] While the first use of this technology was in placing camera operators in balloons to gain an image of the disposition of enemy troops and defensive positions, modern uses of satellite surveillance technologies, remote sensing, and the enhancement of images by computer programmes, together with communications networks for their transmission, continue the aim to provide a transcendent point of view, in spatial terms and in exactitude beyond the capacity of the human eye. Battlefield photography was used as long ago as the Crimean War, the American Civil War and the First World War, either for explicit military purposes or to provide propaganda and journalistic images. As John Taylor has shown in an analysis of war photography, photographic iconism is subject to the paradox that the dissemination of photographs appeals to a discourse of adequacy to the real, of evidence, while on the other hand the control over that dissemination is exercised both by the institutions which allow or withhold access to the pro-photographic event, and by photographers themselves.[3] In the Gulf War, pool arrangements were used to align the reporters with military personnel in a friendly way, initiating them into army culture.[4] The British pools were called Media Response Teams (MRTs), where in exchange for signing declarations to be subject to military discipline and to follow rules and restrictions on reporting, journalists were provided with transmission facilities so that reports could be filed to London in less than an hour. Real-time news reports were common on CNN, most famously those of Peter Arnett in Baghdad who was equipped with a portable satellite transmitter, and these reports were subsequently used by terrestrial broadcasters, with the time between producing a report and its availability in a newsroom being as short as twenty minutes using satellite transmission. Images of air attacks on Baghdad, for instance, were therefore potentially available almost worldwide, since the zones of reception or 'footprints' of satellites now cover 85 per cent of the world. In the land war, Forward Transmission Units (FTUs) were set up so that journalists could be close to action and report it back to their home newsrooms. Photographic images and information were thus controlled institutionally, partly by the restriction of access to transmission facilities.

The digitisation of images for transmission by electronic networks is

not only an issue of institutional control, but also poses a potential challenge to the iconic realism of the photograph as material object. The dissemination of images in digital form is an extension of the process of unfixing the image from its referent, its maker, and its material and cultural determinants. As Guy Debord argues, consumer society involves the rendering of the real and its space-time as a commodity, and photography can be argued to rest on this principle of circulation and simulation, with a rhetoric of objectivity suitable to a society of objects.[5] This argument is based on analogy. The fixed object-like photograph which is circulated for sale is analogous to the hegemonic, industrial, alienated society of modernity, while the fragmented, globally circulating, interactive and indeterminately material digital image is analogous to the fragmented global and media-saturated society of postmodernity. Photography in the work of Benjamin is associated with the age of mechanical reproduction, so that digital images may be seen as an extension of this era or as the opening of new post-photographic era. I would argue that it is much more the case that continuities between modern photography and postmodern digital images can be observed.

An early exploration of digitisation as a challenge to photography was in the exhibition and accompanying catalogue at The Photographers' Gallery in London in 1991 called 'PhotoVideo: Photography in the Age of the Computer'.[6] The book argued that the changes involved were: shifting the location of photographic making from the darkroom to the computer; the new ability to produce originals in electronic screen versions as well as hardcopy, transparency and print; the increased ease of manipulating images electronically; the transmission of images as electronic units of data along phone cables into the global communications system; the accelerated speed of transmission of images, and their movement beyond national and geographical boundaries; the digitisation of existing photographs into electronic data which can be stored and accessed remotely; the use of network technology and access to digitised images to make surveillance and military control easier; and the convergence of still photographic images with moving images, audio, graphics, and interactive systems. Both Jonathan Crary[7] and William Mitchell[8] assigned a determinism to the technologies of digitisation and argued that the 1990s represented a moment of rupture parallel to the rupture of the 1830s when photography arrived

to challenge painting. The industrial, scientific and journalistic applications of photography in the nineteenth and early twentieth centuries are argued to stabilise subjective identities in relation to the real, producing and simultaneously suturing up the distinction between the self and other in a manner which seems to provide a Cartesian certainty about their relations to each other. Empiricism, positivist science and the disciplines allied to these approaches like physics, anthropology, astronomy and biology drew on photographic representation as proof and evidence. This claim of a rupture is counter to the arguments of Virilio and his co-authors, and has also been disputed and historicised by Martin Lister and other contributors to his collection of essays,[9] and by Carolyn Marvin,[10] while anti-technologically determined accounts of audio-visual technologies have also been elaborated for film and television by William Boddy,[11] and for the computer by Darley for example.[12] New technologies do affect the realist claims of photography, although this can be overstated. The pixellation of photographic images, and the grain of video (which is recorded electronically on to a magnetic analogue medium) can connote immediacy and the real (as in surveillance video footage or the 1999 film *The Blair Witch Project*) in the same way as the visibility of photographic grain produced by chemical recording in photography. The primary difference between the truth-claim effect of photography and electronic images is not their visual appearance but the simulation of photo-realism which new technological images can provide, borrowing the truth-claim of photography's immediacy, and simultaneity in time and space of the person who took it and the event being recorded. This simulation appears to run counter to photographic iconism because of the materiality of the production of photographs.

Photographic grain, which is inseparable from the paper on which it is carried, is an iconic sign and material trace of the object photographed. However, the chemical base of the image, which is produced industrially in the absence of the person taking the photograph, does not allow direct intervention in the recording of the image. This separation of the production of the registering material from the activity of registering the image by exposing the chemical surface, is the absence which guarantees photography's apparent claim to truth. In digital images, transcription is substituted by conversion into numerical values and thus digital data. The differences in tone and colour on the photograph

are produced by variations in a continuous spectrum of differences, whereas digital images are produced by the division of the visual field into delimited units which are then converted. Whereas photographs are dependent on a specific technology, set of skills and history of practices, digital images are equivalent in form to other digital information, and can co-exist with, and be converted or transposed into another digital form. As with all technologies, while differences in transmission and technology are significant, it is more important to consider the conceptualisation of technologies in particular forms of discourse, and the uses to which the technologies are put. There are continuities with older forms of photographic culture as well as differences. One of the differences is the celebration of the polysemy of the new digital image in contrast to an assumed stability of meaning in traditional forms of photography, mainly because of the interactivity and intervention enabled for its users. But Robins and Lister argue, for example, that to assume photography as a neutral origin from which digital culture departs means that the ideological factors constraining the practice and viewing of photography are forgotten, yet these ideological limits were the result of a long and complex history and have a politics of representation.[13] Furthermore, photography is not dead, and its continuing power and widespread use would be neglected if the digital were considered to have replaced it. Photographs have been mediated and disseminated in graphic and written media almost since their inception, with a notable example being newspaper photographs. Transmission of photographs electrically was invented in 1903 and used since the early years of the twentieth century, so that convergence and transmission are not new to digital culture. Claiming digital photography as a postmodern form in this way depends on a dehistoricising and technologically determinist discourse.

In socio-cultural terms, Benjamin saw photography and cinema as appropriate representational forms for the urban industrial culture of the turn of the century. Since for Benjamin the city is characterised by speed, change and fragmentation, due to the effects of transportation systems, production line industrialisation and the separation of work from leisure in consumer culture, the cinema enables a contemplation of this kind of life experience by virtue of its rapid alternation of points of view, juxtapositions of images, and speed of narrative movement as part of a leisure experience. Similarly, photography enables the accurate recording of great amounts of detail and the facticity of a

multitude of objects or people, can be used in places where the human eye cannot or would not normally go, and can record movement too rapid for the eye to perceive. Therefore he suggested that photographic technologies enable the retrieval of an optical unconscious parallel to the discovery of a psychic unconscious, discovered at a roughly similar period. Fredric Jameson too, explicitly following Benjamin's argument, suggests that the new urban space of postmodernity (exemplified in hotels and malls) is running ahead of the social means to apprehend it visually, for he regards the urban *flâneurie* of the modern city to be reconfigured and changed by the urban spaces of the present.[14] The photographic image therefore simultaneously claims the status of a representation of the real, but in Jameson's and others' arguments, also suffers from a postmodern alienation from the spaces and cultural experiences which it continues to claim to represent. Thus the characterisation of postindustrial society by Daniel Bell[15] as a culture shaped by intellectual technology and based on information processing and information services would support the characterisation of news media culture as postmodern, because of the importance to both studies of the anxious acceleration of technologies and institutions of representation, based on the photograph, which attempt and fail to represent this culture to itself.

For Jean-François Lyotard, photography, like cinema, is not postmodern, but is instead a continuation of the principles of capitalist modernity. Referring to Benjamin, Lyotard asserts that:

Photography did not appear as a challenge to painting from the outside, any more than industrial cinema did to narrative literature. The former was only putting the final touch to the program of ordering the visible elaborated by the quattrocento; while the latter was the last step in rounding off diachronies as organic wholes, which had been the ideal of the great novels of education since the eighteenth century.[16]

What marks the difference between an era of media culture based on photographic representation and its antecedents is instead the acceleration of the circulation of representations:

The challenge lay essentially in that photographic and cinematographic processes can accomplish better, faster, and with a

circulation a hundred thousand times larger than narrative or pictorial realism, the task which academicism had assigned to realism: to preserve various consciousnesses from doubt.[17]

The preservation from doubt relies on the principles of adequacy to the real according to codes of resemblance which precede modern and postmodern epistemes, and has the objective of stabilising subjective identity in relation to the image object, which is itself stable as the other thing against which this relation can be established.

It remains therefore to explain the motivations for a discourse which asserts the death of photographic analogism, and proclaims a rupture between the modern photograph and the postmodern digital image. Sarah Kember argues that the claim for the death of photography as a privileged form for representing the real is 'technologically deterministic and masks a more fundamental fear about the status of the self or the subject of photography, and about the way in which the subject uses photography to understand the world and intervene in it'.[18] Referring to three uses of digital technology to change the appearance of photographs, she argues against Fred Richin's claim[19] that the viewer is now forced to doubt the realism of any photograph. Kember argues that the shaking of photography's claim to a truth of the visible is in fact a sign of an anxiety about the gendered control of the visible by the power and knowledge which photographers have held. Twenty years ago, Susan Sontag claimed that photography 'is mainly a social rite, a defence against anxiety, and a tool of power', so that, for example, family photographs secure the continuity of family life, and tourist photographs enable the subject to take symbolic control over a space in which he or she is insecure.[20] In relation to the photograph's status as material object, the collectibility of photographs as objects provide an imaginary mastery over time, over an 'unreal' past. Extending her argument that the image is a mark of loss and anxiety, Kember also refers to the use of chemical and digital photographs in the police EFIT (Electronic Facial Identification Technique), where the temporal moment when a face was seen by a witness is reconstituted via the procedures of the digital process, compensating and standing in for both the absence of the criminal, and the evanescence of the eyewitness' visual memory. In her discussion of medical imaging, Kember argues that the exposure of the internal space of the

body in images is a kind of science-fictional spectacle which appears to maintain control over the physical body and the anxieties around it as the other to representation. Recalling the association of photography with nineteenth-century medical studies of the socially marginalised (with special attention to women), Kember argues that the photographic and the digital continue a masculine desire to control the female body in relation to the 'mysteries' of reproduction and sexuality, since in the imaging practices of assisted reproduction the mother's body is either absent from view (producing a relationship between foetus and doctor from which she is excluded) or becomes an object of medico-technical intervention from a voyeuristic and fetishising perspective which derives from masculine lack and fear. Culturally therefore, photography is marked by spatial and temporal displacements, and a politics of the body, which are common to arguments for placing photography as both a modern and a postmodern medium.

There were very few photographic images of dead bodies, either of civilians, the coalition soldiers or the Iraqi army in the Gulf War. John Taylor suggests that the function of photography in the Gulf War was not to provide knowledge or information about the conflict's material effects or the experience of fighting in it,[21] but to support the conspiratorial and hegemonic organisation of public opinion by the Western states, whose elaborate and systematic disinformation and propaganda campaigns are detailed by Douglas Kellner.[22] One of the few examples of a photograph whose iconism challenged the myth of the Gulf War as a 'clean' conflict was a photograph of the charred body of an Iraqi soldier leaning through the windscreen of a burned-out vehicle, in the aftermath of the massacre of retreating Iraqi troops at Mutlah Gap on the Basra road in February 1991. This photograph, by Kenneth Jarecke, was available to British and American newspapers on Sunday 3rd March, but was published only by the *Observer* newspaper in Britain under the caption 'The real face of war'. The caption draws attention to both the iconism of the photograph (its 'real' evidential quality), and the visceral bodiliness of the anonymous man's blackened flesh. The managing editor of *Life* magazine, Jim Gaines, planned to use the photograph, but withdrew it 'in deference to children', and in Britain a debate in newspapers ensued over the propriety of using it.[23] The traumatic denotative realism of the photograph was the crux of this debate, reflecting the critical tradition since Roland

Barthes of counterposing the seemingly uncoded realism of photography with the coding of photography by pictorial conventions and the narrative containment of its meaning by captions and text.[24] The association of photography with anxiety and trauma around the representation of the body which was noted by Kember is clearly appropriate here, for the bodiliness of the Gulf War, or more accurately the concealment of bodily harm in media coverage of the war, relates directly to questions of iconism, materiality, transmission and institutional control. In the following section, in a discussion of institutional factors in contemporary news media culture, the characterisation of the Gulf War as a media war and therefore a postmodern war, begins from the assumption that bodiliness and materiality, in war fighting and in media representations of war, are the factors which postmodern theorisations of the conflict revolve around. The absence of the body, and of the materiality characteristic of photography before digitisation, emerge as the negations which determine the possibility of naming the Gulf War as postmodern.

MEDIA INSTITUTIONS AND PHOTOGRAPHIC TRUTH

The Gulf War of 1991 made much use of miniature cameras on the nosecones of smart bombs, satellite photographs and air reconnaissance images, often from unmanned aircraft. The pilots of Western aircraft saw their targets displayed on screens akin to those of computer combat strategy games, and bombs were guided with reference to real-time video images taken from inside them. Thus Virilio characterised the war as one both fought by means of electronic imaging, and also as a war experienced through the electronic imaging relayed to commanders and the world TV audience.[25] In an earlier work, Virilio uses the mathematical term 'vector' to describe the transmission of information at high speed, to the extent that the speed of information flow (or indeed the speed of travel of a modern weapon like a missile) exceeds the capacity of human consciousness to understand it: 'The measure of extension and of movement is now almost exclusively that of a technical vector, a mode of communication or telecommunication that desynchronises the time from the space of the passage'.[26] While this reconceptualisation of information exchange tallies with versions of the postmodern as a reconfiguration of time and space in regard to

information, it does not engage substantially with questions of the difference in the value and meaning of information in different contexts and for different audiences, an issue which I discuss below. Nevertheless, this analysis does draw attention to the circulation of digitised video images, in the case of the Gulf War, for example, in the creation of a mediascape where the apparent presence of the sights of war substitutes for the kind of visceral and bodily iconicity represented by the Jarecke photograph.

It is the absence which underlay the ubiquitous presence of media images of the Gulf War which motivated Jean Baudrillard's well-known writings on the Gulf War as the war that did not take place. In his first article in January 1991, while the build-up to the war was escalating, Baudrillard discussed the non-declaration of war and the non-engagement of troops as a form of deterrence of war, a form of anti-war which substituted for conflict itself.[27] When the war had begun, he regarded the media representation of the war as a substitute for war, while war was the province of the commentators who argued over the actual form of the war's reality:

> The true belligerents are those who thrive on the ideology of the truth of this war, despite the fact that the war itself exerts its ravages on another level, through faking, through hyperreality, the simulacrum, through all those strategies of psychological deterrence that make play with facts and images, with the precession of the virtual over the real, of virtual time over real time, and the inexorable confusion between the two.[28]

While one understandable response to this argument was Christopher Norris' riposte detailing the facts and figures of death and destruction which 'really' took place, this critique does not engage with Baudrillard's contention that the effect of telecommunicated imagery of war was to render the war itself a virtual and mediated representation.[29] As Virilio has argued, the liveness of war coverage was one of its most striking features, but while liveness connotes both immediacy and realism, and borrows the iconicity of photographic representation, this ontology of liveness in the reports from the allied war-room, live television discussion by experts on the progress of the war, and live CNN coverage of action in Baghdad, does not produce the facticity or truth whose loss

Baudrillard diagnosed. The situation described by Baudrillard relies on two presuppositions. One of these is the abstraction and generalisation of the television audience, which I discuss below. The other is the geographical and cultural specificity of the media coverage being discussed, which refers to the media of Western nations, especially Western Europe and the United States. In this context, the postmodern character of the Gulf War joins the postmodern character of any event which is disseminated in the West and then re-represented from that Western perspective.

John Thompson argues that modernity reorganises time, space and social agency, and that the mass media are crucial to this process.[30] Material production, social control and cultural activity can be acted out independently of local times and space. The division of labour is globalised and relativised in time and space by communications and transport, computers centralise the administration of organisations and institutions away from their local base, and television enables the seeing of the same events in many different places and local time zones. Such an analysis provides the possibility of arguing, as Anne Friedberg does, that: 'The boundaries of space and time which were so dramatically challenged by "modernity" have been, again, radically transformed'.[31] Friedberg comes close to a determinist position by asking her reader to consider:

> the fax-machine-fuelled 'prodemocracy movement' in China; the 'CNN war' in the Persian Gulf; microwave TV signals carrying images of comfortable lifestyles and abundant consumer goods into the meagerly-stocked households of East Germany and the Eastern bloc; satellite beams bringing MTV and the vivid boons of the capitalist West into the fraying economy of the Soviet Union.[32]

There may indeed be politically progressive effects in these examples, but these conflicts seem to have been intensified through the influence of transnational news media culture. The unequal valuation of news sources, and their connotations for the most voracious news consumers in the West, place serious obstacles in the way of positive valuation of transnational news exchange as the basis for international political culture. The proclamation that the Gulf War was a media simulation is discursively significant because it depends on the

acceptance of the institutional situation of the Western media, where the media is generally complicit with hegemonic perspectives on events outside the First World (but also within it), and where interrelations between national broadcasters contain and exchange news images and information in a 'closed circuit' among themselves. In television news, footage of news events is made available to world broadcasters by transnational news agencies like Eurovision and Asiavision, and is accessed by British news broadcasters through the European Broadcasting Union (EBU). Broadcasters request film of news events, passed six times a day between Eurovision and Asiavision, for example, in regularly scheduled windows of about thirty minutes. Individual broadcasting institutions also have arrangements with particular news organisations in other countries, from whom they can request material (for instance BBC has a close relationship with the ABC network in the USA). One of the effects of this arrangement however is that it tends to increase the association of foreign stories with disasters and bad news.

As Rey Chow has shown, in a discussion of video news imagery of the Tiananmen Square massacre, the notion of the real as the raw and violent referent of political news material, tends to be displaced to the Third World by virtue of the accessibility of images in transnational image exchange networks.[33] Studies of TV news content, as Klaus Bruhn Jensen explains, 'have identified imbalances in terms of the regions and topics covered together with an underlying set of criteria for "news" which may hold limited relevance for the countries and audiences that are the end users of the information',[34] on the basis of large-scale quantitative comparative information, like a 1985 UNESCO study of twenty-nine countries.[35] This identified that news coverage is regional, covering events in neighbouring countries, that the US and other Western powers seem to 'make' news events, that news events of 'spectacular and singular happenings' dominate the news for short periods, and that the developing world provided these flareups of trouble while being little covered the rest of the time.[36] News flows thus replicate the flows of capital and resources between First and Third Worlds, and the characterisation of the Gulf War as a postmodern media event rests on an acceptance of the media culture of the Western allied nations as the example and the model for everywhere else.

AUDIENCES

The use of the audience as a legitimating instance for state control of television news coverage can be evidenced by further reference to coverage of the Gulf War, and I wish to present this case and then problematise it by reference to a discussion of alternative approaches to audiences which draw on conceptions of the nation, and then by work which acknowledges the cultural and racial difference within the nation. In relation to the Gulf War, conceptions of audience by the allied military hierarchy were based not on research evidence but on inherited mythologies of the relationship between public support for war and the media coverage of war. The perception of the relationship between media coverage, casualties and public opinion is based on unproven relationships where media coverage is viewed negatively by military authorities, audiences are regarded as manipulable masses, and casualties are a numerical abstraction. The control of the media in the Gulf War was based on studies conducted for the American military and governmental authorities after the Vietnam War. As Stephen Badsey describes,[37] empirical audience studies showed that there was no verifiable link between the media's coverage of the Vietnam War and the public opinion shift against it, and the official history of the war also concludes this,[38] though a large faction in the US military claim that the loss of the war was due to media coverage.[39] Statistical correlations between the number of casualties in Vietnam and public approval of the conduct of the war showed that support fell 15 per cent whenever casualties increased tenfold.[40] Following this statistical logic, in the Gulf War it was claimed by the allies that 10,000 casualties (2 per cent of the total number of US troops) would render the war unacceptable to the US public.[41] Responses to this by the Western allies were to limit reporters' access to the battlefield, and to release their own military footage of attacks, for the Iraqi authorities were quick to invite reporters to the scenes of attacks (like the cruise missile attacks of 1993) in order to show reporters evidence of the human cost of the war, hoping to manipulate public opinion against the war in the US and other Western nations. The problem is the confusion between public opinion and the press and media opinion, for what is shown in the media becomes an index of what the public apparently think. This confusion allows for Mark Poster's claim that

' "information" was the leading character and support for the war the discursive effect'.[42]

In common with developments in the methodologies of film and media studies more generally, academic work on news broadcasting has increasingly turned to the investigation of audience response. There has been a shift from mass communications perspectives on the audience as a statistical abstraction or a manipulable agglomeration to an interest in the particularity of audiences in smaller-scale group-ings, whether selected by locality, gender, age-group, or social class. Similarly, the viewer as a textually produced construct hollowed out by the structures of the television programme as object has been replaced in studies of news broadcasting by a more fluid notion of the dynamic interchange between the particular viewer and the flow of television, with attention also to the more diffuse social uses of television, in social talk and cultural processes of self-definition. While I would not argue for a simple equivalence between these shifts and a shift from the modern to the postmodern, it is the case that the discourse of television studies has moved from determinist models of meaning (determination by the text as object, or by the ideological forms of mass culture) which were evident in theories of the mass culture of modernity, to the problematisation of determinacy, of ideological effects, and of the mastery of critical discourse, which I have argued to be important components of critical elaborations of the postmodern.

Uses and gratifications research describes the uses and pleasures which audiences derive from media and genres within a medium, reversing the effects tradition's emphasis on how media shape attitudes and behaviour, by asking how and why people act on and use media. In this perspective, news is used instrumentally as an information source, as an entertainment, as a resource for constructing self-identity and/or group identity, and as a way of experiencing social interaction virtually or remotely. However, this approach, because it emphasises the different uses and gratifications sought and obtained, may neglect the specificity of the media text and its particular content. Alternatively, the British cultural studies tradition seeks to find out how audiences make meaning from media texts in a social context, preserving the interest in ideology and the critique of media powers which has marked British studies of media communication since the 1970s, but also stressing the positivity of resistant and particular audience activity, and

the pleasures derived from the media by viewers.[43] This approach began to transfer to the USA in the 1980s, and is perhaps most associated with the work of Lawrence Grossberg.[44] This cultural studies work is complemented by studies focusing on audiences outside the US-UK axis, and below I discuss research of this kind. The increasing interest in the specificity of viewer response continues into ethnographic studies, seen by some as a weak form of anthropological ethnography, since it relies on small samples and anecdotal evidence.[45] As Jensen notes, the methodological problems of this work revolve around its generalisability:

> The challenge, not least for qualitative audience studies, would seem to be to devise the criteria for selecting some data – about media, audiences, and their contexts – as evidence, while leaving out most of the potential data, in order to address the research question at hand . . . Ethnographic research faces a special problem of determining what evidence is *not* relevant.[46]

The celebration of the active audience associated with the work of John Fiske[47] and with work on fan culture[48] has been critiqued for its lack of empirical evidence, and for its lack of specification of how resistance relates to a broader context of political action,[49] while David Morley has defended the approach by arguing that it was a necessary moment in the emergence of a discourse which could challenge textual interpretive research.[50] These issues of methodology are discussed more fully in the following chapter.

In the collection of essays edited by Jensen, an interesting resource for considering news broadcasting in relation to the postmodern can be found along with an attempt to bring together different research methodologies. The book deals with the local uses of television news, in a cross-cultural empirical study of households in seven countries watching news on 11 May 1993. The analysts provide qualitative reports about how the news was understood, what important events were seen to be, and what the content of the news was. Thus the study combines both quantitative and qualitative information, and both particular observations of viewer behaviour and general conclusions about the cultural place of news. Despite the fact that the study excluded both very local news broadcasts and transnational ones like CNN,

which would illuminate issues of globalisation and localisation, it emphasises the significance in contemporary news media culture of national media institutions and perceptions of the nation held by broadcasters and audiences. The study focuses on Belarus, a post-communist market economy, Denmark, with public service and commercial TV in a welfare state, India, dominated by national state broadcasting but with increasing competition from transnational broadcasters and cable, Israel, where (at the time) there was only one TV channel and where news centres on war and the evaluation of potential threats to the nation, Italy, where television proprietors are closely involved in politics, Mexico, where TV is both state and com-mercial, and plays a role in political upheavals, and the USA, reference point for debates on world media culture. Jensen's book identifies 'super-themes' which agglomerate the ways that individual countries' news audiences seem to interpret news events, by telling their own versions of what news events mean: 'super-themes are thematic con-structs by which viewers may establish links between the world of their everyday lives and the world as represented in television news stories'.[51]

This kind of multi-perspectival analysis can be read against the conception of the news media as a public sphere which would be suggested by Jürgen Habermas' work on the postmodern. Politically, access to information is regarded by Habermas as the precondition for political knowledge and action, and the creation of citizenship.[52] In an analysis of the role of the media in civil society, Habermas' concept of the public sphere would be a suggestive starting point for considerations of the role of the media in relation to public partici-pation in culture in general and political culture in particular. The function of the public sphere is to mediate between civil society and the state, and it provides a space for the rational debate which would give rise to a consensus on public affairs. The analysis was part of the Frankfurt School's critique of contemporary public life, which involved the denigration of mass society and mass-media communications, and thus its status as an ideal stands against an existing public culture which was regarded as inadequate. The bourgeois public sphere of the eighteenth century was not a representative whole, and formed the basis of a hegemony. Habermas' concept of the public sphere, elabo-rated on the basis of this culture which excluded the working class and

women (among other groups) was not elaborated with these funda-
mental exclusions taken into account, and omitted to discuss alternative
public fora, such as groupings of radicals or proponents of alternative
political systems. Nevertheless, Habermas' support for the quest of an
ideal public sphere, enabled by the circulation of information transna-
tionally, relates interestingly to the national mediascapes investigated
in Jensen's volume, for the perception of the space of the nation as
public sphere is one of the super-themes identified in it.

In the chapter on India, K.P. Jayasankar and Anjali Monteiro
interviewed ten families in Bombay, viewing Channel 1 news on
Doordarshan, the Indian state TV channel.[53] A content analysis showed
that 57 per cent of news stories were about domestic news, and 43 per
cent about foreign news, with foreign news in over 50 per cent of cases
meaning events in neighbouring Asian countries like Pakistan. On
Doordorshan news;'For Indian viewers, the news is inextricably tied up
with their identities as citizens, their stance towards the news bearing
within it a stance towards the state'.[54] Of the 143 stories recorded on
the news day, about 35 per cent were reports on activities of the state,
rising to 60 per cent if stories about foreign relations and terrorism
are included. Viewers' relationships with television news elided into
relationships with the nation-state as they perceived it via the news.
In order to problematise the credibility of television news, viewers
were required to problematise its representation of the state. Therefore
the identities of the viewer, the state and the television news were
interconnected, and functioned through the dynamics of inclusion and
exclusion on which each of these identities rested. The sample of
households were found to identify the state as an ideal representative,
which could be challenged either by outside forces (like terrorist
activities) or by internal threats to its effective functioning as ideal
representative (like the activities of corrupt politicians):

> When the relationship of the 'other' to the state was one of resis-
> tance or antagonism these viewers would identify with the state.
> Conversely, when the interests of the 'other' and the state were seen
> to coalesce, the viewer's resistance could be directed towards both.[55]

The preponderance of news about the nation-state on television
news, and the control of television by the state, together with viewers'

frequent acceptance of its hegemonic authority, militated in favour of the role of the medium in Indian culture as a public sphere in which consensual identities of citizens, state and media could support each other. Despite its focus on resistance, the study of India seems to contradict notions of a postmodern challenge to nation and to the authority of news media culture.

The work on Israeli viewers of television news in Jensen's collection was conducted by Tamar Leibes, and relates interestingly to my discussion of the coverage of Gulf War because of the significance of war to Israeli news broadcasting.[56] Television began in Israel in 1968 after the Six Day War of 1967, to inoculate 'the newly occupied Palestinians against "enemy propaganda"'.[57] In 1993 a second commercial channel was introduced, then cable television, but these developments occurred after Leibes' audience research. Seventy-three per cent of news was about domestic events, and 27 per cent about foreign news, with over 50 per cent of foreign news being about Israel's Arab neighbours. War in a domestic context is a focus of Israel's news, since citizens serve in the armed forces and feel themselves in a wartime situation, although Liebes argues that: 'Israel's monopoly television news did not repress public debate, but rather constituted its public space'.[58] Viewers rarely criticised television news for promoting state ideologies, and frequently commented that it should be more supportive of Israeli agendas in conflicts with Arab nations and when reporting Arab-Israeli violence. Leibes found that the cognitive mechanisms used were 'the management of personal relationships' by displacing these relationships into news stories and surveilling other family members' reactions to them, the 'framing of reality' by relating news items to everyday personal life, and 'mapping structures of power' to identify the individual's position as winner or loser in relation to news events.[59] The superthemes identified were that Israel is regarded as being at the centre of the world so that every news event has a bearing on Israelis, the relative unimportance of particular family problems compared to the huge problems of the Israeli state, the sense that the population are being outwitted by 'them', whether defined as the opposition, the government, religious groups or an external enemy, and 'gridlock', or the sense of being stuck in insoluble political dilemmas.[60] As in the case of India, the research proposed a close match between the self-identification of viewers and the representations of the nation-state

in television news. The perception of a continual state of war seemed both to diminish resistant readings of television news, and to provide the exclusions and consensus required for a strong sense of nationhood. In this warlike environment, television was seen as insufficiently nationalistic, and was criticised for being too much a sphere of debate and too little a representative of national unity.

The news media cultures of India and Israel as discussed in Jensen's study do not seem to be Habermasian spaces of dialogue and public exchange, but instead the relatively unified and national media cultures which the postmodern is said to have superseded. Whereas Habermas' public sphere of the past was characterised by its spatial and dialogical dynamics, the mass audiences of the modern period, in print journalism and television, are despatialised and nondialogical, as Thompson points out in a critique of Habermas' failure to understand the new mass public created in this commercial context.[61] The fact that the television viewers of India and Israel were watching the sole terrestrial and national television channels makes these media cultures unsuitable examples of the fragmented mediascapes studied by Sonia Livingstone and Peter Lunt, or Nick Stevenson, for instance, which appear more obviously postmodern because of this fragmentation.[62] Jameson, and Peter Dahlgren argue that alternative public spheres are undergoing construction in response to increased fragmentation and diversity of culture and the media.[63] Therefore, while there is some purchase to Friedberg's rhetorical question, 'What could provide more vivid proof of the spatial and temporal changes produced by new communications technologies than the global political arena of 1988–1992?', the cultural and political effects of transnational news media culture, like those of postmodern media in general, require more careful and specific analysis.[64] In particular, an attention to the interactions of television news with other aspects of audiences' media cultural experiences, and to viewers' multiple resources for identity construction, are required in order to make a case for the postmodern character of the media culture of television news.

Marie Gillespie's work on the responses of Punjabi teenagers in Southall to the television coverage of the Gulf War in Britain challenges some of the universalisation prevalent in analysis of the war as a simulated experience in Baudrillard's and Virilio's work, and also challenges the reductions to national homogeneity in the analyses of

national news broadcasting in Jensen's collection. For the Southall teenagers of Asian extraction, questions of identity and identification arose around the adversaries in the war, as America versus the Middle East, Christians versus Muslims, West versus East, Allies versus Arabs, or white versus black. As British Asians, some teenagers' families supported Saddam Hussein as a Muslim leader, while in the more culturally normative environment of their schools the teenagers were immersed in the pro-Allied conceptions of the war which were supported by media coverage, and were sometimes afraid of racist violence against them by white Britons. Religious concerns over the continuance of fighting over the Ramadan festival (traditionally a time of peace) and the presence of Western troops in Muslim holy places in Iraq also confused any simple acceptance by the teenagers of the demonisation of Saddam Hussein and Iraq in the British media. As Gillespie comments: 'This shifting of positions according to different contexts is commonplace; indeed, the ability to deal with contradiction, ambivalence and ambiguity pragmatically, while as far as possible remaining true to oneself inwardly, is seen to be sign of maturity'.[65] The alignment of many of the teenagers and their families with the hegemonic discourses of television news coverage was complicated by the disjunctures between their identities as Muslim, non-white, of post-colonial extraction, British, and Westernised. Different aspects of their identities came to the fore at different times in order to constitute the teenagers as the addressees of media discourses about the war, to provide a position from which they could articulate their own views and to adapt themselves to the different cultural environments of the home and school. In the process of constituting themselves as audience for media coverage of the war, questions of nation, race, personal identity and relation to the politics of media representation were not only evident to the teenagers, but often had to be consciously negotiated.

This research not only demonstrates the significance of specificity in complicating totalising versions of media coverage as simulation visited univalently upon a homogeneous audience. It also opens the question of the usefulness of agglomerating audience categories using the nation as their template. The spatial dynamics of the Southall teenagers' experience were not only national but also international because post-colonial, and furthermore ethnic, religious and racial. Temporally, their awareness of their own family, ethnic, cultural histories as postcolonial

histories inflected their understanding of war coverage. The global space and temporal presentness of war coverage seems to be overstated in some of the rhetoric about the Gulf War in postmodern writing. However, Gillespie reports that the familiarity with contemporary entertainment media forms also appeared in the teenagers' understanding of the war coverage, and some of this information supports the notions of virtualisation and denial of bodiliness which I have outlined above in relation to photography and digital images. Southall boys did explicitly parallel live coverage of bombing raids and missile attacks with computer game imagery, and compared the visual representations of war with science fiction film special effects. The girls whose talk is discussed by Gillespie tend to identify either with nurses in the Gulf or with female war reporters, and seemed frankly bored by the boys' fascination with technological spectacle, noting that there must be 'real' visceral death and destruction concealed by it. While there are clearly differences between this kind of research and the critical work by Kember on the relations between digital imaging and anxieties around the body, there are also suggestive parallels. The spectacle of destruction both concealed anxieties over the complexity and difficulty of identifying with either side in the conflict, and functioned to shore up the boys' sense of their own masculinity, and their prowess in and understanding of the masculine military culture of technological efficiency and decisiveness. These positive (though politically dubious) factors interacted productively with the similar imaginaries of cinematic spectacle, and violence in computer games. Contemporary media culture, in the forms of television news coverage, computer games and films, both seduced and interrelated some of its audiences for some of the time, but also divided, alienated and disturbed some of them for some of the time. I would argue that this is itself a postmodern situation, where problematic oscillations between the fullnesses of identity, presence, iconicity and viewership contrast with the virtuality, negation or problematisation of these factors.

I am therefore suggesting that postmodern media culture, and the theorisation and analysis of postmodern media culture, are each marked by significant oscillations between apparently distinct and antagonistic discourses. I would argue that the confrontation between these discourses on news broadcasting is itself part of the contest of discourses which I regard as part of postmodern media culture. On one

hand, the significance to viewers of telecommunicated images of war, encoded digitally and disseminated across global networks, demonstrates a transnational postmodern media culture which draws on the iconicity of photographic realism while at the same time distancing it from bodily and material experience. New news media will either gradually replace terrestrial TV news, or new media will replace terrestrial delivery. These changes will probably produce a greater diversity of news services and wider access to more information, but may also widen the gap between those who are information-rich and those who are information-poor. Politically, this situation will affect the tradition in democracies that citizens can become knowledgeable, and will become so by their use of a small number of widely-used sources of information. But the information society[66] therefore becomes potentially subject to Baudrillard's criticism that there is only spectacle in this information and no content.[67] In this respect, Baudrillard and Virilio, among others, seem to be addressing postmodern media culture with an appropriate discourse. However, on the other hand, the homogenising tendencies of this theoretical work render its conclusions problematic. The contemporary news audience will become more fragmented and more active. In a European context, there is at present no unified European public sphere, due to the different ways in which public service broadcasting, and state regulatory practice, are understood in different countries. A problem for universalising theories of postmodern media culture is that the audience is rendered as virtual and univalent as the images which are being referred to, and there is little acknowledgement of difference either within the object of analysis itself, in the form of detailed discussion of broadcast coverage, or of difference in the specific locations in space and time of the media coverage, which is limited to the television institutions of the West and largely to Western television audiences. The move to studies of audience response, especially ethnographic work on audiences, remedies these insufficiencies in important respects, by restoring the internal difference and specificity of broadcast news as an object of study, and of the audience as a diverse and specific range of cultural actors, with their own agency and capacity for active interpretation. Finally, I would argue that this division between universalising theoretical discourse, and the acknowledgement of difference, specificity and viewer agency, is not separate from postmodern media culture, but instead a key

component of it, and this point is taken further in the following chapter. The contest of discourses between theoretical rhetoric and empirical investigation shows that the study of postmodern media culture is constituted by an address to its object which exhibits equivalent tensions between totalisation and diversity, to the tensions in the media culture which is the referent of its address.

NOTES

1. Walter Benjamin, 'The Work of Art in the Age of Mechanical Reproduction', in *Illuminations*, ed. H. Arendt, trans. H. Zohn (New York: Schocken Books, 1969), p. 212.
2. Paul Virilio, Jean Baudrillard and Stuart Hall, 'The Work of Art in the Electronic Age', *Block* 14 (1988), pp. 4–14.
3. John Taylor, *War Photography: Realism in the British Press* (London: Routledge, 1991).
4. See John Allen, 'From Morse to Modem: Developments in Transmission Technologies and their Impact on the Military-media Relationship', in Ian Stewart and Susan Carruthers (eds), *War, Culture and the Media: Representations of the Military in 20th Century Britain* (Trowbridge: Flicks, 1996), pp. 148–64.
5. Guy Debord, *Society of the Spectacle*, trans. unnamed (Detroit: Black and Red, 1970).
6. Paul Wombell (ed.), *PhotoVideo: Photography in the Age of the Computer* (London: Rivers Oram Press, 1991). My account of the debate around digital photography owes much to Martin Lister, 'Photography in the Age of Electronic Imaging', in Liz Wells (ed.), *Photography: A Critical Introduction* (London: Routledge, 1997), pp. 251–91.
7. Jonathan Crary, *Techniques of the Observer* (Cambridge, MA: MIT Press, 1993).
8. William Mitchell, *The Reconfigured Eye: Visual Truth in the Post-Photographic Era* (Cambridge, MA: MIT Press, 1992).
9. Martin Lister, 'Introductory essay', in Martin Lister (ed.), *The Photographic Image in Digital Culture* (London: Routledge, 1995), pp. 1–26; Kevin Robins, 'Will Image Move Us Still?', in Lister, *The Photographic Image*, pp. 29–50; and Don Slater, 'Domestic Photography and Digital Culture', in Lister, *The Photographic Image*, pp. 129–46.
10. Carolyn Marvin, *When Old Technologies Were New: Thinking About Electric Communication in the Late Nineteenth Century* (Oxford: Oxford University Press, 1988).

11. William Boddy, 'Archeologies of Electronic Vision and the Gendered Spectator', *Screen* 35: 2 (1994), pp. 105–22.
12. A. Darley, 'From Abstraction to Simulation: Notes on the History of Computer Imaging', in Philip Hayward (ed.), *Culture, Technology and Creativity in the Late 20th Century* (London: John Libbey, 1990).
13. Lister, 'Introductory essay', pp. 1–26, and Robins, 'Will Image Move Us Still', pp. 29–50, in Lister, *The Photographic Image*.
14. Fredric Jameson, *Postmodernism, or the Cultural Logic of Late Capitalism* (London: Verso, 1991), see p. 202.
15. Daniel Bell, *The Coming of Post-Industrial Society* (New York: Basic Books, 1973).
16. Jean-François Lyotard, 'Answering the Question: What is Postmodernism?', in Thomas Docherty (ed.), *Postmodernism: A Reader* (Hemel Hempstead: Harvester Wheatsheaf, 1993), p. 40.
17. Ibid.
18. Sarah Kember, *Virtual Anxiety: Photography, New Technologies and Subjectivity* (Manchester: Manchester University Press, 1998), p. 18.
19. See Fred Richin, *In Our Own Image: The Coming Revolution in Photography* (New York: Aperture, 1990).
20. Susan Sontag, *On Photography* (London: Penguin, 1979), p. 8.
21. John Taylor, *Body Horror: Photojournalism, Catastrophe and War* (Manchester: Manchester University Press, 1998), see especially pp. 157–92.
22. Douglas Kellner, *Media Culture: Cultural Studies, Identity and Politics Between the Modern and the Postmodern* (London: Routlege, 1995), see especially pp. 198–228.
23. For a discussion of the controversy around the photograph, see Taylor, *Body Horror*, pp. 181–3.
24. Roland Barthes, 'The Photographic Message', in *Image, Music, Text*, trans. S. Heath (London: Fontana, 1977), pp. 15–31.
25. Paul Virilio, *L'écran du désert: chroniques de guerre* (Paris: Galilée, 1991). For a discussion of Virilio's argument, see Ian Walker, 'Desert Stories or Faith in Facts?', in Lister, *The Photographic Image*, pp. 236–52.
26. Paul Virilio, *The Lost Dimension*, trans. D. Moshenberg (New York: Semiotext(e), 1991), p. 58.
27. Jean Baudrillard, 'The Reality Gulf', *The Guardian*, 11 January 1991, reprinted in Peter Brooker and Will Brooker, *Postmodern After-Images: A Reader in Film, Television and Video* (London: Arnold, 1997), pp. 165–7.
28. Jean Baudrillard, 'La guerre du Golfe n'a pas en lieu', *Libération*, 29 March 1991, quotation trans. in Christopher Norris '"Postscript" (Baudrillard's Second Gulf War article)', in Brooker and Brooker,

Postmodern After-Images, p. 169.

29. Norris, '"Postscript"', pp. 168–71.
30. John Thompson, *The Media and Modernity* (Cambridge: Polity, 1995). His work follows the emphases of Anthony Giddens, *The Constitution of Society* (Berkeley: University of California Press, 1984); and Anthony Giddens, *The Consequences of Modernity* (Cambridge: Polity, 1995).
31. Anne Friedberg, *Window Shopping: Cinema and the Postmodern* (Berkeley: University of California Press, 1993), p. xii.
32. Ibid.
33. Rey Chow, 'Violence in the Other Country: China as Crisis, Spectacle, and Woman', in Chandra Talpade Mohanty, Ann Russo and Lourdes Terres (eds), *Third World Women and the Politics of Feminism* (Bloomington: Indiana University Press 1991).
34. Klaus Bruhn Jensen, 'Introduction', in Klaus Bruhn Jensen (ed.), *News of the World: World Cultures Look at Television News* (London: Routledge, 1998), p. 7.
35. Annabelle Sreberny-Mohammadi with Kaarle Nordenstreng, Robert Stevenson and Frank Ugboajah (eds), *Foreign News in the Media: International Reporting in 29 Countries* (Paris: UNESCO, 1985).
36. Jensen, 'Introduction', p. 7.
37. Stephen Badsey, 'The Influence of the Media on Recent British Military Operations', in Stewart and Carruthers (eds), *War, Culture and the Media*, pp. 5–21.
38. William Hammond, *Public Affairs: The Military and Media 1962–1968* (Washington: Center of Military History, United States Army, 1988), pp. 385–8.
39. Claude Sturgill, *Low Intensity Conflict in American History* (Westport: Praeger 1993), pp. 94–6.
40. Hammond, *Public Affairs*, p. 262.
41. Lawrence Freedman and Efraim Karsh, *The Gulf Conflict 1990–1991: Diplomacy and War in the New World Order* (London: Faber, 1993), p. 52.
42. Mark Poster, *The Second Media Age* (Cambridge: Polity, 1995), p. 160.
43. See for instance David Morley, *The 'Nationwide' Audience* (London: BFI, 1980).
44. See for instance Lawrence Grossberg, Cary Nelson and Paula Treichler, with Linda Baughman and John Macgregor Wise (eds), *Cultural Studies*, New York: Routledge, 1992).
45. See James Lull, 'Critical Response: The Audience as Nuisance', *Critical Studies in Mass Communication* 5 (1988), pp. 239–43.
46. Jensen, 'Introduction', p. 12.
47. John Fiske, *Television Culture* (London: Routledge, 1987); and John

Fiske, *Media Matters* (Minneapolis: University of Minnesota Press, 1994).

48. See Lisa Lewis (ed.), *The Adoring Audience* (London: Routledge, 1991).
49. See Lull, 'Critical Response'; and Meaghan Morris, 'Banality in Cultural Studies', *Block* 14 (1988), pp. 15–25.
50. David Morley, *Television, Audiences and Cultural Studies* (London: Routledge, 1992).
51. Jensen, 'Introduction', p. 19.
52. Jürgen Habermas, *The Structural Transformation of the Public Sphere* (Cambridge, MA: MIT Press, 1989).
53. K.P. Jayasankar and Anjali Monteiro, 'India', in Jensen, *News of the World*, pp. 61–87.
54. Ibid., p. 62.
55. Ibid., p. 87.
56. Tamar Liebes, 'Israel', in Jensen, *News of the World*, pp. 88–102.
57. Ibid., p. 88.
58. Ibid., p. 90.
59. Ibid., p. 102.
60. Ibid.
61. John Thompson, 'Social Theory and the Media', in David Crowley and David Mitchell (eds), *Communication Theory Today* (Cambridge: Polity, 1994), pp. 27–49.
62. Sonia Livingstone and Peter Lunt, *Talk on Television* (London: Routledge, 1994); Nick Stevenson, *Understanding Media Cultures* (London: Sage, 1995).
63. Fredric Jameson, *Postmodernism, or the Cultural Logic of Late Capitalism* (London: Verso, 1991); Peter Dahlgren, *Television and the Public Sphere* (London: Sage, 1995).
64. Friedberg, *Window Shopping*, p. xii.
65. Marie Gillespie, 'Ambivalent Positionings: The Gulf War', in Brooker and Brooker, *Postmodern After-Images*, p. 178.
66. See Frank Webster, *Theories of the Information Society* (London: Routledge, 1995) for analysis of this concept.
67. See Jean Baudrillard, *In the Shadow of the Silent Majorities, or The End of the Social and Other Essays*, trans. P. Foss, J. Johnson and P. Patton (New York: Semiotext(e), 1983a).

6

ARTICULATING MEDIA FROM
THE GLOBAL TO THE LOCAL

This chapter addresses the problem of developing a critical language in which to discuss the interdependencies between media globalisation and the activities of local media audiences. I examine critical perspectives on media globalisation in relation to the postmodern, and on local forms of media reception, arguing that globalisation and localisation are mutually interdependent. In another related sense of the term articulation, I examine the ways in which critical language itself is articulated. At the level of media theory, aspects of globalisation theory and ethnographic work on local media cultures can be seen as attempts to address the perceived inadequacies of each other, as discursive artic- ulations which both define themselves against each other, and also depend on each other. I will argue that this mutual interdependence is part of a discourse which specifies the postmodern character of media culture, and that its characterisation as postmodern also denotes its relationship to the problem of referentiality and examplarity which I have stressed in earlier chapters. The chapter begins by showing how sociological discourses on modernity use the evidence of the global dissemination of media technology and programming to argue that changes in the cultures of 'traditional' or pre-modern societies are decisively altered. However, the global modernity which this argument produces has the effect of rupturing the coherence of the categories of society and nation on which sociological discourse is founded. I then shift attention to other kinds of analytical object, in particular the institutions of media culture which cross national and societal borders.

The political economy of these institutions provides another object in the study of media culture, which allows for the discussion of the back and forth movement of media flows between the First and Third Worlds, redressing the balance against the implicit Westernisation (or Americanisation) which theories of globalisation can involve. Rather than a homogeneous and monolithic notion of media modernity, this dynamic model has claims to be a postmodern position because of its recognition of uneven and negotiated characteristics of media culture. However, such institutional analysis still leaves unclear the relationship of specific media cultures to large-scale processes, and the chapter moves to qualitative ethnographic studies of television audiences, where questions of specificity and difference have been debated. The focus on media audiences as heterogeneous, active in their responses to television, and involved in the production of temporary and nego-tiated identities, is the most radical and postmodern challenge to large-scale sociological discourses of media modernity. The chapter concludes by examining the discourse of difference, heterogeneity and specificity, arguing that it works by reversing the colonialist discourses of anthropology. A paradoxical reversal of the positions of the dominant Western subject and the colonial Other takes place in this discourse, which confuses the temporality and the political claims of a postmodern discourse based on hybridity and difference.

MODERNITY AND GLOBALISATION

The global spread of television sets and television distribution systems appear at first sight to provide evidence for theories of contemporary media culture which emphasise homogeneity. From the middle of the 1980s transnational television flows have increased due to the use of distribution technologies including cable and satellite, and the con-glomeration of television distribution systems. In 1990 there were more than 750 million television sets in over 160 countries, watched by over 2.5 billion people per day, and Chris Barker notes that by 1994 a further 100 million households had been added to this worldwide total.[1] Growth in television viewership is increasing most quickly in developing nations, with a trebling of TV sets in Africa and Asia, and a doubling in Central America. Globalisation theses by Herbert Schiller, for example, have argued that the globalisation of communication in

the second half of the twentieth century has been determined by the commercial interests of US corporations, working in parallel with political and military interests.[2] This discourse connects cultural imperialism with the dynamics of colonialism, arguing that the colonial empires of Britain or France have been replaced by commercial imperialism. Traditional local cultures are said to be eroded by dependencies on media products and their attendant ideologies deriving from the United States, with the effect of globalising consumer culture across regions and populations which become constrained to adapt to its logics and desires, despite their lack of resources to participate in them. This cultural imperialism thesis, developed in the 1950s and 1960s, pays scant regard to local and national specificities in media organisation or consumption, nor to regional flows of media products, based for instance on the legacy of imperial languages like Spanish in Latin America. Not only do regional media flows run across global ones, but also provide the basis for a reversal of media flows from Latin America to Europe, where the export of telenovelas among Latin American cultures and to Europe is a well-known example. Institutionally, the synergy between the separated realms of hardware manufacturing, content providers, and transmission or broadcasting corporations appears to provide market dominance to a few major companies, mainly American and Japanese (like Time-Warner or Sony), so that the assimilation of globalisation to Americanisation has been modified to stress the power of corporate, rather than national, control over media. What happens in the discourse of globalisation is a shift from arguments for the homogeneity of media culture to arguments for the homogeneity of the political economy of the media, despite regional and local differences in the cultural forms which the media take.

Attention turns to the common practices and shared features of media institutions, for while modernisation implies the global dissemination of an ideology (Western capitalism), globalisation on the other hand describes only the market networks of technology and consumerism through which products are disseminated, and thus does not imply that global media products disseminate a coherent ideology. Arjun Appadurai argues that there are mediascapes, technoscapes, financescapes, ideoscapes and ethnoscapes, which are divergent and different, and that although globalisation is a widespread postmodern

phenomenon it is distinguished from modernisation and modernity by this simultaneous universalisation of culture and culture's fragmentation into different local and discursive forms.[3] Globalisation is channelled and regulated by specific institutions in societies and nations, rather than being an autonomous and universal process, and globalisation is itself a political idea which relies on contingent and changeable conditions to operate, and may be resisted or abandoned as a result of political choices. As Alan Scott has argued, critical work on media globalisation rests on a diagnostic discourse, deployed as a resource of proof or exemplification, and can either argue in favour of globalisation, for example as part of a discourse of development or of democratisation, or argue against it by appealing to, for example, nationalistic conservatism or liberal notions of social-democratic planning, with the motive of preserving social cohesion.[4] From this perspective, globalisation is an instance of the long-running struggle between economic forces which destroy the social, and political forces which defend or constitute the social. As Appadurai shows, global markets are regulated by contract and law, and rest on notions of labour, money, profit, and exchange which are familiar in Marxian analysis. But with a Durkheimian emphasis, Appadurai stresses that contracts rely on an idea of the social, since they are worthless unless they are backed up by a belief in reciprocity and trust between parties. So market capitalism can only exist when there is some symbolic and social solidarity in society, and such social bonds always militate against the triumph of market capitalism. Furthermore, media markets are regulated, controlled, and sometimes created by states or organisations of states, so that the global autonomy of multinationals can be overstated, since they are open to political pressures at the level of national and occasionally international political institutions. While the free market and globalisation are seen often as natural facts, they rely on political decisions about deregulation, competition and social value which are taken mainly by nation-states. States and organisations of states both deregulate and encourage globalisation, and also regulate and protect their citizens against it. The state and nation have important roles in theorising the degree of power over culture which media globalisation may have.

But in the context of globalisation theory, the notions of the social and the nation become problematic. The expansion of television

technology and television viewership provides the evidence for socio-
logical work on modernity to explore the consequences of new cultural
forms on societies, for society, regarded as a separable and method-
ologically distinct whole, has been the standard object which such
theories address. But Anthony Giddens argues that the concept of
society as a unit bounded in time and space becomes redundant in
contexts like this, and that traditional societies have been eclipsed by
new forms of social organisation. Giddens argued that the conse-
quences of modernity in culture include 'the *separation of time and space*
and their recombination . . . the *disembedding* of social systems . . . and
the *reflexive ordering and reordering* of social relations . . .'.[5] Space and
time are separated by the introduction of standardised clock time (like
GMT) which links and separates geographical places and their local
times. Live television broadcasting of news events or sporting events,
for instance, overlays one form of time onto another when broadcasts
cross time zones, and brings alternative understandings of space (the
New World Order, for example) to bear on local senses of place.
Disembedding is produced by, for example, the abstraction required in
global communications (like monetary transactions), which divorces
information from material objects and resources. By broadcasting a
wide variety of discourses about culture (about youth, consumption,
social relations and gender, for example), global television enables
reflection on local cultural modes of behaviour, and provides resources
for the construction of identities which borrow from or resist those
available from television. Thus hybrid identities can be formed through
or against global and local cultural forms, with global broadcasting as
the dominant against which these alternatives are measured. The
emphasis of this sociological approach to media globalisation is
therefore on large-scale processes, and their effects on conceptions of
time, space and identity which are said to have a transforming influ-
ence on culture. But the result of this dynamic understanding of culture
is also to disunify the notion of the social as an object of study bounded
in space and time. As the notion of society as a geographically and
temporally coherent object is argued to break down, the nation too as
a geographically and temporally distinct object loses its coherence, and
theory needs to go beyond the boundaries of the state, so that society
is no longer equated with a national territory. Thus Zygmunt Bauman
argues that social theory should abandon its concept of society in the

new postmodern global era.[6] The concept of society belongs, for Bauman, to modernity and its impulses toward homogenisation, integration and order, whereas the culture of postmodernity is characterised by its diversity and fragmentation.

The discourses around large-scale processes of globalisation, with their interest in transnational and national media technologies and distribution flows, thus share the emphases of theories of subjectivity and consumption practices. Scott Lash regards the postmodern as an intensification of modernity's characteristic technologisation and standardisation in the field of consumption as well as production.[7] Rather than a break into a different culture, the postmodern is conceived as a quantitative increase of modern forms which have the effect of disseminating particular relations between subjects and objects. Lash argues that the feature which distinguishes postmodern culture from the modern is the different valuation given to words and images. The discursive regime of modernity, associated with rationalism, distanciation of the spectator from the object, an emphasis on textual meaning, and the privileging of the verbal, is displaced by a postmodern regime which prioritises the visual or figural, takes material from the everyday, contests rationalism, and encourages the immersion of the spectator in a cultural experience, leading to the aestheticisation of everyday life and the blurring of boundaries between elite and popular culture. Consumption becomes a resource for the creation of transient and plural identities in contrast to the consumption choices made by other, competing social groups. Mike Featherstone, like Lash, associates this shift into the postmodern with advertising and promotional culture in general, since promotional culture involves the aestheticisation of everyday commodities and experiences, and the domination of signs and images in the (urban and mainly Western) experience of social subjects.[8] With regard to postmodern subjectivity, there is a parallel here with Fredric Jameson's view that 'the alienation of the subject is displaced by the latter's fragmentation' where the alienated subject of modernity is replaced by transient identities constituted in relation to such things as advertising images.[9]

Featherstone, following the work of Pierre Bourdieu[10] regards this apparent freedom with caution, arguing that its function is to enable distinctions of taste which legitimate members of the middle class in distinction both to each other and to less privileged social groups. The

positive feature of this situation is the possibility of play with and in identity, measured against what are regarded as former monolithic identities (like stereotypes of masculinity), where Frank Mort, for example, claims that men are 'getting pleasures previously branded taboo or feminine',[11] and Mica Nava claims that 'constructions of masculinity or femininity are less fixed'.[12] However, the emphasis on difference of class, gender and region in studies of consumption tempers claims for the contemporary as a moment of free postmodern play with objects and identities, and this is supplemented by ethnographic work, for example by Beverley Skeggs on working-class women's attitudes.[13] Her work on these women's talk showed that consumption involved as much pain as pleasure, and choices of object were a potential source of embarrassment, subject to the judgement of others including husbands, other family and friends, or comparison with the middle-class standards communicated in television home decor programmes. Furthermore, a transition from the mass production of goods in the manner associated with Henry Ford's production lines and the impe-rialism model of global media and commodity flows, to the production of goods for smaller 'niche' markets and a notion of a democracy of taste and consumption, does not imply a resistance to globalisation, since niche markets may be international or transnational as well as local. The use of the term postmodern, though it derives from Western intellectual culture, has enabled an alternative to the discourse of hierarchy and supervision of a 'common' culture which is associated with modernity, and facilitated the entry into the debate of feminist and non-Western critics. The result of this is to produce a discourse in which the certainties of the grand narratives of imperialist Western modernity can be challenged by a focus on difference in media con-sumption practices. But these practices need also to be placed by their interrelation with larger-scale determinants, demonstrating again that the specific and the local are articulated in reference to them.

Later in this chapter, I return to questions of imperialism in relation to the status in theoretical discourse of the fragmented, resistant audience member, to draw parallels between the postcolonial other and this postmodern media subject. But at this point, it is important to note the shifts in theoretical approaches to media culture which I have discussed. The discourse of media theory has moved from dis-cussing the structural determinants of culture (for example theories of

globalisation as a producer of ideology) to theories of subjective agency (choice, the search for negotiated individual identities, micro-analyses of agency and empowerment). The danger here is that rather than exploring how cultural representations encode and debate ideologies originating in economic and productive relations, the analysis remains at the level of culture alone, comparing and contrasting different representations and cultural expressions at a great distance from their determining factors in terms of production. In other words, media theory can idealise and reify particular aspects of media culture, which are divorced from systematic and structural determinations. The effacement of production which the media theory of an earlier generation discerned in media texts, for example the naturalisation of cultural relations in television programmes, commercials and films, might reappear at another level. Media theory now emphasises individual choices and negotiations within culture, with an uncertainty over how these specific choices, actions and beliefs can be related to an understanding of social forces, institutions and possibilities for change.

ARTICULATING THE GLOBAL AND THE LOCAL

It is worth asking, therefore, how different kinds of attention to such questions as gender, race and ethnicity would be produced by the different theoretical currents I have identified so far. At this stage, I base this discussion on two television 'texts', with the proviso that selecting a text as object will produce only a partial understanding. The following sections of this chapter address audiences and ethnography, whose different potentials as objects of research and kinds of theorisation are equally significant to work on contemporary media. First, I consider research on an MTV video by Madonna, where cultural sensitivities resulted in the withdrawal of the video, with interesting consequences for the global imaginary of the MTV channel. Second, I consider some television commercials shown in Singapore which advertise Western products, to discuss how transnational brands adopt locally specific cultural references. I am less interested in producing a nuanced analysis of these particular objects, than in showing how exemplary objects would be constructed and critiqued differently by different critical discourses. In common with the emphasis of this book as a whole, these

examples are chosen in part to explore problems of exemplarity itself, rather than to stand as proof of a particular critical argument.

The video for Madonna's song 'Like a Prayer' was shown on MTV in 1989, and Carla Freccero notes that despite recent criticism's celebration of Madonna for her political empowerment and freewheeling post-modern style, the MTV context of her videos contains their significance within a context of media globalisation.[14] MTV can be regarded as an American-owned capitalist enterprise which aims to bring non-American music to the American market, and to stimulate desires for American products outside the United States. The media institution of MTV could then function as an example of postmodern corporate global media culture, for the channel is available across diverse cultures and markets. It is not only concerned with disseminating American or Western musics, since it sometimes screens videos originated outside Western pop culture, but its address to a youth culture with supposed shared concerns and consumer desires would support the argument that its overall effect is one of homogenisation. MTV's own self-pro-moting advertising seems to support this, with such slogans as, 'One world, one image, one channel: MTV', which celebrate the effacement of difference by global consumerism. In the late 1980s there was a business synergy between Madonna and Pepsi-Cola, where Pepsi commercials on MTV involved the use of extracts from Madonna's 'Like a Prayer' video, in which the leading character (Madonna) has an ambiguous sensual and religious encounter, probably in fantasy, with the icon of a black saint who appears to come to life in a church. MTV audiences in forty countries saw a commercial on 2 March 1989 in which a Native Australian ('Aborigine') runs across a desert (in California rather than Australia) to a bar where Madonna's 'Like a Prayer' Pepsi commercial is playing on the TV. This appears to be an example of the promotion of a univalent commodity capitalism, able to connect soft drinks with pop music in a colossal marketing system which is invariant across national, regional and local cultures.

However, Pepsi cancelled screenings of the commercial after protests from religious groups, objecting both to the video's use of Catholic imagery and its proto-colonial representation of the Native Australian. Forces of ethnic and religious protest demonstrated their ability to remove the commercial, if not to alter the system of economic relations which enabled it. The religious and postcolonial critics of the

commercial and the video represent a collective agency which refuses the univalence of MTV's and Pepsi's transnational ambitions. But the two forms of protest are themselves uneasily linked, despite each of them's focus on the politics of appropriation and the value of difference. The appropriation of Catholic imagery was resisted because it seemed to devalue the moral tenets of Catholic Christianity and to play in a postmodern but illegitimate way with seduction and sexuality. The appropriation of the Native Australian was resisted because it seemed to draw on stereotypes of traditional cultures in order to assimilate them into the global consumerism which was engaged in their destruction. In both cases, the value of the traditional was asserted as the other to a postmodern global media text. But at the same time, the protests' success was made possible by the recognition of cultural, religious and ethnic difference by the global corporate culture. Homogenisation seems to give way to difference and local agency, supporting a definition of the postmodern based on the valuation of difference. On the other hand, part of Pepsi's and MTV's efforts at homogenisation is precisely to incorporate the 'traditional' and the ethnically specific. This has a pertinence also to the debates around Madonna's own agency in relation to the transnational media in which she is represented. For, from the perspective of an auteurist defence of Madonna as an artist who troubles and critiques ideological representations (of gender identities, religious dogmas and sexual practices, for example), she is enabled by her marketability to use money from big corporations to make video commercials which sometimes decentre the product in favour of promoting not only her star image but also her sometimes subversive political and cultural interventions.[15] In the case of the MTV Pepsi commercial featuring Madonna's video, it could be argued that Madonna's agency is progressive, critiquing the unspoken sexual and racial politics of Catholic religious iconography. The question which is not resolved is how to decide whose agency (Pepsi's, MTV's, Madonna's, religious or ethnic protesters') is progressive and whose is not.

The events around the 'Like a Prayer' video resonate with the arguments posed by Homi Bhabha, for despite a critique of agency as in itself resistant to globalisation, Bhabha cites a collective political agency as a resistant force.[16] He argues that colonisers have appropriated the material, discursive and cultural resources of the colonised,

and that the colonised are enabled to fight back by reappropriating the resources of the coloniser. The resistant subject is a hybrid of the postcolonial legacy of Western forms of subjectivity and cultural identity, together with the otherness from the Western which the colonial experience has mapped onto that subject. Bhabha claims the authority to speak for the colonised, producing a metalanguage of critique which aims to return agency to the colonised via the discourse of Western rationalism. He calls culture a 'strategy of survival' which 'is both transnational and translational'.[17] It is transnational in slavery, the imposition of colonial cultures on those they 'civilise', in migration to the West, and in refugee movements inside and outside the Third World. 'Culture is translational because such spatial histories of displacement – now accompanied by the territorial ambitions of "global" media technologies – make the question of how culture signifies, or what is signified by *culture*, a rather complex issue.'[18] The hybrid resistant subject can be described as postmodern because of his or her 'translated' culture and identity, internally different as well as representing difference for the West. This resistant subject's agency is the resource for combating the homogenising forces of globalisation in culture. What results is a conception in which one kind of postmodern agency, that of globalising forces of homogenisation, fights against another, the resistant difference of the postcolonial other. I am suggesting then, that the example of the MTV video and Bhabha's analysis of cultural resistance is significantly different but also significantly similar. In each case, a homogenising dominant can be characterised as postmodern, while a differentiating resistant agency is also attributed with the postmodern power to counteract it. Both homogenisation and local difference have the capacity to stand as examples of the postmodern, and to trouble the meaning of that term.

This issue of the internal splitting of the postmodern and the subject can be taken further by reference to another textual example, before I turn to methodological questions of audience research which will be the location for the final stage in this argument. Unpublished research by Clara Min Win Ong on television commercials for Western products in Singapore begins from the premise that the growing middle class of the Pacific Rim (Japan, China, and the 'Four Dragons' of Hong Kong, Singapore, South Korea and Taiwan) have an appetite for consumption.[19] The marketing of globalised Western products deploys local strategies,

for although Singapore was a British colony, and thus has a Western legacy visible in its public institutions and its consumer culture, the mixed population of Chinese, Malay and Eurasian people also have particular ethnic and cultural traditions. As Charles Forceville argued,

> we simply *must* consider to what extent many advertisements are embedded in a cultural context on penalty of not being able to interpret them; conversely, an analysis of the knowledge necessary to interpret an ad . . . can reveal much about the (sub)culture in which it is embedded.[20]

There are only a few commodity brands (like Marlboro and Coca-Cola) which use the same campaigns worldwide, and then only after testing them with a variety of audiences. More commonly, brands are marketed in locally specific ways, so that in Asian markets, L'Oreal replaced their primary cosmetics model Andie MacDowell with the Chinese star Gong Li, who was said to personify the beauty and elegance of the Chinese woman. Questions of transnationality and translation affect not only the apparent equivalence of the signifieds of beauty and femininity in the different versions of L'Oreal commercials, but also the translatability of consumer culture itself across different cultural spaces.

A sequence of television commercials for McDonald's in Singapore (created by Leo Burnett Singapore) used the character 'Mr Kiasu', created by Comix Factory in 1990, drawing on the Singaporean concept of 'kiasuism', meaning 'being afraid to lose out', and Singlish phrases (combining English, Chinese and Malay) like 'better faster grab' to promote free gifts available with food. As Ong showed, relatively unproblematic translations of marketing practices are accompanied here by the culturally specific use of kiasuism, articulating the global and the local across differences of race, language and ethnicity that are themselves articulated though a multicultural Singaporean identity. McDonald's also adopted and adapted traditional symbols and practices in their Lunar New Year 1996 commercials (also by Leo Burnett), featuring Donald Duck, Goofy and Minnie Mouse under the names and in the costumes of the Chinese gods of Luck, Wealth and Longevity respectively, holding their respective traditional symbols of oranges, a gold ingot and a peach. One ad shows a mother bringing home the red and orange packets of burgers to happy children, while at the end of

the ad the daughter sings 'Mai Dan Lao zhu nin xin nian hao' ('McDonald's wishes you a Happy New Year'). The red and orange of the company's logo blend fortuitously with the colours of Chinese traditional symbols, and the representation of the older generation's symbolic gifts to the younger links the cultural practice of the past with Singaporean consumer culture. Singaporean ads for McDonald's Chicken McNuggets use Chubby Checker's song 'The Twist' and feature four actors dipping McNuggets in sauces to the adapted refrain 'Come on everybody, come and dip again, do the Singapore dip'. The actors represent the four predominant Singaporean ethnic groups of Indian, Malay, Eurasian and Chinese. Their codes of dress and gesture are appropriate to these ethnic codes, as are the sauces provided in this market: curry, garlic and chilli, barbecue, and sweet and sour respectively. The signification of McDonald's as the catalyst of racial and national unification is supported in the final shot by the four actors appearing to hold up the McDonald's logo together. In these commercials, McDonald's becomes an agent of unification between ethnic and racial groups, between an imagined cultural heritage and the present, and between a Western popular cultural text and a specifically Singaporean national identity.

These commercials concern the relationship between media culture and translation, around the issue of the politics of agency. Reading Bhabha 'against the grain', it can be argued that McDonald's television commercials assert the agency of this transnational brand in constituting an articulated relationship between the Western and the Asian, the global and the local, the modern and the traditional, whereby consuming subjects are addressed precisely as subjects of their own postcolonial experience. This analysis reverses the sense of Bhabha's argument, when he states that: 'My purpose in specifying the enunciative present in the articulation of culture is to provide a process by which objectified others may be turned into subjects of their history and experience'.[21] Bhabha's aim is to privilege cultural enunciation as resistance, but I would argue that the enunciations of media culture pre-empt and deter such resistance while adopting the same terrain. In a discussion of Michel Foucault's work, Bhabha argues:

Reading from the transferential perspective, where the Western ratio returns to itself from the time-lag of the colonial relation,

then we see how modernity and postmodernity are themselves constituted from the marginal perspective of cultural difference. They encounter themselves contingently at the point at which the internal difference of their own society is reiterated in terms of the difference of the other, the alterity of the postcolonial site.[22]

I agree that the postmodern appears very clearly as difference rather than homogeneity, if the globalising ambitions of McDonald's are aligned with the postmodern. The Singaporean commercials for McDonald's seem to demonstrate, like Pepsi's MTV commercial featuring Madonna, the simultaneous co-existence of homogeneity and difference in media culture. However, where Bhabha attributes a transforming agency to the fragmented, hybrid, local subject in and of the postmodern, I would argue that fragmentation, hybridity and locality are also assimilable into the institutions and texts of postmodern media culture, with the effect of troubling the politics of difference and resistance.

Globalisation can refer either to production (the objects and texts produced by global corporations), distribution (a global network of transmission technologies or institutions), or consumption (global mass audiences), and at each level processes of fragmentation and resistance are possible. Global corporations can be restrained by national or local restrictions on their activity, global networks may transmit the same object or text everywhere, but this does not determine modes of reception or the relative social significance of reception in different social contexts. Cesare Poppi, who is in general critical of postmodernist discourse, has therefore argued that postmodern theory and theory of globalisation should be regarded as discursive strategies which are themselves political, rather than diagnostic, tools: 'Globalization theory – like much "postmodernism theory" of which it represents one of the correlates – is as much the premise for the phenomenon that it describes as it is the result of extra-theoretical developments'.[23] Globalisation theory is a set of responses to problems of constituting a discourse which can address both homogenising and differentiating processes, and also economic, institutional, textual and reception practices. This is why it is so closely allied to theorisations of the postmodern, which is also a discourse which attempts to address similar problems of structure, agency, determination and difference.

The injunction to respect the radical otherness and difference of people's use of media texts in contemporary theory of the media, and the difficulty of specifying the dynamics of media by large-scale models of determination, are therefore aspects of the postmodern in my view. I argue that the postmodern is not only a term for the organisation or the textual features of contemporary media, but also for the changed conceptual landscape of media theory.

MEDIA AUDIENCE RESEARCH

The confidence to state general principles about media reception, use and effects has increasingly given way to work on particular media involvements and the specifics of agency by media audiences. Audience identity has itself fragmented into a complex of determinations, including class, region, age, gender, race, or occupation. A classic work which can exemplify this is Tamar Liebes' and Elihu Katz's study of cross-cultural interpretation of *Dallas*, where assumptions about the programme's global dissemination of American consumerist ideology were decisively countered by a range of different and sometimes incompatible kinds of retelling of the programme's concerns.[24] Israeli Arabs and Moroccan Jews, for example, emphasised the importance of kinship relations in the programme, while viewers in Russia more frequently discussed the manipulation of the characters by the writers and producers who created them. Both globalisation theory and ethnographic studies of local media cultures have emerged because of perceived inadequacies of theories of national media cultures and national ideologies as diagnosis or critique. Media audiences are regarded as both active and specific either as individuals or temporary subcultures, rather than as passively positioned by textual structures or aggregated as masses by institutional structures or technological apparatuses. The relation of media ethnography to critique is double-edged, as Christine Geraghty as shown in a wide-ranging discussion which explores similar problems to those I address in this section.[25] On one hand the attention in ethnographic audience studies to the negotiation of meaning by audiences emphasises the role of media in quotidian experience in a particular geographical, class and gendered cultural location, and corrects previous tendencies to monolithic notions of positioning in relation to totalising ideologies. But the

dependence of ethnographic research on studies of small samples of viewers tends to neglect their relation to large-scale ideological determinants, and the use of interview and observation methodologies focuses on conscious and articulable behaviour which can become reified and over-specific.

The movement from a model of the audience as a collective resistant subject to a more nuanced and problematic object of research can be seen in the development of work on youth subcultures in British cultural studies over the last twenty years, and provides an illustration of an increasing self-consciousness of the methodological problems which I regard as part of the postmodern. Work on youth subcultures takes its bearings from the work of the Birmingham Centre for Contemporary Cultural Studies, and in particular the books written in the 1970s by Stuart Hall and Tony Jefferson, Paul Willis, and Dick Hebdige.[26] Their emphasis on class as a determinant of different modes of youth experience challenged earlier accounts of youth culture as largely univalent, and showed that youth subcultures existed in relation to parental class-inflected culture. Thus youth subcultures, especially those of the working class, were seen as spaces of resistance to dominant culture where the evidence for resistance was found in attitudes to schooling, and in codes of taste, behaviour and appearance. The valuation of these subcultures as actively produced (as opposed to passively reproducing dominant commercial culture), authentic (rather than imposed by the culture industries) and resistant (rather than conforming to the dominant ideology), forms the basis of the positive value given to the same traits in studies of a whole range of cultural practices beyond youth subcultures in cultural studies in general. But as Sarah Thornton has pointed out, youth subcultures were regarded in masculine terms, and the dominant which they opposed was discursively constructed as feminine.[27] The resistance which the researchers had discerned at one level could be characterised as complicit at another level with conventional patterns of gender power. In response to this problem with the value of resistance, Angela McRobbie sought to discover whether girls were really absent from youth subcultures, whether subcultures reproduce gender inequality, and whether there are distinct feminine subcultures.[28] The emphasis on dance in McRobbie's work derives from the sense that the public space of the street, the apparent 'home' of youth subcultures, is less safe for girls, for

dance occurs in internal locations like clubs. Thornton found that dance clubs were not regarded as 'hip' by male youth, and the musical tastes and social rituals of dance clubs frequented by women were therefore exiled from value, so that the work of Willis, Hall and others seemed to reproduce a masculine definition of resistance and exclude young women's activities. Thus problems with the status of resistance in male youth culture led to a desire to supplement this work, and also reflected on the gendering of the research discourse which had produced it.

The attention to gender which feminist concerns brought to this issue had the effect of bringing the agency of young women to the fore, so that resistance would then appear progressive in its gendering as well as being both active and authentic. McRobbie aimed to show how girls negotiate their own feminine identities, under the constraints of family duties and behavioural controls which affect them more than boys. Girls, she argued, continued or challenged pre-existing models of teenage girlhood, in collusion with or in opposition to a sense of their future roles as wives and mothers. This process of negotiation was conducted by using and remodelling mass-produced commercial cultural products, thus refusing the characterisation of mass-media culture as univalent by showing how its resources were adapted for resistant activity. Her work on working-class readers of *Jackie* comic argued that its emphasis on romance prepared girls for their roles as wives and mothers, while reading the comic in class at school, and remodelling school uniforms in line with the dictates of fashion, replaced an official culture of the school with an informal feminine culture which functioned as a space of temporary resistance to this ideological demand. But again, as Martin Barker argued, McRobbie's study of this subculture values feminist (resistant) over feminine (conformist) practices, reproducing the radical versus complicit opposition evident in Birmingham cultural studies work of the 1970s, but this time in the sphere of gender identity.[29] Furthermore, a temporal projection presupposed an originary identity for the girls which was then corrupted by the practices into which *Jackie* interpellated them. The discourse of media audience research, in this example, was trapped in a series of oppositions of gender and agency which it seemed unable to escape.

McRobbie's later work on more recent magazines like *Just Seventeen*

followed an emphasis in feminist criticism on pleasure, reflexivity of critique, and questioning of ideological criticism, marking an increasing self-consciousness about the relation of theoretical discourse to its objects and to the subjects who it studies.[30] The discourse of research now aligned the theorist with the 'ordinary' readers she studied, admitted McRobbie's own pleasure in the texts of *Just Seventeen*, and allowed the possibility that the girls, like the critic herself, may not have been successfully interpellated by the magazines. The movement toward the dissolution of the theorist's position of mastery became mirrored in the differentiation and fluidity of the resistant identities which McRobbie found in her research subjects, and in the magazines around which media use was constellated. Consumption of products replaced romance in the magazines as the dominant mode of incorporation of readers, together with an ironisation of the presentation of the pop stars featured in them, less as a icon of romance than of sexual interest. McRobbie argued that the reader therefore had access to a more fluid and autonomous sense of identity and femininity, where the self 'can be endlessly constructed, reconstructed and customised. No longer lavishing attention on the male partner, the girl is free to lavish attention on herself and she is helped in this task by the world of consumer goods at her disposal'.[31] The *Jackie* analyses which she previously produced still function as an other against which a more feminist, more autonomous, and more playful model of femininity is measured. But the trajectory of McRobbie's work stands as an example here of the problems in the study of media audiences of moving from a homogenising model of media culture to a focus on differentiation, fluidity of identity and multiple forms of agency, which occur at the same time as a similar loosening of discursive mastery in the discourse of audience research itself.

The recent surge of interest in studies of specific media cultures, and in particular ethnographic studies of responses to media products, can be seen as a response to problems of critical legitimacy and practice which I argue are themselves aspects of the postmodern. Indeed Poppi has argued that specific cultural groups, like the resistant television audience groups studied in media audience research, are just as much imaginary unities as national cultures have been shown to be. Ethnicity assumes shared subjectivities between its members, and this assumption of subjective communities comes from the grand narrative of

modernity which assumed a universal subjective community. So the discourse of ethnicity repeats the assumptions of modernity in a reduced form. Therefore, rather than a resistance to globalisation as a homogenised subjectivity, the emphasis on audience specificity is a corollary of globalisation, and the two are interdependent. For Poppi, in an essay which is not specifically concerned with media audiences, 'what is being globalized is the tendency to stress "locality" and "difference", yet "locality" and "difference" presuppose the very development of worldwide dynamics of institutional communication and legitimation'.[32] Local subcultures presuppose global cultures which articulate them, and ethnographies presuppose globalising theories which they both assume and modify. While media ethnographies respond to the fragmentation observed in the postmodern by Fredric Jameson and others, the study of audience groups and subcultures carries over some of the founding assumptions of the sociological account of modernity. While some media audience cultures can claim a degree of cultural unity, their legitimation as local, for researchers and sometimes for themselves, is articulated in and against a media culture which is both national and global. As Henry Jenkins notes in a study of the Gaylaxian fans of *Star Trek*:

> Resistant reading can sustain the Gaylaxians' own activism, can become a source of collective identity and mutual support, but precisely because it is a subcultural activity which is denied public visibility, resistant reading cannot change the political agenda, cannot challenge other constructions of gay identity, and cannot have an impact on the ways people outside the group think about the issues which matter to the Gaylaxians.[33]

Some of the media-oriented subcultures studied by ethnographers do not have a constituted identity except when an identity is constructed in the process of the ethnographic work. In relation to the many studies of women viewers of soap opera, for example, Ien Ang and Joke Hermes have noted the tendency of researchers to essentialise the classed and gendered responses of particular research subjects so that it is assumed that all women of a particular class will enjoy television programmes in the same way.[34] Furthermore, when differences between women as a constituted group have been a topic of inquiry in

work on soap operas, the studies 'do not go as far as problematizing the category of "woman" itself'.[35] The work of Katz and Liebes sits somewhere between these poles, since their research on *Dallas* sought to articulate the local in and against the global, working on relatively defined national and ethnic groups, but ones whose coherence was neither self-created nor constituted solely by the researchers. As a general point, however, the identity of a media audience group can only constitute itself against the possibility of other different audience groups, whether in the discourses of the group itself, of television audience measurement, ethnographic studies, or textual analysis.

The fragmented subject of postmodern theory is a terminal in a diffuse set of social relations and multiple choices, in which the priority of one determination over another cannot be established a priori. Whether class, race, gender, or favourite TV programme is the most significant determinant of behaviour or belief is not in principle predictable. Media ethnography in social science is a form of implicit subject-production, though there are a range of ways in which this occurs. Among these are accounts of media fandom which construct media audiences as exotic others, where the audience group's subjectivity is constituted against a normative audience whose viewership it reacts against. In another kind of formulation, the ethnographer's discourse counters differences between researcher and audience with a collective subjectivity. An example of this would be in Julia Hallam and Margaret Marshment's study of women viewers of the British television serial *Oranges are Not the Only Fruit* (1989), where the researchers conclude that the diversity of viewers' responses 'remained within a recognizable "we" of common experiences and pleasures which seemed to owe much to our common positions as women'.[36] The imperative of some of this work is to rescue suppressed voices from a dominant culture which excludes them, thus claiming the agency of the subjects who are investigated, and claiming a political discursive agency for the analysis itself. Hallam and Marshment claim that:

we were not 'looking for' negotiated or resistant readings among the respondents . . . but our feminist standpoint does need to be taken into account. We hoped to find that they did like [the serial] and did interpret it in line with the preferred reading

because ... it would ... thus constitute a significant feminist anti-homophobic intervention in popular culture.[37]

Postmodern ethnography, responding to the perceived illegitimacy of realist modes of discourse and the positivism of social science, may even adopt postmodern textual modes to reproduce the complexity of contemporary culture. But these modes of writing, because of their immersion in the culture and discourse of their object, threaten to give up the project of critique and the political effectivity of their results. The problem, which is the problem of the postmodern, is how to find a rhetorical form which does justice to what the ethnographer observes, in a language game that is simultaneously reflexive and referential, with the purpose of communication and knowledge.

Ethnographic audience studies have derived much of their methodology from anthropology. As the discipline for examining different societies, anthropology rests on the assumption of developmental progress, where a primitive society exemplifies an earlier stage of development to the Western one. The totalisation of the notion of human progress as the temporal scheme mapped onto these societies requires the differentness of societies to be recognised so that this difference can be recouperated into the total story of humanity. The effect of the discourses of the postmodern on anthropology is to introduce into it a crisis in the epistemological security of this process of mastering difference and turning it into a homogeneous discourse about the teleological progress of the human. A fundamental point of origin for this debate is the work of Clifford Geertz in anthropology. Sharing some of the awareness of problems of discursive legitimacy which I have explored in postmodern theory, he sees ethnography as a textual practice, and takes the analysis of culture to be 'not an experimental science in search of law but an interpretive one in search of meaning'.[38] Geertz's 'thick description' (a term borrowed from the Oxford philosopher Gilbert Ryle) involves discerning 'a stratified hierarchy of meaningful structures in terms of which [social behaviours] are produced, perceived and interpreted, and without which they would not ... in fact exist'.[39] In media study, observing the behaviour of TV audiences is not enough – the observation must be interpreted in relation to the cultural categories which make it meaningful as socially symbolic action. Furthermore, the information gained by the

ethnographer must be an interpretation of what he or she observes, and when the information is relayed by a participant like a television viewer, the ethnographer's data will be interpretations of the participant's interpretations of his/her and others' actions and thoughts. Thus ethnography becomes textual analysis:

> Doing ethnography is like trying to read (in the sense of 'construct a reading of') a manuscript – foreign, faded, full of ellipses, incoherencies, suspicious emendations, and tendentious commentaries, but written not in conventionalised graphs of sound but in transient examples of shaped behaviour.[40]

The point of observation and interpretation is to get a sense of the tensions and dynamics of social life. This is a theory of articulation, a theory which, though it retains some notions of intentionality which may now seem outdated, is primarily oriented around the performance of meaning in a cultural context. The question Geertz asks about cultural action or behaviour is not its ontological status but its import as an articulation.

Geertz's subjects are shown to be expressing quite ordinary and shared feelings and tensions in their behaviour, but an exploration of their culture also reveals the intricate, singular and different ways in which they express these things: 'Understanding a people's culture exposes their normalness without reducing their particularity'.[41] People who live in a culture make first-order interpretations of their world, and each layer adds another order to this. But people in cultures also think about their own cultural behaviours, and thus provide 'native models' whereby they reflect on their own actions and motivations. So layer on layer of interpretation is produced, exaggerating the constructed quality of the ethnographer's text. Geertz parallels ethnographic description with fiction, saying that each is a form of writing which legitimates itself by a form of realism or mimetic adequacy to a sense of the real: 'It is not against a body of uninterpreted data, radically thinned descriptions, that we must measure the cogency of our explications, but against the power of the scientific imagination to bring us into touch with the lives of strangers'.[42] Of course this is done by writing things down, and Geertz sees the ethnographer as primarily a writer, so that evanescent events are

transcribed for posterity. But the observing, transcribing and interpreting functions involved are not as separate as they might appear, and in fact contaminate each other. To be an ethnographer means invoking several identities (participant-observer, recorder, author, interpreter, theorist) and producing a writing which will contain these different identities. The participant observers of television audience studies, who profess to belong to the subcultures they study, can forget that what they do in producing ethnography is a cultural practice itself, bracketed off from the 'natural' behaviour of those people who are their objects of analysis, and which will inevitably alter and prescribe the behaviour which is observed. More commonly in the discourse of ethnographic audience research, the researcher reflects on his or her agenda but tries to present viewers as either sharing his or her enthusiasms or politics, or being approached transparently by the researcher. Geertz comments that:

> The tension between the pull of this need to penetrate an unfamiliar universe of symbolic action and the requirements of technical advance in the theory of culture, between the need to grasp and the need to analyse, is, as a result, both necessarily great and essentially irremovable. Indeed, the further theoretical development goes, the deeper the tension gets.[43]

Thus for Geertz, ethnography is not a teleological science in which results improve and theory is complexified, but one where each study is particular, there is no necessary advance, and there is no obsession with arrival at a grand truth. Ethnography, from this point of view, begins to be conceived in the same terms as a postmodern practice of textuality.

One of the assumptions of postmodern theory is that theoretical discourses are constituted in and through language, as rhetorics rather than truth-claims, and are articulated in, and conditioned by, particular local contexts which preclude them from functioning as guiding principles outside of their original context. But there must still be one axiom which permits this view to function. This is that respect for difference is a rule which is itself indifferent and absolute. Habermas characterises the postmodern critique of Enlightenment reason, and thus its legacy in a social science which attempts to determine and

critique the role of the media, as entailing a confusion between two analytical discourses.[44] These are, first, a critique of scientific positivism and its concern for unmediated fact, and second a critical rationalist discourse in which reflective thinking in the public discourse of theory aims to evaluate the justice of specific social dynamics. For Habermas, the postmodern critique of reason confuses these two discourses while drawing on both of them. The critique draws on a positivistic discourse to establish a changed epistemological field, and draws on reflective thought to evaluate the significance of this change and its to adumbrate its consequences. My discussion of audience research has aimed to show that problems in the analytical discourse of audience studies repeat this tension between two uses of theoretical discourse, which I signalled at the start of this chapter and which I have explored elsewhere in this book. The interpretive activity of the audience is adduced as evidence which demonstrates the agency and difference of contemporary television viewers, and is also reflected on as a sign of the need to reevaluate the effectivity of analytical discourses about television. I would argue that the term postmodern suitably denotes not only the global, national and local culture of contemporary television, in which each of these spatial boundaries is interdependently articulated, but also, in the field of theoretical discourse itself, denotes the implausibility of a single analytical discourse on television, resulting in the current admixture of approaches deriving from the traditions of cultural anthropology, cultural studies and textual ideology critique.

Once the master discourse of the Western anthropologist is recognised as one discourse among many, and its claims to derive from the scientific modernity of the West as the endpoint of progress are relativised, its mastery is threatened. Not only is its mastery threatened as a political and scientific project, but also its mastery as discourse. Ethnographic work on media audiences has therefore become concerned to recognise difference in the media cultures it studies, and the difference which problematises the positivistic writing of its own discourse. This recognition of problems of addressing and writing the audience is the mark left by the postmodern on the discourse of audience research. One of the effects of this postmodern problem is the status of the recognition of difference, for to celebrate difference for itself is little contribution to the study of contemporary media. The demonstration of difference as represented by, for example, aberrant or

subcultural decodings, represents a weak form of relativistic difference which is consonant with the postmodern, and reflects the non-mastery of the discourse of research itself. I argued above that Bhabha's valuation of hybridity as resistant difference leads into a similar problem, where the postmodern difference of the non-Western hybrid both reflects the hybrid identities and cultures of the Western postmodern, and is also argued to provide a simultaneous valuation of difference and agency for this Western culture's other, the postcolonial subject. In this formulation, the postmodern becomes equivalent to the postcolonial, and is a sign that the cultures and subjects of the West are, or contain the possibility to become, as hybrid as their non-Western Others. This reverses the anthropological discourse, where the Other was a representation of humanity's past on the long march to Western modernity, so that now the Other non-Western hybrid identity is the endpoint towards which the West is travelling. But although such a reversal is interesting in itself, it collapses together the poles of the dominant and the resistant, and movements from centre to margin and margin to centre. What threatens to remain, in the discourses of the postmodern, the postcolonial and media theory, is a retotalisation of difference which despite its heterogeneity and political potential, lacks a direction.

NOTES

1. Chris Barker, *Global Television: An Introduction* (Oxford: Blackwell, 1997), p. 4.
2. Herbert Schiller, *Mass Communications and American Empire* (New York: Augustus M. Kelly, 1969); Herbert Schiller, *Communication and Cultural Domination* (New York: Sharpe M.E., 1976).
3. Arjun Appadurai, 'Disjunction and Difference in the Global Cultural Economy', in Mike Featherstone (ed.), *Global Culture: Nationalism, Globalization and Modernity* (London: Sage, 1990), pp. 295–310.
4. Alan Scott, 'Introduction', in Alan Scott (ed.), *The Limits of Globalisation: Cases and Arguments* (London: Routledge, 1997), pp. 1–22.
5. Anthony Giddens, *The Consequences of Modernity* (Cambridge: Polity, 1990), pp. 16–17.
6. Zygmunt Bauman, *Intimations of Postmodernity* (Cambridge: Polity, 1992).
7. Scott Lash, *The Sociology of Postmodernism* (London: Routledge, 1990).

8. Mike Featherstone, *Consumer Culture and Postmodernism* (London: Sage, 1991).

9. Fredric Jameson, *Postmodernism, or the Cultural Logic of Late Capitalism* (London: Verso, 1991), p. 14.

10. Pierre Bourdieu, *Distinction: A Social Critique of the Judgement of Taste*, trans. R. Nice (London: Routledge, 1984).

11. Frank Mort, 'Boys Own? Masculinity, Style and Popular Culture', in Rowena Chapman and Jonathan Rutherford (eds), *Male Order: Unwrapping Masculinity* (London: Lawrence & Wishart, 1988), p. 194.

12. Mica Nava, 'Consumption and its Contradictions', *Cultural Studies* 1: 2 (1987), p. 208.

13. Beverley Skeggs, *Formations of Class and Gender* (London: Sage, 1997).

14. Carla Freccero, 'Our Lady of MTV: Madonna's "Like a Prayer"', in Margaret Ferguson and Jennifer Wicke (eds), *Feminism and Postmodernism* (London: Duke University Press, 1994), pp. 179–99.

15. On debates around Madonna, see also Linda Lewis, *Gender Politics and MTV: Voicing the Difference* (Philadelphia: Temple University Press, 1990); Meaghan Morris, 'Banality in Cultural Studies', *Block* 14 (1988), pp. 15–25; J. Brown and L. Schultze, 'The Effects of Race, Gender, and Fandom on Interpretations of Madonna's Music Videos', *Journal of Communication* 40: 2 (1990), pp. 88–102; Ramona Curry, 'Madonna from Marilyn to Marlene – Pastiche and/or Parody', *Journal of Film & Video* 42: 2 (1990), pp. 15–30; M. Garber, 'Fetish Envy', *October* 54 (1990), pp. 45–56.

16. Homi Bhabha, *The Location of Culture* (London: Routledge, 1994).

17. Ibid., p. 172.

18. Ibid.

19. Clara Min Win Ong, 'Foreign Company Advertising in Singapore: A Critical Evaluation', unpublished dissertation submitted at the University of Reading, 1997.

20. Charles Forceville, *Pictorial Metaphor in Advertising* (Englewood Cliffs, NJ: Prentice Hall, 1996), p. 80

21. Bhabha, *Location of Culture*, p. 178.

22. Ibid., p. 196.

23. Cesare Poppi, 'Wider Horizons with Larger Details: Subjectivity, Ethnicity and Globalization', in Alan Scott (ed.), *The Limits of Globalisation: Cases and Arguments* (London: Routledge, 1997), p. 284.

24. Tamar Liebes and Elihu Katz, *The Export of Meaning: Cross Cultural Readings of 'Dallas'* (Cambridge: Polity, 1993).

25. Christine Geraghty, 'Audiences and "Ethnography": Questions of Practice', in Christine Geraghty and David Lusted (eds), *The Television Studies Book* (London: Arnold, 1998) pp. 141–57.

26. Stuart Hall and Tony Jefferson (eds), *Resistance Through Rituals: Youth Subcultures in Postwar Britain* (London: Hutchinson, 1976); Paul Willis, *Learning to Labour: How Working Class Kids Get Working Class Jobs* (Aldershot: Saxon House, 1977); Dick Hebdidge, *Subculture: The Meaning of Style* (London: Methuen, 1979).

27. Sarah Thornton, *Club Cultures: Music, Media and Subcultural Capital* (Cambridge: Polity, 1995).

28. Julie Garber and Angela McRobbie,'Girls and Subcultures', in *Feminism and Youth Culture: From* Jackie *to* Just Seventeen (Basingstoke: Macmillan, 1991).

29. Martin Barker, *Comics: Ideology, Power and the Critics* (Manchester, Manchester University Press, 1989).

30. Angela McRobbie, *'More!*: New Sexualities in Girls' and Women's Magazines', in James Curran, David Morley and Valerie Walkerdine (eds), *Cultural Studies and Communication* (London: Edward Arnold, 1996), pp. 172–95.

31. Angela McRobbie, *Postmodernism and Popular Culture* (London: Routledge, 1994), p. 165.

32. Poppi,'Wider Horizons with Larger Details', p. 285.

33. Henry Jenkins, in John Tulloch and Henry Jenkins, *Science Fiction Audiences: Watching Doctor Who and Star Trek* (London: Routledge, 1995), p. 264.

34. Ien Ang and Joke Hermes,'Gender and/in Media Consumption', in Ien Ang, *Living Room Wars: Rethinking Audiences for a Postmodern World* (London: Routledge 1996).

35. Ibid., p. 117.

36. Julia Hallam and Margaret Marshment, 'Framing Experience: Case Studies in the Reception of *Oranges are Not the Only Fruit'*, *Screen* 36: 1 (1995), p. 14.

37. Ibid., p. 3.

38. Clifford Geertz, *The Interpretation of Cultures: Selected Essays* (London: Fontana, 1967), p. 5.

39. Ibid., p. 7.

40. Ibid., p. 10.

41. Ibid., p. 14.

42. Ibid., p. 16.

43. Ibid., p. 25.

44. Jürgen Habermas,'Modernity's Consciousness of Time and its Need for Self-Reassurance', in Jürgen Habermas, *The Philosophical Discourse on Modernity: Twelve Lectures*, trans F. Lawrence (Cambridge, MA: MIT Press, 1987).

7

COMPUTER-BASED MEDIA

———— ⊃⊂ ————

This chapter evaluates claims that interactive computer-based media offer new kinds of subject-positioning, virtual experiences and social roles to their users. It has been argued, both by theorists of the postmodern, and by discourses circulating in the popular media (especially magazines based on virtuality and Internet culture) that a qualitative change in the meanings of subjectivity, community, society and politics is occurring and will continue to escalate. Computer-mediated interaction, therefore, stands as an example and a determinant of a shift to a postmodern media culture. This culture has been evaluated both as a positive, even utopian realignment of the relations between people which media enable and produce, but it has also been regarded as a perpetuation of politically regressive structures of domination and inequality. What is at stake, therefore, are questions of determination by technologies and by socio-political structures, questions of agency, empowerment and access, and questions of discursive effectivity in shaping the terms in which media culture is understood. These issues are aligned closely with the concerns of the earlier chapters in this book, and in common with my assessment of postmodern media culture in those earlier chapters, I argue here for the recognition of the different and conflicting significations of computer-mediated media communication as the objects of discourse, and the significance of this difference and conflict as part of the postmodern itself. This chapter traces the relationships between one of the dominant screen media of the twentieth century, the cinema, and the newer technologies of the screen, arguing that models of subjectivity which are proposed in writing about computer interactivity have a heritage shared with versions of

proto-cinematic spectacle at the beginning of the twentieth century. I also draw parallels between the representations of space in computer games and in the interactive computer environments like MUDs (Multi-User Domains), with representations of exploration and spatial domination in colonial discourse. In relation to technology, I demonstrate the consonance between the development of interactive computer entertainment products and the industries of military production and space exploration. The argument of this chapter is that, while computer-mediated communication plays an important role in the discursive delimitation of postmodern media culture, it is deployed as a discursive object in ambivalent ways which often deny its relations with media cultures which are already familiar.

TECHNOLOGICAL DETERMINISM

The technological determinist discourse of media theory attributes social and cultural effects to specific media.[1] The early proponents of this approach include Harold A. Innis[2] and his student Marshall McLuhan,[3] who, as I have argued in earlier chapters, consider communication from the perspective of information theory. It is argued that writing, typewriting, cinema, television and computers, bring profound changes to culture and human capacities due to the effect of their technological and cultural form rather than their contents. McLuhan wrote that: 'The "content" of a medium is like the juicy piece of meat carried by the burglar to distract the watchdog of the mind'.[4] This discourse remains prevalent in commentators writing about both analogue and digital media, including Friedrich Kittler,[5] and its traces can be read in Jean Baudrillard's work on new technologies. Baudrillard follows McLuhan's emphasis on technological form, but reverses McLuhan's proclamation that new media will bring the universal interinvolvement of people in a global village, by stressing the absorption of subjectivity, sociality and meaning into the 'pure' exchange of exchangeable digital units of data:

> All our machines are screens. We too have become screens, and the interactivity of men [sic] has become the interactivity of screens. Nothing that appears on the screen is meant to be deciphered in depth, but actually to be explored instantaneously, in an

abreaction immediate to meaning – or an immediate convolution of the poles of representation.[6]

The separation between the subject, the message and the medium is, in Baudrillard's view, replaced by the collapse of these poles into each other:

> The machine (the interactive screen) transforms the process of communication, the relation from one to the other, into a process of commutation, i.e. the process of reversibility from the same to the same. The secret of the interface is that the Other is within it virtually the Same – otherness being surreptitiously confiscated by the machine.[7]

The determining instance in Baudrillard's analysis is therefore the technology itself, which is attributed with an agency in abolishing the distance and difference necessary to distinctions between self and other, medium and message, real and representation. This analysis precludes the possibility of critique in the form of a political discourse on the interrelation of the human with technology. In contrast to the alienation of worker from machine, 'new technology, new machines, new images, interactive screens, do not alienate me at all. With me they form an integrated circuit . . . Here, the quality of being human, as opposed to being a machine, is undecidable'.[8] This proclamation of the end of the human appears to contrast strongly with the techno-logical utopianism of McLuhan, for example, and also with the popu-larising discourses on interactive computer-based media in consumer magazines. However, Baudrillard's apocalypticism and his vagueness about who the newly unalienated non-subjects of the technology are, is perhaps surprisingly paralleled by the popularisers of computer-based media.

Many of the commentators who have popularised the characteri-sation of computer-based media as progressive are associated with *Wired* magazine and with *Mondo 2000* magazine, each of which are American in origin. Some of the key figures here include Kevin Kelly, Howard Rheingold and Nicholas Negroponte.[9] This discourse, in con-trast to Baudrillard's, is positive about technology's relationship with culture, and promotes the extension of computer communication and

interchange as tools for the extension of democracy and humanistic understanding. The first edition of *Mondo 2000* magazine proclaimed in 1989:

> The old information élites are crumbling. The kids are at the controls. This magazine is about what to do until the *millennium* comes. We're talking Total Possibilities. Radical assaults on the limits of biology, gravity and time. The end of artificial Scarcity. The dawn of a new humanism. High-jacking technology for personal empowerment, fun and games.[10]

The valuation of youth, and the alignment of new technologies with an anti-hegemonic radicalism is predicated both on a millennialist rhetoric and a claim that a community of computer hackers will be the new subjects of the paradisical technoculture ushered in by the technology. However, the unstated claim is that the technoliterate pioneers will become a new elite, in effect the rulers and facilitators of a new utopian society. As Ziauddin Sardar argues: 'Cyberpunks are latter-day Utopians, the counterpart of Sir Thomas Moore, Francis Bacon, Tommaso Campanella and other European Utopians who cannibalised the ideas and cultures of the "New Worlds" to construct their redeeming fantasies'.[11] The millennialism and utopianism of *Mondo 2000*'s discourse is shadowed by the dubious politics of a self-proclaimed elect group, whose resistance is predicated on their alliance with the hegemonic aims of the corporate culture which originated and profits from the extension of technological media culture across the globe.

It is important to recall that magazines require advertising to reduce their cover prices to a level which potential readers will accept. A typical issue of *Wired* magazine contains twenty-two pages of colour advertising before the contents page is reached, and has a regular feature titled 'Fetish' in which the latest technological consumer products are featured. Of course, as in the case of any other glossy magazine, many of the feature articles are prompted by the release of new products which are tested, evaluated, or simply celebrated. While my concern in this section is primarily the editorial material shared by these magazines and the books written by some of their feature contributors, these discourses of comment and debate attain their visibility in part because of their assimilability into the commercial

context of technology marketing. In this sense my approach follows that of Sardar, whose writing on cyberspace draws parallels between the corporate aims of new technology producers and the aims of colonial companies. The cultures of computer media producers can be argued to be forms of colonisation and endo-colonisation, in other words the development of new markets for the re-export of goods produced in the Third World by Western-controlled industries, and the diffusion of these goods within the home markets in which those corporate producers are based:

> The monopolistic tendencies of those who control cyberspace reflect the ethos of the East India Companies. Just like the Imperial Companies, the access providers, like Sprint and Pacific Bell, are monopolies licensed by central government with a mandate to chart new territories and are working to promote a particular world view.[12]

In this situation, it quickly becomes a problem for the popularisers of technoculture to decide who the agents of the apparently new postmodern media culture of computer-based communications are.

I argued above that *Mondo 2000* initially portrayed the young technologists and computer hackers of the late 1980s as a subversive band of individualistic radicals, whose role would be to take control of the new technologies. Their aim would be to inaugurate a new elite who would harness the supposed potential of the technology to empower people. This empowerment remained vague, as a mixture of fun and games, the bypassing of market-determined scarcity and supply-demand economics, and a quasi-religious hastening of an apocalyptic reformation of the human spirit. The editorial of the second issue of *Mondo 2000* however, said:

> Call it a hyper-hip wet dream, but the information and communications industry requires a new *active* consumer or it's going to stall . . . This is one reason why we are amplifying the mythos of the sophisticated and creative hacker . . . A notion of TV couch potatoes (not to mention embittered self-righteous radicals) is not going to demand access to the next generation of the extensions of man.[13]

The constituency of agents in the new technoculture changes from a select community of hackers to a mass consumer public. The activity and radicalism of the hacker becomes a potential for everyone who has access to the technology, and the concern of the editorial is that the computer user will become as passive as the television viewer in the guise of 'couch potato', or as marginalised as the 'radical'. A middle course is therefore steered between these, in which the agency of the intelligent consumer will be the force which realises the potential of the 'extensions of man', an explicit reference to the subtitle of McLuhan's 1964 *Understanding Media*. The objective of *Mondo 2000* magazine is, therefore, not to form the virtual centre of a small community of utopian-anarchistic hackers, but instead to become the site in which consumers of computer technology recognise themselves and their aspirations. In a move familiar from other publications (like football fanzines or Barbie comics), the magazine both seeks to represent the consuming subject to himself or herself, and to extend the desire of and for this particular subjectivity into a desire for products.

If the subject of computer-mediated technology is not in fact the lone hacker, but instead the consumer of technoculture who aspires to the outlaw status of the radical and at the same time seeks the reassurance of a virtual community, it is important to consider the economic and geographical determinants of this identity. Sardar estimates the cost of access to cyberspace as about £1,680 ($2,700) per year, based on the price of a computer every two years, and the Internet service provider's and telephone company's annual charges.[14] Only about a quarter of the world's population have access to personal telephony, and an even smaller proportion of this group have the disposable income required for the purchase and renewal of the computer technology required to access the World Wide Web. Thus the substantive constituency represented both by Baudrillard's 'we' who are now reduced to screens (rather than subjects) by technology, and by the editorial of *Mondo 2000* magazine, is a very specific one. This 'we' is predominantly white, male, employed and living in what Jean-François Lyotard called 'the most highly developed societies'.[15] Although the high technology machines which run the Internet are made by workers in the Third World, in offshore plants in Vietnam, the Philippines or Mexico, for example, these people have little access to the supposedly worldwide technoculture which they themselves

produce. They are the information-poor, who exist in the realm of the 'scarcity' mentioned by *Mondo 2000*, the alienation mentioned by Baudrillard, and in the virtual territory ripe for colonisation by the technocultural corporatism which Sardar critiques. This economic and political reality therefore raises questions about the possibility of communities formed by or through computer-mediated communications.

In earlier chapters of this book I have outlined and critiqued Jürgen Habermas' notion of the public sphere as one of the centres of debates about postmodern media culture. Habermasian notions of the public sphere reappear both explicitly and implicitly in analyses and popularisations of computer-mediated communications, because one of the supposed advantages of this media culture is the possibility of communication at a distance between users of the technology. This communication, assuming that it can take place between rational subjects, can be argued to be the basis of a radically extended democratic and participative culture. Habermas wrote:

> By the 'public sphere' we mean first of all a realm of our social life in which something approaching public opinion can be formed. Access is guaranteed to all citizens. A portion of the public sphere comes into being in every conversation in which private individuals assemble to form a public body.[16]

I have already drawn attention to the fact that, for the foreseeable future, access to computer communications technology cannot be guaranteed to all citizens. But I would like to consider the final sentence of this quotation, in which a public sphere can be formed by individuals forming a collective 'social body'. One of the writers associated with *Wired* magazine, Howard Rheingold, has defined virtual communities as being produced by the quantitative increase of subscribers to a virtual discussion site: 'Virtual communities are social aggregations that emerge from the Net when enough people carry on those public discussions long enough, with sufficient human feeling, to form webs of personal relationships in cyberspace'.[17] The first question which can be posed here is the point of quantitative increase of subscribers which will enable the formation of a community, and the length of time for which a discussion must be continued. These are perhaps trivial questions, but they are given added force by the final

quantitative measure, 'sufficient human feeling'. This is important because of the similarity between this notion of 'human feeling' and Baudrillard's point, quoted above, that the 'quality of being human' as opposed to being a machine, becomes undecideable when people are connected interactively in computer media culture. Reading back the question of quantity into Baudrillard's terms, it could be argued that when enough people are connected for long enough to a virtual community, they precisely lose the ability to possess 'sufficient human feeling' to form a community. Rheingold's metaphor for the communal links between people is that of a 'web': if people are connected enough by the interactive technology of the World Wide Web, they will form a 'web of personal relationships'. Or, adopting Baudrillard's negative version of a similar scenario, if people's webs of personal relationships are constituted by interactions on computer media, these personal relationships take on the forms of the technological media in which they take place.

My point is that Habermas' notion of the public sphere is, in this instance, one with a reversible value. For Rheingold, the computer media offer a postmodern version of a 'traditional' community, a public sphere. For Baudrillard, the public sphere of postmodern media culture is a simulation generated by the form of the technologies by which it is constituted. For Rheingold, the Habermasian public sphere is a legitimating value which allows him to value computer-mediated communication as the inheritor and regenerator of the social totality. For Baudrillard, the Habermasian public sphere is already a simulation, whose vacuity exposes the rhetoric of the social and of sociology as the servant of technoculture. In posing this equivalence and reversibility between Rheingold's utopianism and Baudrillard's dystopianism, I have neglected some of Rheingold's hesitancy about the promise of technoculture. In fact, Rheingold does declare that:

> Perhaps cyberspace is one of the informal places where people can rebuild aspects of community that were lost when the malt shop became a mall. Or perhaps cyberspace is precisely the *wrong* place to look for the rebirth of community, offering not a tool for conviviality but a life-denying simulacrum of real passion and true commitment to one another. In either case, we need to find out soon.[18]

Nevertheless, I would argue that Rheingold's hesitancy demonstrates further the equivalence between the positive and negative discursive constructions of technoculture, since his two versions of community in the quotation are posed as equivalent opposites. Both of these are possible futures because Rheingold (though not Baudrillard) regards the achievement of virtual culture as not yet completed, and it is this sense of being poised at a moment of change that I discuss next in relation to virtual reality.

VIRTUAL REALITY

Virtual reality (VR) systems use binocular screens close to the viewer's eyes, together with sensors attached to parts of the body, so that a virtual environment can be presented on the screens to the user. This is a simulation produced mathematically by a computer, and the feedback of actions by the user into this virtual environment produces an impression of movement and activity by the user in the virtual world. As Philip Hayward argues, this kind of virtual world is still in an early phase of development, and as yet there are no generally available systems which can provide a photorealistic immersion with whole body feedback.[19] The VR reality is therefore doubly virtual in the sense of being a discursive object used by commercial, media and academic commentators to consider, advertise and promote the development of these systems. Hayward describes a 'gradual diffusion through a range of (sub)cultural channels whose character and concerns have moulded the public image and perception of the phenomenon'.[20] The first of these discursive constructions was an article by James Foley in *Scientific American* in October 1987 on advanced interfaces like the dataglove, a device worn on the hand of the user whereby movements of the hand control the position and actions of the virtual representative of the user in the virtual environment. Conventional gestures allowing manipulation of the VR environment with datagloves include forming a fist to grasp and therefore move an object, and pointing in order to 'fly' through virtual space. Rebecca Coyle points out that 'the real is constantly rendered "virtual" in order to be more manageable', and this approach to the significance of the technology would lead to an instrumental understanding of VR as a tool for the more efficient manipulation of the real by means of its simulation.[21] From this perspective,

the VR dataglove is literally an 'extension of man', as McLuhan might have argued, and provides the basis of a potentially positive understanding of the technology in humanist terms.

Apparatuses which provide virtual representations in and of movement in space and time have been claimed as both examples of, and the agents for, a postmodern subjectivity. The simulation of the real from models has been described by Anne Friedberg, in a discussion of media virtuality, as 'a gradual and indistinct epistemological tear along the fabric of modernity, a change produced by the increasing cultural centrality of an integral feature of both cinematic and televisual apparatuses: a *mobilised "virtual" gaze'.*[22] The subjective experience in postmodern media culture is one in which technology transports the consumer to a virtual environment primarily experienced visually:

> The *virtual gaze* is not a direct perception but a *received* perception mediated through representation. I introduce this compound term in order to describe a gaze that travels in an imaginary *flânerie* through an imaginary elsewhere and an imaginary elsewhen.[23]

The historical roots of this virtual media experience go back at least to the spectacles and tourist experiences of the nineteenth century, and to popular literature, and involve physical movement and the experience of travel in space and time. Science fiction, historiography and archaeology, which all blossomed in the later decades of the nineteenth century, share an interest in representing a future moment, a documented moment in the past, or an arrested time, and spatialising this environment so that it can be explored and traversed by a spectator or his or her fictional surrogate. The common feature in these different aspects of culture is the refinement of techniques of representation which can make what is past, absent, or fantastic into something which can be recreated, simulated and rendered virtually present for an individual subject. For Friedberg, the fundamental origin of the virtual is the cinema: 'The cinema developed as an apparatus that combined the "mobile" with the "virtual". Hence, cinematic spectatorship changed, in unprecedented ways, the concepts of the *present* and the *real'*.[24] Virtual temporal and spatial mobility were the principal attractions of such proto-cinematic devices as the diorama and panorama, which used highly realistic painted backdrops and carefully

arranged effects of perspective and depth of field to seem to place the spectator in a remote landscape, or at the occurrence of a famous past event. These devices were enthralling because they transported the spectator to alien places and times by means of visual technologies and supporting special effects. What was experienced was a vision of another place and another time, but the whole spectacle depended on the spectator's familiarity with how to look, and on some familiarity with the cultural significance of what was represented. As theories of spectatorship have shown, the principle of cinema and other audio-visual technologies is to offer what is recognisable and familiar, balanced against the pleasures of the new, of what cannot be experienced in quotidian reality. The spectator is moved through represented space and time, and offered an imaginary spatial and temporal mastery.

These technologies of virtual movement rely on the spatial containment of the subject of perception and the object of perception or screen inside a conventional space, most often a physical building constructed for the purpose. But the move to immersive experiences of virtual spatial and temporal movement, towards what is now called virtual reality, runs on a historical line of development from these cinematic and proto-cinematic devices through fairground rides, before arriving at its current form. Douglas Trumbull was the special effects filmmaker who worked on the psychedelic sequence in *2001: A Space Odyssey* (1968) which portrays the shift from our dimension to the curious space of the white room at the end of the film. He also produced the spacecraft which seems to be made of light in *Close Encounters of the Third Kind* (1977), the Los Angeles of 2019 in *Blade Runner* (1982), and directed both *Silent Running* (1971) and *Brainstorm* (1983). In each of the films, there are sequences where both the character and the spectator are allowed to be still and look at the effects-world created. The effects shot is sublime, both beautiful and awesome in its disturbing strangeness. After being dissatisfied with the generally negative reception of *Brainstorm*, Trumbull began to work on multimedia experiences for theme parks, rather than on films. One of these is the 'Ridefilm Theatre', which consists of a module in which fifteen people can be seated and enveloped by a 180 degree spherically curved screen. The projection of high-resolution images on to the screen is accompanied by the synchronised physical movement of the module to produce effects of motion for the spectators. It is in effect a simulator (like the

modules and screens used in flight simulators), a combination of cinema and fairground ride. What virtual reality does is to replace the site-specific installations of the cinema screen and the fairground ride or simulator with a privatised technology closely attached to the body of its user. This notion had already been explored in the late 1950s and early 1960s.[25] Both the Stereoscopic Television Apparatus for Individual Use (STAIU) of 1957 and the Sensorama Simulator of 1961 were patented by Morton Heilig, and used headsets to produce 3D vision, together with a vehicle with seats accommodating four people at once, and supporting effects like breezes of air, smells and tactile sensations. Virtual reality technologies separate the immersive bodiliness of these experiences from the public spaces and leisure cultures in which they have originated. From this perspective, the citation of virtual reality as the agent of a postmodern subjectivity has more to do with the privatisation and bodiliness of an audio-visual simulation than with its relation to the real.

However, Slavoj Žižek's work on VR proposes a more Baudrillardian inversion and reversibility of the relationship between the real and its virtual representation. Žižek argues that VR offers a 'lesson' about the ontological status of representation itself, for, in virtual reality, 'true the computer-generated "virtual reality" is a semblance, it does foreclose the Real, but what we experience as the "true, hard, external reality" is based upon exactly the same exclusion'.[26] Žižek's 'Real' is the Lacanian Real of the inaccessible edge of representability, which cannot be assimilated into symbolisation, and symbolisation of any kind both reaches for, and fails to capture, that which is symbolised. Žižek continues: 'The ultimate lesson of "virtual reality" is the virtualization of the very "true" reality: by the mirage of "virtual reality", the "true" reality itself is posited as a semblance of itself, as a purely symbolic edifice'.[27] While Žižek's writing derives from a specifically psychoanalytic set of concerns, its conclusions about VR return to issues of the collapse of the real and its representation. I argued above that the discursive construction of virtual communities and the virtual interactions of computer-based media communications could be construed as either the reinvigoration of social interaction, or the simulation of social interaction in the terms of the technologies used to facilitate it. In the case of VR, which is already a virtual object in the sense that it exists at the moment as a discursive construction rather than an

achieved media technology, a similar phenomenon can be observed, in that the categories of real and representation collapse into each other. One of the consequences of research into VR technologies is the production of discourses about it in popular media. Popular journalism, television programmes, and popular scientific publications have created what Hayward calls 'a simulacrum of the medium *in advance* (against which its products will be compared)'.[28] VR has been employed as a resource for fictional speculations about technoculture in films including *Tron* (1982), *The Last Starfighter* (1985), *Lawnmower Man* (1992) and *The Matrix* (1999). The technology has been imagined as an escape from the banality and complexity of the real, as a means of exploring postmodern notions of virtual identity, and as a fantasy of empowerment and eroticism. Thus VR as a postmodern medium should be regarded as a means to debate and disseminate notions of postmodern media culture. It is a site in which questions of the real and its representation, and culture and its politics, are fought out in the domain of discourses addressed to a virtual object.

The unavailability of VR paradoxically makes it available to become a simulated object not only in written discourses about postmodern culture, but also in visual media themselves. Films including *Tron*, *Lawnmower Man* and *The Matrix* have been advertised by the promotion of spectacular effects sequences, in which the cinema spectator is invited to admire cinema's simulation of the simulacrum of VR. This double distance from the material reality of the technology, and its abstraction from economic and political concerns, is ironically evident in the promotion of *Lawnmower Man*. The film raises questions about the gendering and institutional control of VR technology by representing a 'virtual rape' by VR, and the co-option of the technology by sinister corporations. However, these political aspects of the film were not alluded to in the use of the 'virtual rape' sequence of the film for publicity purposes, when the extract was repeatedly shown in television advertising, and referred to in journalistic promotions, but without reference to the sexual violence in which the narrative placed the VR simulation.[29] As I have argued above, the dissemination of consumer technologies of computer-mediated communication can be paralleled to the assimilation of territories by Western colonisers, and this suggests the further parallel between the gendering of colonialism and the gender politics of VR. Colonial territories were available to

Westerners as places to play out sexual fantasies which were socially unacceptable in their home culture, and representations of colonial territories often figured them allegorically as women. Sardar argues that: 'If cyberspace is the newly discovered Other of Western civilisation, then its colonisation would not be complete without the projection of Western man's repressed sexuality and spiritual yearning on to the new continent'.[30] It is therefore important to consider the deployment of VR as a discursive object by feminist critics of postmodern media culture, to evaluate the place of the body as the other to virtual technological representations, and to consider the relationship between discourses of technological determinism and sexuality.

Virtual reality, as Andrew Gibson has shown, promises an extension and mutation of form which goes beyond the body, thus seeming to literalise anti-essentialist postmodern concerns: 'there is no clear boundary between the matter controlled by the computer and the material of the observer'.[31] This indistinct boundary between actions in the 'real' and the 'virtual' environments, enabled by devices like the dataglove, facilitates a liberatory discourse which separates the subject from the body which is argued to have determined its gendered identity hitherto. Donna Haraway's work on cyborgs defines them either as creatures that are part human and part machine, or as a network of people connected by a computer-based communications medium, and the user of VR would figure in her argument as a cyborg subject because of the interface between the physical body and its virtual representative. For Haraway, the discourse of cyborg feminism assists in a struggle to reinvent nature, for it redeems:

odd boundary creatures – simians, cyborgs and women – all of which have had a destabilizing place in the great Western revolutionary, technological and biological narratives. These boundary creatures are, literally, *monsters*, a word that shares more than its root with the word, to *demonstrate*. Monsters signify.[32]

The monstrous goes beyond the organic body, and confronts non-representability, non-naturalness, contingency, fusion, and difference, showing 'how not to be Man, the embodiment of the Western logos'.[33] The virtual object of VR and its separation from the physical body of its user therefore represents a locus for theorising an escape from social

distinctions based on the body, like racism, sexism or the stigmatisation of disability. The cyberspatial environments of VR are significant as examples because they represent at the same time a technologically mediated, inhuman world, but one which can be visualised as a spatial phenomenon and made susceptible to human action (via devices such as the dataglove). Thus discourses on VR can simultaneously claim that it supersedes the human and the body, and also enables the human and bodiliness to be reinserted into it in the form of the embodied perceiving position (through a graphic representation of the user). VR experiences, for Scott Bukatman for instance, offer 'a *fantasy* of cyborg empowerment and a *real* tactics of adaptation to the exigencies of terminal reality'.[34]

However, writers addressing the current, as opposed to predicted, uses of VR technologies stress their linkage with the discourses of the Western logos which Haraway seeks to evade. With reference to the spatialisation of VR, Sally Pryor and Jill Scott argue that it inherits a Western notion of perspectival space: 'VR rests on an unstated foundation of conventions such as Cartesian space, objective realism and linear perspective . . . they are deeply rooted in an historical philosophy that privileges perspective, with its implications of detachment, objectivity and observation'.[35] The mind and body are conceptualised according to Descartes' metaphysics, where the binary opposition of mind and body is paralleled by oppositions between subjectivity and the object, self and other, culture and nature, reason and emotion, male and female, public and private.[36] Similarly, Anne Balsamo shows that in immersive VR technologies, the already existing naturalisation of perspective seeing renders the body a redundant extra.[37] Once the perspective eye/I is paramount, bodies are dematerialised as its other, inheriting the feminisation of the body as other to the rational observing eye. The body returns as either corporeal meat, or as raw material for, among other practices, reproductive technology and cyberporn. Linda Howell and others have written persuasively on the power of representational technologies used in assisted reproduction to give the status of an independent being to the unborn child, displacing its relation to the mother's body.[38] Against such critics as Stafford[39] who claims that electronic imaging systems are liberating, Sarah Kember argues that imaging technologies are directly related to a tradition of nineteenth-century medical photography.[40] CAT scans and magnetic resonance imaging, Kember argues, are means for controlling and classifying the

female body, and thus draw on traditions of gender normativisation and surveillance which have existed for over a century.

The scientists working in VR have links with countercultural environ-mentalist politics, and the laid-back culture of Silicon Valley personified by the founder of Apple Computers, Steve Jobs. They are predomi-nantly white, middle class and currently in their forties, and Hayward associates them and their technological interests with science fiction, rock music culture and psychedelia, and New Age mysticism. The science fiction novelist William Gibson is considered the 'father' of VR technology, coining the term 'cyberspace' in his novel *Neuromancer* (1984), though he had nothing to do with the development of the technology or the institutions producing it. When Gibson used the term cyberspace to describe the graphic representation of computer data, he drew on a tradition of virtual worlds already common in science fic-tion and fantasy literature, and the gender politics of cyberpunk fiction closely match those of discourses on VR. The pioneer of VR technology, Jaron Lanier, was also the son of a science fiction writer. Cyberpunk fiction has both suggested but also failed to imagine the relativisation and virtualisation of the gendered body, since the body is always that to which the cyberpunk hero returns. Inheriting the generic conventions of the romance and the adventure story, cyberpunk fiction gives back a body and a romantic partner to the (male) protagonist. While cyber-punk and the discourses around VR imagine the destabilisation of the relations between the body and representation, they return finally to the Western logos. At the end of *Neuromancer*, at the boundary between text and the real, the human returns. When writers on VR turn from its utopian potentials to its concrete material uses in contemporary institutions, it fits all too easily into practices of surveillance, leisure, exploitation and domination. What is at stake, then, is the relationship between the discursive construction of VR as a postmodern media cul-ture, and its embedding in social and cultural practices. My particular interest in this debate is the ambivalence and virtuality of VR and other computer media when they become the objects of discourses about postmodern media culture.

COMPUTER GAMES AND MUDS

Scott Bukatman distinguishes between types of interface: those that

incorporate sensory engagement, including computer games and theme parks, and those which promote engagement by narrativisation, like literature. Computer games possess both sensory engagement and narrative, and Bukatman contrasts the constraining influence of narrative with the possibilities opened up by VR:

> Repeatedly, the operations of narrative constrain the effects of a new mode of sensory address, and so the fascination with the rise of virtual reality systems might represent a possible passage beyond narrative into a new range of spatial metaphors. The richer the sensory interface, the more reduced is the function of narrative.[41]

Nevertheless, as I have argued above, narrative returns to virtual reality in the narrativisation of the technology as a virtual object, and the contest between critical writings which figure computer media as either liberatory or constraining, as either definitively new or as continuations of cultural and political forms from the Western tradition. I would now like to consider computer games as narrative media, in relation to the ways in which they can be in turn narrativised as discursive objects.

The first discourse which I shall consider is the question of the determination of the cultural significance of computer games by their historical development. This narrative about games concerns their relationship with the American military and space industries, making a connection with Fredric Jameson's view that postmodern media culture is an expression of the global ambitions of late capitalism, and co-exists with the domination of Western powers. The three forces prompting the development of VR, too, are the defence industry for combat and surveillance, NASA for remote sensing and exploration (telepresence) and the games industry. In an earlier chapter I discussed representations of conflict, and referred to media representations of the Gulf War, and it is relevant here to note the relationship between the technological development of both VR and game technologies with military systems of command and control. The Gulf War has been represented in games, including MicroProse's F15 Strike Eagle II, where the user is in control of a simulated cockpit of an F15, drawing on the technology which produced computer-controlled weaponry in the first place. The display system used by Allied Gulf War bombers

enables a representation of the battlefield to appear in real time, with symbols representing allied and enemy equipment, the target, and a bomb or missile. A pathway is shown representing the attack flight-path, and eye movements of the pilot can be read by the system as commands (to fire, for example). The parallel between military and games systems is not only in the institutional links between games development and military funding of VR, but also at the level of inter-face representations, where contemporary aircraft and combat games use similar interface conventions. There is also a cultural crossover between the physical proficiency required in games, their action and goal directed nature, and their reported popularity in the masculine culture of military pilots.[42]

As Leslie Haddon explains, the first games were developed by researchers in computer science departments of American universities in the 1960s, then adopted by computer amateurs in the 1970s.[43] Each of these groups designed games as ways of learning about computer programming. The Massachusetts Institute of Technology (MIT) intro-duced its first computing courses in 1959, and the military and science fictional scenarios of games, evident since their earliest incarnations, derive from the institutional links between computer science depart-ments and the American military, and from the masculine culture of MIT personnel. MIT set up an AI (artificial intelligence) research team which obtained funding from NASA's military and space computing budget. The community of computer hackers at MIT used games to develop new ways of processing information and presenting it, and in 1962 Steve Russell completed and exhibited the science fiction combat game Spacewar. Games arcades are the second line of development of computer games, and led to the production of versions of arcade games for the home computer and console markets. Nolan Bushnell, an engineer who had played computer games as a student, designed an arcade version of Spacewar in 1971, and the success of his next game, Pong, enabled him to found the Atari computer company. The Space Invaders game of 1978 was the first to be successful internationally in the arcade market, where it began to replace pinball machines. Haddon sees the predominance of action games as resulting from the fact that early games designers were male, and that masculine arcade culture favoured noisy and fast action games, often related to other media products marketed to young males like action films or comics.

Major component manufacturers like National Semiconductor were entering the consumer market with digital watches and calculators in the mid 1970s, and saw games as a new market for their products. It was the American company Sanders Electronics, mainly working in the defence industry, which was the first to produce a commercial games package, Odyssey, in 1972, which could be used on a domestic television set.

This narrative history of computer games allows a connection to be established between a technology, the narrative forms of many games, the masculine culture of computing research in the United States, and the masculine culture of the American military. The determination of games by this set of cultural factors can be taken further by Mary Fuller's and Henry Jenkins' research on video games, which uncovers direct parallels between the representations of the frontier, the New World and the Other in video games and in documents of the colonisation of the New World.[44] In an analysis of Nintendo computer games, Fuller and Jenkins demonstrate shared narrative tropes, representations of space, and representations of gender among a range of computer games and documents concerning the colonisation of the New World, including Christopher Columbus' *Diario* (1492–93), Walter Raleigh's *Discoveries of the large, rich and beautiful empire of Guiana* (1596) and John Smith's *True Relation of such occurences and accidents of noate as hath hapned in Virginia* (1608). Fuller and Jenkins conclude that the discursive construction of computer games, far from being a distinctively new form of textual and cultural form, repeats the rhetoric of the colonial period in Renaissance modernity,

> the desire to recreate the Renaissance encounter with America without guilt: this time, if there are any others present, they really won't be human (in the case of Nintendo characters), or if they are, they will be other players like ourselves, whose bodies are not jeopardized by the virtual weapons we wield.[45]

Nintendo games, therefore, become instances of a tamed and virtualised conquest of the other, and this analysis can be supported by further examples including MicroProse Colonization, which allows the user to: 'Play the colonist and found a nation in the New World. Outwit rivals, forge alliances, create new industries, prevent revolts and

eventually you'll be able to declare independence'. It is misleading, however, to assume the determination of games by this single narrative, despite its significance. Dan Fleming reports that Sigeru Miyamoto, the designer of Donkey Kong and the Super Mario games for Nintendo, consciously drew on a multitude of sources in the media culture of the time when designing games.[46] These included Disney films, the techno-fantasy of Japanese and American popular film and comic culture, and Star Wars (1977). So while there are traces of Western colonial narratives in some of these sources (like Star Wars), some of the features of the games, including the physical characteristics of the characters, derive from multiple intertexts in the media cultures of the developed nations.

This multiplicity of determinants makes textual analysis of computer games a problematic methodology, just as I have argued elsewhere in this book in relation to other examples of postmodern media products. In Spectre Supreme, the game combines the military scenario of a tank battle with the science fictional features of a hyperspace gateway and the wire-frame playing space used in some of the sequences in Tron. More strangely, the goal of the game is to collect flags which resemble those used in golf to mark holes, and the instructions to the player combine all of these discursive fragments together:

> In Spectre, you see a virtual world from the point of view of a battle craft, a 'Spectre', roaming around a computerized arena. The object of the game, of course, is survival. Shoot your enemies, collect ammo and flags, and race on to higher levels. That's basically all there is to it. Try not to get too addicted, okay!

The Star Trek: 25th Anniversary game combines the numerous determinants and resonances which can be observed in the television series on which it is based. It is at once a combat game, in which the player is required to defend the Enterprise against space pirates, Romulans and Klingon spacecraft, and a strategy game where the player is confronted with aliens to whom he or she must behave humanely, or with puzzles which require simple logical deduction and spatial skills. The game's manual explains:

> In Star Trek®: 25th Anniversary™ you take on the role of the captain of the U.S.S. Enterprise™, James T. Kirk. As Captain Kirk,

you are faced with the same command decisions he faced, but it's your choices that will decide the fate of the U.S.S. Enterprise™ crew.

The reward for successful navigation through the game is measured against the imperatives of Starfleet, which are not the same as the simple readiness to exterminate others and the speed of physical response to stimuli which shoot-'em-up games require:

> The better you do in a given mission, the higher the rating Starfleet will give you. Solving puzzles, aiding others, and behaving like a representative of Starfleet in general is the key to high ratings. Violence never helps your rating, and may actually hurt it.

The liberal humanism of the *Star Trek* television series is incorporated into the game, in conjunction with more conventional features of combat-based computer games. Despite these differences in the aims and intertextual sources for them, there is a very limited set of activities which playing them involves. In many games, reading information on the screen and adducing what is significant from it parallels the cognitive activities of reading a book, while the solving of puzzles involving combinations of shapes and colours, the collection of useful objects, or the ordering of activities in order to solve a problem, derive from board games and puzzle magazines. The dexterity with a virtual weapon, and the navigation of a represented space, are familiar from both children's games and the paintball combat beloved of corporate middle-managers. The components of game play in computer games are scarcely evidence in themselves for a distinctively new form of post-modern media culture.

However, in computer-mediated interactions the relationship of the body to the machine both opens the possibility of considering this media culture as postmodern, and also problematises the evaluation of such a claim. Utopian and dystopian discourses about cyberspace and virtual communication have both emphasised the capacity of these technologies to free users from what Michael Benedikt calls 'the ballast of materiality', because in cyberspace the body disappears into the weightlessness of cyberspace and time.[47] But to play a game is partly to identify with the features of the game world, with the possibility of

'losing' the body, and also to pass beyond them into a bodily relation to the geometry of the game, coordinating eyes, mind and hands in a merging with the physicality of play itself. This duality is particularly evident in Multi-User Dungeons (or Dimensions), which were first created in the early 1980s by Richard Bartle as interactive multi-user games to be played on the Internet.[48] MUDs are text-based environments where standardised keyboard commands (like 'say' or 'move') are followed by content created by the user (producing a result like 'Kate says hello' on the screens of the other players). Users speak, move, manipulate objects or sometimes create new locations or objects in the medium of writing. After the user has set up his or her character description, when someone types <look> they will receive a description of the character in the guise of human, animal, or machine. Depending on the constraints of a particular MUD, users may either choose the characteristics of their character (known as an avatar) from a range of options including age, sex, physical and psychological qualities, or create them entirely. Even the options of a neutral sex or multiple sexes exist in tension with the maleness and femaleness of users, and while there are many more male MUD users than female, this imbalance is redressed by the choice by male users to become female avatars. Becoming female has some advantages, since users tend to be more friendly and helpful to female avatars. Nevertheless, as Sherry Turkle points out, 'to pass as a woman for any length of time requires understanding how gender inflects speech, manner, the interpretation of experience', and thus a recognition of how gender as a cultural code relates to bodily sex.[49] While Dawn Deitrich raises the sensible objection that the socialisation of gender is so pervasive and complex that it is not possible to simply exchange one identity for another in a virtual environment 'by assuming a "different point of view"', the construction of an avatar's gender in parallel or contradistinction to the sex of the avatar, and to both the gender and the sex of the user, is at least the opening up of a space where a relativity of gender in relation to the body can be experienced.[50] What is at stake then, is the virtualisation of identity because of the separation of user and avatar, via the physical materiality of an interaction with a technology. The determinations of identity are deferred by a new technology, but one which depends on the deferral and difference provided by writing, a form of communication which is 'traditional'. As a postmodern

media culture, MUD cultures both embrace the novelty of media technologies and the heterogeneity of identity, but produce this newness by a dependence on traditional forms of communication.

There is a tension between a rhetoric which refers to computer-mediated communication as a community, and the solitariness of the time of the interaction and its dependence on a relation between the user's individual body and the computer itself. Indeed these public and private forms of cultural engagement fold into each other on the basis of their dependency on each other. For participation in a virtual community or computer-mediated environment provides the possibility of separation from bodily surveillance in the 'real' world, precisely in order that a virtual body and identity can be publicly performed in virtual computer space. It is significant I think, that Mark Lajoie has described the Internet as a 'spectacular hall of mirrors', for the attraction of a hall of mirrors is to see oneself differently, as a virtual mirror image, but also to allow this distorted image to be seen by others in a public space.[51] However, it is one of the attractions of virtual communication that the body which produces the mirror image need never appear to other interlocutors, and such a confrontation with the material body has the potential to defeat the liberatory promises of virtual communication. When Howard Rheingold reports his over-whelmingly positive experiences in the virtual community of the Whole Earth 'Lectronic Link (WELL), he gives a brief and surprising account of going to a party at which his virtual interlocutors were present in the flesh:

> I looked around at the room full of strangers when I walked in. It was one of strangest sensations of my life. I had contended with these people, shot the invisible breeze around the electronic watercooler . . . But there wasn't a recognizable face in the house. I had never seen them before.[52]

The party is a public space, parallel to the public space of the WELL itself, but where the bodiliness of others gives Rheingold an experience of otherness and defamiliarisation. What was other becomes familiar, and what was familiar becomes other, with the body as a liminal and indeterminate separator between these two modes. This confusion of boundaries reappears later in Rheingold's essay, when he confesses that:

Not only do I inhabit my virtual communities; to the degree that I carry around their conversations in my head and begin to mix it up with them in real life, my virtual communities also inhabit my life. I've been colonized; my sense of family at the most fundamental level has been virtualized.[53]

The space of the 'head' as interior and private is 'colonised' by the public interactions of the WELL, in an equal and opposite movement to Rheingold's private computer use which admits him to that community. Throughout this chapter I have been concerned with the reversibility of the terms of evaluation of computer media culture. I have also problematised this medium with regard to the determinants, at the levels of technology, politics and subjectivity, which would allow it to function as an example of postmodern media culture. In common with arguments made earlier in this book, my contention is that this indeterminacy of the object, and the problem of adducing it as a component of postmodern media culture, is a feature of the postmodern itself.

NOTES

1. The point has also been made in Sean Cubitt, 'Introduction: Le réel, c'est l'impossible: the sublime time of special effects', *Screen* 40: 2 (1999), pp. 123–30.
2. Harold A. Innis, *The Bias of Communication* (Toronto: University of Toronto Press, 1951); Harold A. Innis, *Empire and Communications* (rev. Mary Innis, Toronto: Toronto University Press, 1972).
3. Marshall McLuhan, *Understanding Media: The Extensions of Man* (London: Ark, 1987).
4. Ibid., p. 32.
5. Friedrich Kittler, 'Gramophone, film, typewriter', *October* 41 (Summer 1987), trans. D. von Mücke, pp. 101–18.
6. Jean Baudrillard, *Xerox and Infinity*, trans. Agitac (London: Touchepas, 1988), unnumbered 9th page.
7. Ibid.
8. Ibid., unnumbered 17th page.
9. Book-length works include Kevin Kelly, *Out of Control: The New Biology of Machines* (London: Fourth Estate, 1994); Howard Rheingold, *Virtual Reality* (London: Secker and Warburg, 1991); Howard Rheingold, *The*

Virtual Community: Homesteading on the Electronic Frontier (Reading, MA: Addison-Wesley, 1993); Nicholas Negroponte, *Being Digital* (London: Coronet, 1995).

10. *Mondo 2000* 1 (1989), p. 11, quoted in Vivian Sobchack, 'Democratic Franchise', in Ziauddin Sardar and Jerome R. Ravetz (eds), *Cyberfutures* (London: Pluto, 1996), pp. 83–4.
11. Ziauddin Sardar, 'alt.civilizations.faq: Cyberspace as the Darker Side of the West', in Ziauddin Sardar and Jerome R. Ravetz (eds), *Cyberfutures* (London: Pluto, 1996) p. 34.
12. Ibid., p. 33.
13. *Mondo 2000* 2 (Summer 1990), pp. 8–9, quoted in Sobchack, 'Democratic Franchise', p. 84.
14. Sardar, 'alt.civilizations.faq', p. 23.
15. Jean-François Lyotard, *The Postmodern Condition: A Report on Knowledge*, trans. G. Bennington and B. Massumi (Manchester: Manchester University Press, 1984), p. xxiii.
16. Jürgen Habermas, 'The Public Sphere: An Encyclopedia Article', in Stephen Brunner and Douglas Kellner (eds), *Critical Theory and Society* (London: Routledge, 1989), p. 136.
17. Rheingold, *Virtual Community*, p. 5.
18. Ibid., p. 26.
19. Philip Hayward, 'Situating Cyberspace: The Popularisation of Virtual Reality', in Philip Hayward and Tana Wollen (eds), *Future Visions: New Technologies of the Screen* (London: BFI, 1993), pp. 180–204.
20. Ibid., p. 180.
21. Rebecca Coyle, 'The Genesis of Virtual Reality', in Philip Hayward and Tana Wollen (eds), *Future Visions: New Technologies of the Screen* (London: BFI 1993), p. 156.
22. Anne Friedberg, *Window Shopping: Cinema and the Postmodern* (Berkeley, CA: University of California Press, 1993), p. 2.
23. Ibid., p. 3.
24. Ibid.
25. See Coyle, 'Genesis of Virtual Reality', p. 151.
26. Slavoj Žižek, *Tarrying with the Negative: Kant Hegel and the Critique of Ideology* (Durham, NC: Duke University Press, 1993) p. 44.
27. Ibid.
28. Hayward, 'Situating Cyberspace', p. 182.
29. Ibid., pp. 187–8.
30. Sardar, 'alt.civilizations.faq', p. 33.
31. Andrew Gibson, *Towards a Postmodern Theory of Narrative*, Postmodern Theory series (Edinburgh: Edinburgh University Press, 1996), p. 255.

32. Donna Haraway, *Simians, Cyborgs and Women: The Reinvention of Nature* (London: Free Association, 1991), p. 2.
33. Ibid., p. 173.
34. Scott Bukatman, 'cybersubjectivity & cinematic being', in Christopher Sharrett (ed.), *Crisis Cinema: The Apocalyptic Idea in Postmodern Narrative Film*, PostModernPositions series 6 (Washington, DC: Maisonneuve Press 1993), p. 98.
35. Sally Pryor, in Sally Pryor and Jill Scott, 'Virtual Reality: Beyond Cartesian Space', in Philip Hayward and Tana Wollen (eds), *Future Visions: New Technologies of the Screen* (London: BFI, 1993), p. 168.
36. See Elizabeth Grosz, *Sexual Subversions* (Sydney: Allen and Unwin, 1989).
37. Anne Balsamo, *Technologies of the Gendered Body: Reading Cyborg Women* (London: Duke University Press, 1996); see also Lisa Cartwright, *Screening the Body: Tracing Medicine's Visual Culture* (Minneapolis: University of Minnesota Press, 1995).
38. On visualisations of the fetus in relation to technologies of vision, see also Linda Howell, 'The Cyborg Manifesto Revisited: Issues and Methods for Technocultural Feminism', in Richard Dellamora (ed.), *Postmodern Apocalypse: Theory and Cultural Practice at the End* (Philadelphia: University of Pennsylvania Press, 1995), pp. 199–218.
39. B. Stafford, *Body Criticism: Imaging the Unseen in Enlightenment Art and Medicine* (Cambridge, MA: MIT Press, 1991).
40. Sarah Kember, *Virtual Anxiety: Photography, New Technologies and Subjectivity* (Manchester: Manchester University Press, 1998).
41. Bukatman, 'cybersubjectivity & cinematic being', p. 79.
42. See Coyle, 'Genesis of Virtual Reality', p. 156.
43. Leslie Haddon, 'Interactive games', in Philip Hayward and Tana Wollen (eds), *Future Visions: New Technologies of the Screen* (London: BFI, 1993), pp. 123–47.
44. Mary Fuller and Henry Jenkins, 'Nintendo and New World Travel Writing: a Dialogue', in Steven G. Jones (ed.), *Cybersociety: Computer-Mediated Communication and Community* (London: Sage, 1995), pp. 57–72.
45. Ibid., p. 59.
46. Dan Fleming, *Powerplay: Toys as Popular Culture* (Manchester: Manchester University Press, 1996), pp. 182–4.
47. Michael Benedikt, 'Introduction', in Michael Benedikt (ed.), *Introduction to Cyberspace: First Steps* (Cambridge, MA: MIT Press, 1991), p. 4. I am grateful to Francesca Froy for alerting me to this and other references to the body in computer-mediated communication.
48. I am grateful to Piotr Sitarski of the University of Lodz for his unpublished paper, 'Can I be Plural in MUDs?: Reflections on Characters in

Multi-User Dungeons', which alerted me to some of the issues raised in this section.

49. Sherry Turkle, *Life on the Screen: Identity in the Age of the Internet* (New York: Simon and Shuster, 1995), p. 212.

50. Dawn Deitrich, '(Re)-Fashioning the Techno-Erotic Woman: Gender and Textuality in the Cyberculture Matrix', in Steven Jones (ed.), *Virtual Culture: Identity and Communication in Cybersociety* (London: Sage, 1997), p. 176.

51. Mark Lajoie, 'Psychoanalysis and Cyberspace', in Rob Shields (ed.), *Cultures of the Internet* (London: Sage, 1996), p. 85.

52. Howard Rheingold, 'The Virtual Community: Finding Connection in a Computerised World', in Hugh Mackay and Tim O'Sullivan (eds), *The Media Reader: Continuity and Transformation* (London: Sage, 1999), p. 274.

53. Ibid., p. 281.

BIBLIOGRAPHY

Adam, Barbara and Stuart Allan (eds), *Theorizing Culture: An Interdisciplinary Critique after Postmodernism* (London: UCL Press, 1995).

Adorno, Theodor, 'Introduction to Benjamin's *Schriften*', trans. R. Hullot-Kentor, in Gary Smith (ed.), *On Walter Benjamin* (Cambridge, MA: MIT Press, 1988), pp. 2–17.

Adorno, Theodor and Max Horkheimer, *Dialectic of Enlightenment*, trans. J. Cumming (London: Verso, 1997).

Ahmad, Aijaz, 'Jameson's Rhetoric of Otherness and the "National Allegory"', *Social Text* 17 (1987), pp. 3–25.

Allen, John, 'From Morse to Modem: Developments in Transmission Technologies and their Impact on the Military-Media Relationship', in Ian Stewart and Susan Carruthers (eds), *War, Culture and the Media: Representations of the Military in 20th Century Britain* (Trowbridge: Flicks, 1996), pp. 148–64.

Alleyne, Mark, *News Revolution: Political and Economic Decisions about Global Information* (Basingstoke: Macmillan, 1997).

Althusser, Louis, 'Ideology and Ideological State Apparatuses: Notes towards an Investigation', in Louis Althusser, *Lenin and Philosophy*, trans. B. Brewster (London: New Left Books, 1971), pp. 121–73.

Ang, Ien, *Desperately Seeking the Audience* (London: Routledge, 1991).

Ang, Ien and Joke Hermes, 'Gender and/in Media Consumption', in Ien Ang, *Living Room Wars: Rethinking Audiences for a Postmodern World* (London: Routledge, 1996), pp. 108–29.

Appadurai, Arjun, 'Disjunction and Difference in the Global Cultural Economy', in Mike Featherstone (ed.), *Global Culture: Nationalism, Globalization and Modernity* (London: Sage, 1990), pp. 295–310.

Atkinson, Paul and Amanda Coffey, 'Realism and its Discontents: On the Crisis of Cultural Representation in Ethnographic Texts', in Barbara Adam

and Stuart Allan (eds), *Theorizing Culture: An Interdisciplinary Critique after Postmodernism* (London: UCL Press, 1995), pp. 41–57.

Attfield, Judy, 'Barbie and Action Man: Adult Toys for Girls and Boys, 1959–93', in Pat Kirkham (ed.), *The Gendered Object* (Manchester: Manchester University Press, 1996), pp. 80–9.

Bachman, Gideon and Umberto Eco, 'The Name of the Rose', in *Sight and Sound* 55: 2 (Spring 1986), pp. 129–31.

Badsey, Stephen, 'The Influence of the Media on Recent British Military Operations', in Ian Stewart and Susan Carruthers (eds), *War, Culture and the Media: Representations of the Military in 20th Century Britain* (Trowbridge: Flicks, 1996), pp. 5–21.

Balsamo, Anne, *Technologies of the Gendered Body: Reading Cyborg Women* (London: Duke University Press, 1996).

Barker, Chris, *Global Television: An Introduction* (Oxford: Blackwell, 1997).

Barker, Martin, *Comics: Ideology, Power and the Critics* (Manchester: Manchester University Press, 1989).

Barthes, Roland, *Mythologies*, trans. A. Lavers (London: Granada, 1973).

Barthes, Roland, 'The Photographic Message', in *Image, Music, Text*, trans. S. Heath (London: Fontana, 1977), pp. 15–31.

Baudelaire, Charles, *Art in Paris 1845–1862: Reviews of Salons and Other Exhibitions*, ed. and trans. Jonathan Mayne (Oxford: Phaidon, 1965).

Baudrillard, Jean, *For A Critique of the Political Economy of the Sign*, trans. C. Levin (St. Louis, MO: Telos, 1981).

Baudrillard, Jean, *In the Shadow of the Silent Majorities, or The End of the Social and Other Essays*, trans. P. Foss, J. Johnson and P. Patton (New York: Semiotext(e), 1983a).

Baudrillard, Jean, *Simulations*, trans. P. Foss, P. Patton and P. Beitchman (New York: Semiotext(e), 1983b).

Baudrillard, Jean, 'The Ecstasy of Communication', trans. J. Johnston, in Hal Foster (ed.), *Postmodern Culture* (London: Pluto, 1985), pp. 126–34.

Baudrillard, Jean, *The Evil Demon of Images*, trans. P. Patton and P. Foss (Sydney: Power Institute, 1987).

Baudrillard, Jean, *America*, trans. C. Turner (London: Verso, 1988a).

Baudrillard, Jean, *Xerox and Infinity*, trans. Agitac (London: Touchepas, 1988b).

Baudrillard, Jean, *Fatal Strategies*, trans. P. Beitchman and W. Niesluchowski (London: Pluto, 1990a).

Baudrillard, Jean, *Revenge of the Crystal: Selected Writings on the Object and its Destiny, 1968–83*, ed. and trans. P. Foss and J. Pefanis (London: Pluto, 1990b).

Baudrillard, Jean, 'La guerre du Golfe n'a pas en lieu', *Libération*, 29 March 1991a.

Baudrillard, Jean, 'The Reality Gulf', *The Guardian*, 11 January 1991b, reprinted in Peter Brooker and Will Brooker (eds), *Postmodern After-Images: A Reader in Film, Television and Video* (London: Arnold, 1997), pp. 165–7.

Baudrillard, Jean, *The Illusion of the End*, trans. C. Turner (Cambridge: Polity, 1994).

Baudry, Jean-Louis, 'The Apparatus: Metapsychological Approaches to the Impression of Reality in the Cinema', in P. Rosen (ed.), *Narrative, Apparatus, Ideology* (New York: Columbia University Press, 1986), pp. 299–318.

Bauman, Zygmunt, *Intimations of Postmodernity* (Cambridge: Polity, 1992).

Bauman, Zygmunt, *Postmodern Ethics* (Oxford: Blackwell, 1993).

Bazalgette, Cary and David Buckingham (eds), *In Front of the Children: Screen Entertainment and Young Audiences* (London: BFI, 1995).

Beardsworth, Richard, 'Just Attempts at Justice', *Paragraph* 10 (October 1987), pp. 103–9.

Bell, Daniel, *The Coming of Post-Industrial Society* (New York: Basic Books, 1973).

Benedikt, Michael (ed.), *Introduction to Cyberspace: First Steps* (Cambridge, MA: MIT Press, 1991).

Benjamin, Walter, *Illuminations*, ed. H. Arendt, trans. H. Zohn (New York: Schocken Books, 1969).

Bertens, Hans, *The Idea of the Postmodern: A History* (London: Routledge, 1995).

Best, Steven and Douglas Kellner, *Postmodern Theory: Critical Investigations* (Basingstoke: Macmillan, 1991).

Bhabha, Homi, *The Location of Culture* (London: Routledge, 1994).

Bignell, Jonathan, 'Dracula Goes to the Movies: Cinematic Spectacle and Gothic Literature', in Dominique Sipière (ed.), *Dracula: Insemination-Dissemination* (Amiens: University of Picardie Press, 1996a), pp. 133–43.

Bignell, Jonathan, 'Spectacle and the Postmodern in Contemporary American Cinema', *la licorne*, special issue 'Crise de la représentation dans le cinéma américain', 36 (1996b), pp. 163–80.

Bignell, Jonathan, *Media Semiotics: An Introduction* (Manchester: Manchester University Press, 1997).

Bignell, Jonathan, 'The Detective at the End of History: Postmodern Apocalypse in *The Name of the Rose* and *Seven*', in Dominique Sipière and Gilles Menegaldo (eds), *Les Récits Policiers au Cinéma, la licorne* Colloques 7 (Poitiers: University of Poitiers Press, 1999a), pp. 195–203.

Bignell, Jonathan (ed.), *Writing and Cinema* (Harlow: Longman, 1999b).

Bignell, Jonathan, 'A Taste of the Gothic: Film and Television Versions of *Dracula*', in Erica Sheen and Robert Giddings (eds), *The Classic Novel: From Page to Screen*, (Manchester: Manchester University Press, 2000), pp. 114–30.

Bignell, Jonathan, '"Get Ready For Action!": Reading Action Man Toys', in Tony Watkins and Dudley Jones (eds), '*A Necessary Fantasy?': The Heroic Figure in Children's Popular Culture* (New York: Garland, forthcoming).

Birkett, Dea, 'I'm Barbie, buy me', *The Guardian*, Weekend section, 28 November 1998, pp. 13–19.

Boddy, William, 'Archeologies of Electronic Vision and the Gendered Spectator', *Screen* 35: 2 (1994), pp. 105–22.

Bould, Mark, 'Preserving Machines: Recentring the Decentred Subject in *Blade Runner* and *Johnny Mnemonic*', in Jonathan Bignell (ed.), *Writing and Cinema* (Harlow: Longman, 1999), pp. 164–78.

Bourdieu, Pierre, *Distinction: A Social Critique of the Judgement of Taste*, trans. R. Nice (London: Routledge, 1984).

Boyarin, Jonathan, 'At Last All the *Goyim*: Notes on a Greek Word Applied to Jews', in Richard Dellamora (ed.), *Postmodern Apocalypse: Theory and Cultural Practice at the End* (Philadelphia: University of Pennsylvania Press, 1995), pp. 41–58.

Broderick, Mick, 'Heroic Apocalypse: *Mad Max*, Mythology and the Millennium', in Christopher Sharrett (ed.), *Crisis Cinema: The Apocalyptic Idea in Postmodern Narrative Film*, PostModernPositions series 6 (Washington, DC: Maisonneuve, 1993), pp. 251–72.

Brooker, Peter, *Modernism/Postmodernism* (Harlow: Longman, 1992).

Brooker, Peter and Will Brooker (eds), *Postmodern After-Images: A Reader in Film, Television and Video* (London: Arnold, 1997).

Brown, J. and L. Schultze, 'The Effects of Race, Gender, and Fandom on Interpretations of Madonna's Music Videos', *Journal of Communication* 40: 2 (1990), pp. 88–102.

Bruhn Jensen, Klaus (ed.), *News of the World: World Cultures Look at Television News* (London: Routledge, 1998).

Bruno, Giuliano, 'Ramble City: Postmodernism and *Blade Runner*', in Christopher Sharrett (ed.), *Crisis Cinema: The Apocalyptic Idea in Postmodern Narrative Film*, PostModernPositions series 6 (Washington, DC: Maisonneuve, 1993), pp. 236–49.

Buckingham, David (ed.), *Reading Audiences: Young People and the Media* (Manchester: Manchester University Press, 1993).

Bukatman, Scott, 'cybersubjectivity & cinematic being', in Christopher Sharrett (ed.), *Crisis Cinema: The Apocalyptic Idea in Postmodern Narrative Film*, PostModernPositions series 6 (Washington, DC: Maisonneuve, 1993), pp. 76–102.

Burman, Erica, 'Developmental Psychology and the Postmodern Child', in Joe Docherty, Edward Graham and Mhemooda Malek (eds), *Postmodernism and the Social Sciences* (Basingstoke: Macmillan, 1992), pp. 95–110.

Burman, Erica, 'The Pedagogics of Post/Modernity: the Address to the Child as Political Subject and Object', in Karín Lesnik-Oberstein (ed.), *Children in Culture: Approaches to Childhood* (Basingstoke: Macmillan, 1998), pp. 55–88.

Butler, Judith, *Bodies that Matter: On the Discursive Limits of Sex* (London: Routledge, 1993).

Cartwright, Lisa, *Screening the Body: Tracing Medicine's Visual Culture* (Minneapolis: University of Minnesota Press, 1995).

Chow, Rey, 'Violence in the Other Country: China as Crisis, Spectacle, and Woman', in Chandra Talpade Mohanty, Ann Russo and Lourdes Terres

(eds), *Third World Women and the Politics of Feminism* (Bloomington: Indiana University Press, 1991), pp. 81–100.

Collins, Jim, *Uncommon Cultures: Popular Culture and Post-Modernism* (London: Routledge, 1989).

Connor, Steven, *Postmodernist Culture: An Introduction to Theories of the Contemporary*, 2nd edn (Oxford: Blackwell, 1997).

Cope, Nigel, 'Barbie eyes up Action Man in Toytown battle', *The Independent*, 26 January 1996, p. 6.

Coyle, Rebecca, 'The Genesis of Virtual Reality', in Philip Hayward and Tana Wollen (eds), *Future Visions: New Technologies of the Screen* (London: BFI, 1993) pp. 148–65.

Crary, Jonathan, *Techniques of the Observer* (Cambridge, MA: MIT Press 1993).

Cubitt, Sean, 'Introduction: Le réel, c'est l'impossible: the sublime time of special effects', *Screen* 40: 2 (1999a), pp. 123–30.

Cubitt, Sean, 'Orbis Tertius', *Third Text* 47 (Summer 1999b), pp. 3–10.

Cunningham, Helen, 'Moral Kombat and Computer Game Girls', in Cary Bazalgette and David Buckingham (eds), *In Front of the Children: Screen Entertainment and Young Audiences* (London: BFI, 1995), pp. 188–200.

Curry, Ramona, 'Madonna from Marilyn to Marlene – Pastiche and/or Parody', *Journal of Film and Video* 42: 2 (1990), pp. 15–30.

Dahlgren, Peter, *Television and the Public Sphere* (London: Sage, 1995).

Darley, A., 'From Abstraction to Simulation: Notes on the History of Computer Imaging', in Philip Hayward (ed.), *Culture, Technology and Creativity in the Late 20th Century* (London: John Libbey, 1990).

Dawson, Graham, 'War Toys', in Gary Day (ed.), *Readings in Popular Culture: Trivial Pursuits?* (Basingstoke: Macmillan, 1989), pp. 98–111.

Dawson, Graham, *Soldier Heroes: British Adventure, Empire and the Imagining of Masculinities* (London: Routledge, 1994).

Dayan, Daniel and Elihu Katz, *Media Events: The Live Broadcasting of History* (Cambridge, MA: Harvard University Press, 1992).

Debord, Guy, *Society of the Spectacle*, trans. unnamed (Detroit, MI: Black and Red, 1970).

Deitrich, Dawn, '(Re)-Fashioning the Techno-Erotic Woman: Gender and Textuality in the Cyberculture Matrix', in Steven Jones (ed.), *Virtual Culture: Identity and Communication in Cybersociety* (London: Sage, 1997), pp. 169–84.

DeLauretis, Teresa, 'Gaudy Rose: Eco and Narcissism', in Rocco Capozzi (ed.), *Reading Eco: An Anthology* (Bloomington: Indiana University Press, 1997), pp. 239–55.

Deleuze, Gilles, *Cinema 1: The Movement-Image*, trans. H. Tomlinson and B. Habberjam (London: Athlone, 1986).

Deleuze, Gilles, *Cinema 2: The Time-Image*, trans. H. Tomlinson and R. Galeta (London: Athlone, 1989).

Dellamora, Richard (ed.), *Postmodern Apocalypse: Theory and Cultural Practice*

at the End (Philadelphia: University of Pennsylvania Press, 1995).

Derrida, Jacques, *Signéponge/Signsponge*, trans. R. Rand (New York: Columbia University Press, 1984).

Dickinson, Roger, Ramaswami Harindranath and Olga Linné (eds), *Approaches to Audiences: A Reader* (London: Arnold, 1998).

Doel, Marcus and David Clarke, 'From Ramble City to the Screening of the Eye: *Blade Runner*, Death and Symbolic Exchange', in David Clarke (ed.), *The Cinematic City* (London: Routledge, 1997), pp. 140–67.

Dominic, Joseph, Barry Sherman and Gary Copeland, *Broadcasting/Cable and Beyond: An Introduction to Modern Electronic Media*, 3rd edn (New York: McGraw Hill, 1996).

Dresser, Nori, *American Vampires: Fans, Victims and Practitioners* (New York: Vintage, 1990).

Dyer, Richard, 'Dracula and Desire', *Sight and Sound* 3: 1 (January 1993), pp. 8–12.

Dyer, Richard, 'To Kill and Kill Again', *Sight and Sound* 7: 9 (September 1997), pp. 14–18.

Dyer, Richard, *White* (London: Routledge, 1997).

Dyer, Richard, *Seven* (London: BFI Modern Classics, 1999).

Eagleton, Terry, *The Ideology of the Aesthetic* (Oxford: Blackwell, 1990).

Eagleton, Terry, *The Illusions of Postmodernism* (Oxford: Blackwell, 1996).

Eco, Umberto, *The Role of the Reader* (Bloomington: Indiana University Press, 1979).

Eco, Umberto, 'A Guide to the Neo-Television of the 1980s', *Framework* 25 (1984), pp. 18–25.

Eco, Umberto, *Reflections on The Name of the Rose* (London: Secker and Warburg, 1985).

Eco, Umberto, *The Name of the Rose*, trans. W. Weaver (New York: Warner, 1986).

Eco, Umberto, 'Casablanca: Cult Movies and Intertextual Collage', in *Travels in Hyperreality*, trans. W. Weaver (London: Picador, 1987), pp. 197–211.

Eco, Umberto, 'Living in the New Middle Ages', in Umberto Eco, *Travels in Hyperreality*, trans. W. Weaver (London: Picador, 1987), pp. 73–85.

Eco, Umberto, 'The Multiplication of the Media', in Umberto Eco, *Travels in Hyperreality*, trans. W. Weaver (London: Picador, 1987), pp. 145–50.

Eco, Umberto, *Foucault's Pendulum*, trans. W. Weaver (London: Secker & Warburg, 1989).

Featherstone, Mike, *Consumer Culture and Postmodernism* (London: Sage, 1991).

Ferguson, Margaret and Jennifer Wicke (eds.), *Feminism and Postmodernism* (London: Duke University Press, 1994).

Fernández, María, 'Postcolonial Media Theory', *Third Text* 47 (Summer 1999), pp. 11–17.

Fiske, John, *Television Culture* (London: Routledge, 1987).

Fiske, John, *Media Matters* (Minneapolis: University of Minnesota Press, 1994).

Fleming, Dan, *Powerplay: Toys as Popular Culture* (Manchester: Manchester University Press, 1996).

Forceville, Charles, *Pictorial Metaphor in Advertising* (Englewood Cliffs, NJ: Prentice Hall, 1996).

Freccero, Carla, 'Our Lady of MTV: Madonna's "Like a Prayer"', in Margaret Ferguson and Jennifer Wicke (eds.), *Feminism and Postmodernism* (London: Duke University Press, 1994), pp. 179–99.

Freedman, Lawrence and Efraim Karsh, *The Gulf Conflict 1990–1991: Diplomacy and War in the New World Order* (London: Faber, 1993).

Friedberg, Anne, *Window Shopping: Cinema and the Postmodern* (Berkeley: University of California Press, 1993).

Frith, Simon and Howard Horne, *Art into Pop* (London: Methuen, 1987).

Fukuyama, Francis, 'The End of History?', *The National Interest* 16 (1989), pp. 3–18.

Fukuyama, Francis, *The End of History and the Last Man* (New York: Free Press, 1992).

Fuller, Mary and Henry Jenkins, 'Nintendo and New World Travel Writing: A Dialogue', in Steven G. Jones (ed.), *CyberSociety: Computer-Mediated Communication and Community* (London: Sage, 1995), pp. 57–72.

Gane, Mike, *Baudrillard's Bestiary: Baudrillard and Culture* (London: Routledge, 1991a).

Gane, Mike, *Baudrillard: Critical and Fatal Theory* (London: Routledge, 1991b).

Gane, Mike (ed.), *Baudrillard Live: Selected Interviews* (London: Routledge, 1993).

Garber, M., 'Fetish Envy', *October* 54 (1990), pp. 45–56.

Geertz, Clifford, *The Interpretation of Cultures: Selected Essays* (London: Fontana, 1967).

Gelder, Ken, *Reading the Vampire* (London: Routledge, 1994).

Geraghty, Christine, 'Audiences and "Ethnography": Questions of Practice', in Christine Geraghty and David Lusted (eds), *The Television Studies Book* (London: Arnold, 1998), pp.141–57.

Gibson, Andrew, *Towards a Postmodern Theory of Narrative*, Postmodern Theory series (Edinburgh: Edinburgh University Press, 1996).

Giddens, Anthony, *The Constitution of Society* (Berkeley: University of California Press, 1984).

Giddens, Anthony, *The Consequences of Modernity* (Cambridge: Polity, 1995).

Gillespie, Marie, 'Ambivolent Positionings: The Gulf War', in Peter Brooker and Will Brooker, *Postmodern After-Images: A Reader in Film, Television and Video* (London: Arnold, 1997), pp. 172–81.

Grossberg, Lawrence, Cary Nelson and Paula Treichler, with Linda Baughman and John Macgregor Wise (eds), *Cultural Studies* (New York: Routledge, 1992).

Grosz, Elizabeth, *Sexual Subversions* (Sydney: Allen and Unwin, 1989).

Habermas, Jürgen, 'Modernity – An Incomplete Project', trans. S. Ben-Habib, in Hal Foster (ed.), *Postmodern Culture* (London: Pluto, 1985), pp. 3–15.

Habermas, Jürgen, 'Modernity's Consciousness of Time and its Need for Self-Reassurance', in Jürgen Habermas, *The Philosophical Discourse on Modernity: Twelve Lectures*, trans. F. Lawrence (Cambridge, MA: MIT Press, 1987a), pp. 1–22.

Habermas, Jürgen, *The Theory of Communicative Action, vol. 2 Lifeworld and System: A Critique of Functionalist Reason* (Cambridge: Polity, 1987b).

Habermas, Jürgen, 'The Public Sphere: An Encyclopedia Article', in Stephen Brunner and Douglas Kellner (eds), *Critical Theory and Society* (London: Routledge, 1989a).

Habermas, Jürgen, *The Structural Transformation of the Public Sphere: An Inquiry into a Category of Bourgeois Society*, trans. T. Burger with F. Lawrence (Cambridge, MA: MIT Press, 1989b).

Hables Gray, Charles, *Postmodern War: The New Politics of Conflict* (London: Routledge, 1997).

Haddon, Leslie, 'Interactive Games', in Philip Hayward and Tana Wollen (eds), *Future Visions: New Technologies of the Screen* (London: BFI, 1993), pp. 123–47.

Hall, Stuart, 'The Local and the Global: Globalization and Ethnicities', in Anthony King (ed.), *Culture, Globalization and the World System* (Basingstoke: Macmillan, 1991), pp. 19–30.

Hall, Stuart and Tony Jefferson (eds), *Resistance Through Rituals: Youth Subcultures in Postwar Britain* (London: Hutchinson, 1976).

Hallam, Julia and Margaret Marshment, 'Framing Experience: Case Studies in the Reception of *Oranges are Not the Only Fruit*', *Screen* 36: 1 (1995), pp. 1–15.

Hammond, William, *Public Affairs: The Military and Media 1962–1968* (Washington, DC: Center of Military History, United States Army, 1988).

Hannerz, Ulf, 'Scenarios for Peripheral Cultures', in Anthony King (ed.), *Culture, Globalization and the World System* (Basingstoke: Macmillan, 1991), pp. 107–28.

Haraway, Donna, *Simians, Cyborgs and Women: The Reinvention of Nature* (London: Free Association, 1991).

Hayward, Philip, 'Situating Cyberspace: The Popularisation of Virtual Reality', in Philip Hayward and Tana Wollen (eds), *Future Visions: New Technologies of the Screen* (London: BFI, 1993), pp. 180–204.

Hebdidge, Dick, *Subculture: The Meaning of Style* (London: Methuen, 1979).

Hebdige, Dick, *Hiding in the Light: On Images and Things* (London: Routledge, 1988).

Hegel, Georg Willhelm Friedrich, *The Philosophy of History*, trans. J. Silbee (New York: Dover, 1956).

Heim, Michael, *Metaphysics of Virtual Reality* (Oxford: Oxford University Press, 1993).

Hendershot, Heather, 'Dolls: Odour, Disgust, Femininity and Toy Design', in Pat Kirkham (ed.), *The Gendered Object* (Manchester: Manchester University Press, 1996), pp. 90–102.

Herman, Edward and Robert McChesney, *The Global Media: The New Missionaries of Global Capitalism* (London: Cassell, 1997).

Homer, Sean, *Fredric Jameson: Marxism, Hermeneutics, Postmodernism* (Cambridge: Polity, 1998).

hooks, bell, 'Postmodern Blackness', in Joseph Natoli and Linda Hutcheon (eds), *A Postmodern Reader* (Albany: SUNY Press, 1993), pp. 510–18.

Howell, Linda, 'The Cyborg Manifesto Revisited: Issues and Methods for Technocultural Feminism', in Richard Dellamora (ed.), *Postmodern Apocalypse: Theory and Cultural Practice at the End* (Philadelphia: University of Pennsylvania Press, 1995), pp. 199–218.

Hutcheon, Linda, *The Politics of Postmodernism* (London: Routledge, 1989).

Hutcheon, Linda, 'Circling the Downspout of Empire', in Bill Ashcroft, Gareth Griffiths and Helen Tiffin (eds), *The Post-Colonial Studies Reader* (London: Routledge, 1995), pp. 130–5.

Huyssen, Andreas, *After the Great Divide: Modernism, Mass Culture and Postmodernism* (Basingstoke: Macmillan, 1986).

Innis, Harold A., *The Bias of Communication* (Toronto: University of Toronto Press, 1951).

Innis, Harold A., *Empire and Communications*, rev. Mary Innis (Toronto: Toronto University Press, 1972).

Ito, Mitsuko, 'Inhabiting Multiple Worlds: Making Sense of SimCity 2000™ in the Fifth Dimension', in Robbie Davis-Floyd and Joseph Dumit (eds), *Cyborg Babies: From Techno-Sex to Techno-Tots* (London: Routledge, 1998), pp. 301–16.

Jameson, Fredric, *The Political Unconscious: Narrative as a Socially Symbolic Act* (London: Methuen, 1981).

Jameson, Fredric, 'Postmodernism, or the Cultural Logic of Late Capitalism', *New Left Review* 146 (July/August 1984), pp. 53–92.

Jameson, Fredric, 'Postmodernism and Consumer Society', in Hal Foster (ed.), *Postmodern Culture* (London: Pluto, 1985), pp. 111–25.

Jameson, Fredric, 'Reading without Interpretation: Postmodernism and the Video-text', in Derek Attridge and Nigel Fabb (eds), *The Linguistics of Writing: Arguments between Language and Literature* (Manchester: Manchester University Press, 1987), pp. 199–233.

Jameson, Fredric, 'Postmodernism and Utopia', in Fredric Jameson, *Utopia Post Utopia: Configurations of Nature and Culture in Recent Sculpture and Photography* (Boston, MA: Institute of Contemporary Arts, 1988).

Jameson, Fredric, *Postmodernism, or the Cultural Logic of Late Capitalism* (London: Verso, 1991).

Jameson, Fredric, *The Geopolitical Aesthetic: Cinema and Space in the World System* (London: BFI, 1992).

Jenkins, Henry, *Textual Poachers: Television Fans and Participatory Culture* (London: Routledge, 1992).

Keep, Christopher, 'An Absolute Acceleration: Apocalypticism and the War Machines of Waco', in Richard Dellamora (ed.), *Postmodern Apocalypse: Theory and Cultural Practice at the End* (Philadelphia: University of Pennsylvania Press, 1995), pp. 262–73.

Kellner, Douglas, *Media Culture: Cultural Studies, Identity and Politics Between the Modern and the Postmodern* (London: Routlege, 1995).

Kelly, Kevin, *Out of Control: The New Biology of Machines* (London: Fourth Estate, 1994).

Kember, Sarah, *Virtual Anxiety: Photography, New Technologies and Subjectivity* (Manchester: Manchester University Press, 1995).

Kinder, Marsha, *Playing with Power in Movies, Television and Video Games* (Berkeley, CA: University of California Press, 1991).

Kishan Thussu, Daya (ed.), *Electronic Empires: Global Media and Local Resistance* (London: Arnold, 1998).

Kittler, Friedrich, 'Gramophone, film, typewriter', *October* 41 (Summer 1987) trans. D. von Mücke, pp. 101–18.

Kroker, Arthur, 'Baudrillard's Marx', *Theory, Culture & Society* 2: 3 (1985), pp. 69–83.

Kroker, Arthur and Michael Dorland, 'Panic Cinema: Sex in the Age of the Hyperreal', in Christopher Sharrett (ed.), *Crisis Cinema: The Apocalyptic Idea in Postmodern Narrative Film*, PostModernPositions series 6 (Washington, DC: Maisonneuve, 1993), pp. 10–16.

Lajoie, Mark, 'Psychoanalysis and Cyberspace', in Rob Shields (ed.), *Cultures of the Internet* (London: Sage, 1996), pp. 70–98.

Lash, Scott, *The Sociology of Postmodernism* (London: Routledge, 1990).

Lesnik-Oberstein, Karín, 'Childhood and Textuality: Culture, History, Literature', in Karín Lesnik-Oberstein (ed.), *Children in Culture: Approaches to Childhood* (Basingstoke: Macmillan, 1998), pp. 1–28.

Lewis, Linda, *Gender Politics and MTV: Voicing the Difference* (Philadelphia: Temple University Press, 1990).

Lewis, Lisa (ed.), *The Adoring Audience* (London: Routledge, 1991).

Liebes, Tamar and Elihu Katz, *The Export of Meaning: Cross Cultural Readings of 'Dallas'* (Cambridge: Polity, 1993).

Lister, Martin, 'Introductory Essay', in Martin Lister (ed.), *The Photographic Image in Digital Culture* (London: Routledge, 1995), pp. 1–26.

Lister, Martin, 'Photography in the Age of Electronic Imaging', in Liz Wells (ed.), *Photography: A Critical Introduction* (London: Routledge, 1997), pp. 251–91.

Livingstone, Sonia and Peter Lunt, *Talk on Television* (London: Routledge, 1994).

Lull, James, 'Critical Response: The Audience as Nuisance', *Critical Studies in Mass Communication* 5 (1988), pp. 239–43.

Lynch, Kevin, *The Image of the City* (Cambridge, MA: MIT Press, 1960).

Lyotard, Jean-François, *Discours, Figure* (Paris: Klinksieck, 1971).

Lyotard, Jean-François,'Acinema', trans. P. Livingston, *Wide Angle* 2: 3 (1978), pp. 52–9.

Lyotard, Jean-François, *The Postmodern Condition: A Report on Knowledge*, trans. G. Bennington and B. Massumi (Manchester: Manchester University Press, 1984).

Lyotard, Jean-François, *The Differend: Phrases in Dispute*, trans. G. Van den Abbeele (Minneapolis: University of Minnesota Press, 1988).

Lyotard, Jean-François, *The Inhuman*, trans. G. Bennington (Cambridge: Polity, 1991).

Lyotard, Jean-François, *The Postmodern Explained to Children: Correspondence 1982–1985*, trans. D. Barry, B. Maher, J. Pefanis, V. Spate and M. Thomas (London: Turnaround, 1992).

Lyotard, Jean-François,'Answering the Question: What is Postmodernism?', in Thomas Docherty (ed.), *Postmodernism: A Reader* (Hemel Hempstead: Harvester Wheatsheaf, 1993), pp. 38–46.

Lyotard, Jean-François and Jean-Loup Thébaud, *Just Gaming*, trans. W. Godzich (Manchester: Manchester University Press, 1985).

Mackay, Hugh and Tim O'Sullivan (eds), *The Media Reader: Continuity and Transformation* (London: Sage, 1999).

Marvin, Carolyn, *When Old Technologies Were New: Thinking About Electric Communication in the Late Nineteenth Century* (Oxford: Oxford University Press, 1988).

Mattel UK Ltd., *Girls' Toys '98* (Maidenhead: Mattel, 1998).

McLuhan, Marshall and Quentin Fiore, *The Medium is the Massage* (Harmondsworth: Penguin, 1967).

McLuhan, Marshall, *Understanding Media: The Extensions of Man* (London: Ark, 1987).

McLuhan, Marshall, *Essential McLuhan*, ed. E. McLuhan and F. Zingrone (London: Routledge, 1997).

McLuhan, Marshall, with Harley Parker, *Counterblast* (Toronto: McClelland and Stewart, 1968).

McNair, Brian, *News and Journalism in the UK: A Textbook* (London: Routledge, 1994).

McQuail, Dennis, *Mass Communication Theory* (London: Sage, 1994).

McRobbie, Angela, *Postmodernism and Popular Culture* (London: Routledge, 1994).

McRobbie, Angela,'*More!*: New Sexualities in Girls'and Women's Magazines', in James Curran, David Morley and Valerie Walkerdine (eds), *Cultural Studies and Communication* (London: Edward Arnold, 1996), pp. 172–95.

McRobbie, Angela (ed.), *Back to Reality: Social Experience and Cultural Studies* (Manchester: Manchester University Press, 1997).

Mellencamp, Pat (ed.), *Logics of Television: Essays in Cultural Criticism*

(London: BFI, 1990).

Metz, Christian, *The Imaginary Signifier: Psychoanalysis and the Cinema*, trans. B. Brewster (Bloomington: Indiana University Press, 1982).

Mitchell, William, *The Reconfigured Eye: Visual Truth in the Post-Photographic Era* (Cambridge, MA: MIT Press, 1992).

Morley, David, *The 'Nationwide' Audience* (London: BFI, 1980).

Morley, David, *Television Audiences and Cultural Studies* (London: Routledge, 1992).

Morris, Meaghan, 'Banality in Cultural Studies', *Block* 14 (1988), pp. 15–25.

Morris, Meaghan, 'Feminism, Reading, Postmodernism', in Thomas Docherty (ed.), *Postmodernism: A Reader* (Hemel Hempstead: Harvester Wheatsheaf, 1993), pp. 368–89.

Mort, Frank, 'Boys Own? Masculinity, Style and Popular Culture', in Rowena Chapman and Jonathan Rutherford (eds), *Male Order: Unwrapping Masculinity* (London: Lawrence & Wishart, 1988), pp. 193–224.

Nava, Mica, 'Consumption and its Contradictions', *Cultural Studies* 1: 2 (1987), pp. 204–10.

Neale, Stephen, *Genre* (London: BFI, 1980).

Negrine, Ralph, *The Communication of Politics* (London: Sage, 1996).

Negroponte, Nicholas, *Being Digital* (London: Coronet, 1995).

Nichols, Bill, *Representing Reality: Issues and Concepts in Documentary* (Bloomington: Indiana University Press, 1991).

Nichols, Bill, *Blurred Boundaries: Questions of Meaning in Contemporary Culture* (Bloomington: Indiana University Press, 1994).

Norris, Christopher, 'Textuality, Difference, and Cultural Otherness: Deconstruction v. Postmodernism', *Common Knowledge* 3: 3 (Winter 1994), pp. 39–59.

Ong, Clara Min Win, 'Foreign Company Advertising in Singapore: A Critical Evaluation', unpublished dissertation submitted at the University of Reading, 1997.

Osborne, Peter, *The Politics of Time: Modernity and the Avant-Garde* (London: Verso, 1995).

Passerin D'Entrèves, Maurizio and Seyla Benhabib, *Habermas and the Unfinished Project of Modernity* (Cambridge: Polity, 1996).

Polan, Dana, '"Above All Else to Make You See": Cinema and the Ideology of Spectacle', in Jonathan Arac (ed.), *Postmodernism and Politics* (Manchester: Manchester University Press, 1986), pp. 55–69.

Poovey, Mary, 'Feminism and Postmodernism – Another View', in Margaret Ferguson and Jennifer Wicke (eds.), *Feminism and Postmodernism* (London: Duke University Press, 1994), pp. 34–52.

Poppi, Cesare, 'Wider Horizons with Larger Details: Subjectivity, Ethnicity and Globalization', in Alan Scott (ed.), *The Limits of Globalisation: Cases and Arguments* (London: Routledge, 1997), pp. 284–305.

Porter, David (ed.), *Internet Culture* (London: Routledge, 1997).

Poster, Mark, *The Second Media Age* (Cambridge: Polity, 1995).

Pryor, Sally and Jill Scott, 'Virtual Reality: Beyond Cartesian Space', in Philip Hayward and Tana Wollen (eds), *Future Visions: New Technologies of the Screen* (London: BFI, 1993), pp. 166–79.

Readings, Bill, *Introducing Lyotard: Art And Politics* (London: Routledge, 1991).

Rheingold, Howard, *Virtual Reality* (London: Secker and Warburg, 1991).

Rheingold, Howard, *The Virtual Community: Homesteading on the Electronic Frontier* (Reading, MA: Addison-Wesley, 1993).

Rheingold, Howard, 'The Virtual Community: Finding Connection in a Computerised World', in Hugh Mackay and Tim O'Sullivan (eds), *The Media Reader: Continuity and Transformation* (London: Sage, 1999), pp. 273–86.

Richard, Nelly, 'Postmodernism and Periphery', trans. N. Caistor, *Third Text* 2 (1987–8), pp. 6–12.

Richin, Fred, *In Our Own Image: The Coming Revolution in Photography* (New York: Aperture, 1990).

Rickett, Frank, 'Multimedia', in Philip Hayward and Tana Wollen (eds), *Future Visions: New Technologies of the Screen* (London: BFI, 1993), pp. 72–91.

Robins, Kevin, 'Will Image Move Us Still?', in Martin Lister (ed.), *The Photographic Image in Digital Culture* (London: Routledge, 1995), pp. 29–50.

Robinson, David, 'Hollywood Rules', in *The Chronicle of Cinema 1895–1995*, vol. 5, 1980–1994, supplement to *Sight and Sound* 5: 1 (January 1995), pp. 126–7.

Robinson, David, 'New Technologies', in *The Chronicle of Cinema: 1895–1995*, vol. 5, 1980–1994, supplement to *Sight and Sound* 5: 1 (January 1995), p. 117.

Ross, Andrew, *Strange Weather: Culture, Science and Technology in the Age of Limits* (London: Verso, 1991).

Ross, Andrew, 'Wet, Dark, and Low, Eco-Man Evolves from Eco-Woman', in Margaret Ferguson and Jennifer Wicke (eds.), *Feminism and Postmodernism* (London: Duke University Press, 1994), pp. 221–48.

Saberhagen, Fred and James Hart, *Bram Stoker's Dracula* (London: Pan, 1992).

Sabin, Roger, *Adult Comics* (London: Routledge, 1993).

Sage, Victor, '*Dracula* and the Victorian Codes of Pornography', in Dominique Sipière (ed.), *Dracula: Insemination-Dissemination* (Amiens: University of Picardie Press, 1996), pp. 31–47.

Sardar, Ziauddin, 'alt.civilizations.faq: Cyberspace as the Darker Side of the West', in Ziauddin Sardar and Jerome R. Ravetz (eds), *Cyberfutures* (London: Pluto, 1996), pp. 14–41.

Schiller, Herbert, *Mass Communications and American Empire* (New York: Augustus M. Kelly, 1969).

Schiller, Herbert, *Communication and Cultural Domination* (New York: Sharpe M.E., 1976).

Schiller, Herbert, *Information Inequality* (London: Routledge, 1996).

Scott, Alan, 'Introduction', in Alan Scott (ed.), *The Limits of Globalisation:*

Cases and Arguments (London: Routledge, 1997), pp. 1–22.

Sedgwick, Eve, *The Coherence of Gothic Conventions* (London: Methuen, 1986).

Seiter, Ellen, *Sold Separately: Parents and Children in Consumer Culture* (New Brunswick: Rutgers University Press, 1993).

Sharrett, Christopher, 'Introduction: Crisis Cinema', in Christopher Sharrett (ed.), *Crisis Cinema: The Apocalyptic Idea in Postmodern Narrative Film*, PostModernPositions series 6 (Washington, DC: Maisonneuve, 1993).

Shaw, Martin, *Civil Society and Media in Global Crises: Representing Distant Violence* (London: Cassell, 1996).

Simpson, David, 'Feminisms and Feminizations in the Postmodern', in Margaret Ferguson and Jennifer Wicke (eds.), *Feminism and Postmodernism* (London: Duke University Press, 1994), pp. 53–68.

Skeggs, Beverley, *Formations of Class and Gender* (London: Sage, 1997).

Slater, Don, 'Domestic Photography and Digital Culture', in Martin Lister (ed.), *The Photographic Image in Digital Culture* (London: Routledge, 1995), pp. 129–46.

Smart, Barry, *Postmodernity* (London: Routledge, 1993).

Sobchack, Vivian, 'Democratic Franchise', in Ziauddin Sardar and Jerome R. Ravetz (eds), *Cyberfutures* (London: Pluto, 1996), pp. 77–89.

Sontag, Susan, *Against Interpretation* (New York: Stein and Day, 1966).

Sontag, Susan, *On Photography* (London: Penguin, 1979).

Spivak, Gayatri, 'Can the Subaltern Speak', in Cary Nelson and Lawrence Grossberg (eds), *Marxism and the Interpretation of Culture* (Urbana: University of Illinois Press, 1988), pp. 271–313.

Springer, Claudia, 'The Pleasure of the Interface', *Screen* 32: 3 (1991), pp. 303–23.

Springer, Claudia, *Electronic Eros: Bodies and Desire in the Postindustrial Age* (London: Athlone Press, 1996).

Sreberny-Mohammadi, Annabelle, with Kaarle Nordenstreng, Robert Stevenson and Frank Ugboajah (eds), *Foreign News in the Media: International Reporting in 29 Countries* (Paris: UNESCO, 1985).

Sreberny-Mohammadi, Annabelle, Dwayne Winseck, Jim McKenna and Oliver Boyd-Barrett (eds), *Media In Global Context: A Reader* (London: Arnold, 1997).

Stafford, Barbara, *Body Criticism: Imaging the Unseen in Enlightenment Art and Medicine* (Cambridge, MA: MIT Press, 1991).

Stearn, Gerald (ed.), *McLuhan Hot and Cool* (Harmondsworth: Penguin, 1968).

Stevenson, Nick, *Understanding Media Cultures* (London: Sage, 1995).

Stoker, Bram, *Dracula* (Oxford: Oxford World's Classics, 1983).

Stoker, Bram, *Dracula*, ed. A. Auerbach and D. Skal (New York: Norton Critical Editions, 1997).

Storey, John, *Cultural Consumption and Everyday Life* (London: Arnold, 1999).

Sturgill, Claude, *Low Intensity Conflict in American History* (Westport: Praeger, 1993).

Taubin, Amy, 'The Allure of Decay', *Sight and Sound* 6: 1 (January 1996), pp. 22–4.

Taylor, John, *War Photography: Realism in the British Press* (London: Routledge, 1991).

Taylor, John, *Body Horror: Photojournalism, Catastrophe and War* (Manchester: Manchester University Press, 1998).

Theweleit, Klaus, *Male Fantasies*, vol. 1 (Minneapolis: University of Minnesota Press, 1987).

Theweleit, Klaus, *Male Fantasies*, vol. 2 (Minneapolis: University of Minnesota Press, 1989).

Thompson, John, 'Social Theory and the Media', in David Crowley and David Mitchell (eds), *Communication Theory Today* (Cambridge: Polity, 1994), pp. 27–49.

Thompson, John, *The Media and Modernity* (Cambridge: Polity, 1995).

Thornton, Sarah, *Club Cultures: Music, Media and Subcultural Capital* (Cambridge: Polity, 1995).

Tran, Mark, 'Toy soldiers vie for Star Wars', *The Guardian*, 26 August 1997, p. 15.

Tulloch, John and Henry Jenkins, *Science Fiction Audiences: Watching Doctor Who and Star Trek* (London: Routledge, 1995).

Turetzky, Philip, 'Televisual Bodies: Television and The Impulse Image', in Christopher Sharrett (ed.), *Crisis Cinema: The Apocalyptic Idea in Postmodern Narrative Film*, PostModernPositions series 6 (Washington DC: Maisonneuve, 1993), pp. 103–27.

Turkle, Sherry, *The Second Self: Computers and the Human Spirit* (New York: Touchstone, 1984).

Turkle, Sherry, *Life on the Screen: Identity in the Age of the Internet* (New York: Simon and Shuster, 1995).

Vattimo, Gianni, *The End of Modernity: Nihilism and Hermeneutics in Post-Modern Culture*, trans. J. Snyder (Cambridge: Polity, 1988).

Vattimo, Gianni, *The Adventure of Difference: Philosophy after Neitzsche and Heidegger*, trans. C. Blamires with D. Harrison (Cambridge: Polity, 1993).

Virilio, Paul, *L'écran du désert: chroniques de guerre* (Paris: Galilée, 1991a).

Virilio, Paul, *The Lost Dimension*, trans. D. Moshenberg (New York: Semiotext(e), 1991b).

Virilio, Paul, *The Vision Machine*, trans. D. Moshenberg (New York: Semiotext(e), 1991c).

Virilio, Paul, Jean Baudrillard and Stuart Hall, 'The Work of Art in the Electronic Age', *Block* 14 (1988), pp. 4–14.

Virilio, Paul and Sylvere Lotringer, *Pure War*, trans. M. Ploizotti (New York: Semiotext(e), 1983).

Walker, Ian, 'Desert Stories or Faith in Facts?', in Martin Lister (ed.), *The Photographic Image* (London: Routledge, 1995), pp. 236–52.

Walkerdine, Valerie, 'Children in Cyberspace: A New Frontier?', in Karín

Lesnik-Oberstein (ed.), *Children in Culture: Approaches to Childhood* (Basingstoke: Macmillan, 1998), pp. 231–47.

Webster, Frank, *Theories of the Information Society* (London: Routledge, 1995).

Weeks, Jeffrey, *Sexuality and its Discontents: Meanings, Myths and Modern Sexualities* (London: Routledge, 1985).

Wicke, Jennifer, 'Postmodern Identities and the Politics of the (Legal) Subject', in Margaret Ferguson and Jennifer Wicke (eds.), *Feminism and Postmodernism* (London: Duke University Press, 1994), pp. 10–33.

Wicke, Jennifer and Margaret Ferguson, 'Introduction: Feminism and Postmodernism; or, The Way We Live Now', in Margaret Ferguson and Jennifer Wicke (eds.), *Feminism and Postmodernism* (London: Duke University Press, 1994), pp. 1–9.

Williamson, Judith, *Decoding Advertisments: Ideology and Meaning in Advertising* (London: Marion Boyars, 1978).

Willis, Paul, *Learning to Labour: How Working Class Kids Get Working Class Jobs* (Aldershot: Saxon House, 1977).

Wilson Carpenter, Mary, 'Representing Apocalypse: Sexual Politics and the Violence of Revelation', in Richard Dellamora (ed.), *Postmodern Apocalypse: Theory and Cultural Practice at the End* (Philadelphia: University of Pennsylvania Press, 1995), pp. 107–35.

Winston, Brian, *Media Technology and Society, A History: From the Telegraph to the Internet* (London: Routledge, 1998).

Wombell, Paul (ed.), *PhotoVideo: Photography in the Age of the Computer* (London: Rivers Oram Press, 1991).

Žižek, Slavoj, *Tarrying with the Negative: Kant, Hegel and the Critique of Ideology* (Durham, NC: Duke University Press, 1993).

INDEX

—◦—